BATHERS, BODIES, BEAUTY

The Visceral Eye

Based on the Charles Eliot Norton Lectures
2004

Linda Nochlin

BATHERS, BODIES, BEAUTY

The Visceral Eye

Harvard University Press

CAMBRIDGE, MASSACHUSETTS, AND LONDON, ENGLAND 2006

Publication of this book has been supported through the generous provisions of the Maurice and Lula Bradley Smith Memorial Fund.

Library of Congress Cataloging-in-Publication Data

Nochlin, Linda.
Bathers, bodies, beauty / Linda Nochlin.
 p. cm.—(The Charles Eliot Norton lectures ; 2003–2004)
Includes index.
ISBN 0-674-02116-9 (alk. paper)
1. Nude in art. 2. Aesthetics. 3. Baths in art. 4. Swimmers in art.
I. Title. II. Series.

ND1290.5.N63 2006
757'.22—dc22 2005050369

Designed by Gwen Nefsky Frankfeldt

To my daughters, Jess and Daisy

\mathscr{C}ontents

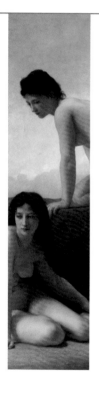

Renoir's *Great Bathers:*
Bathing as Practice, Bathing
as Representation

1

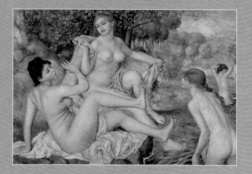

THE WOMEN LINGER at the water's edge, and they are stunning in the most unusual way: large women, voluptuous, abundant, delighted. They lounge along the river bank, they lift their arms toward the sun, their hair ripples down their backs, which are smooth and broad and strong. There is softness in the way they move, and also strength and sensuality, as though they revel in the feel of their own heft and substance.

"Step back from the canvas, think, feel. This is an image of bounty, a view of female physicality in which a woman's hungers are both celebrated and undifferentiated, as though all her appetites are of a piece, the physical and the emotional intertwined and given equal weight. Food is love on this landscape, and love is sex, and sex is connection, and connection is food; appetites exist

in a full circle, or in a sonata where eating and touching and making love and feeling close are all distinct cords that nonetheless meld with and complement one another.

"Renoir, who created this image, once said that were it not for the female body, he never could have become a painter. This is clear: there is love for women in each detail of the canvas, and love for self, and there is joy, and there is a degree of sensual integration that makes you want to weep, so beautiful it seems, and so elusive."[1]

I didn't write these words, of course. This is a set piece that constitutes the prologue to *Appetites: Why Women Want,* a chillingly honest, sometimes exasperating study of female appetite and its repression by the late Caroline Knapp, an anorexic and a passionate student of anorexia. As such, it might be compared with Michel Foucault's analysis of Velázquez's *Las Meninas* in the long opening chapter of *Les Mots et les choses,* a chapter in which that author "seeks to demonstrate . . . the spatial mapping within which knowledge becomes knowledge rather than accidental array of facts and objects."[2] When I first read Knapp's paragraphs, I hated them with the kind of visceral hatred that makes you, or at least me, want to hurl a book across the room. All that sentimental cant about food and softness and sex, especially the bit about Renoir loving women—as a feminist, as an art historian with the

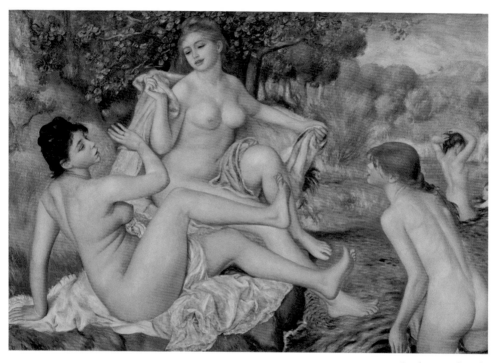

1 · Auguste Renoir,
The Great Bathers,
1884–1887

proper sort of critical training, as a person who, fifteen years ago
when I first started working on the painting, sought to demystify
the male artist's disempowering idealization of the female body,
and for whom *The Great Bathers (Les Grandes Baigneuses)* was the
paradigm of all I found wrong with the traditional representation
of the nude, I found the painting, and Knapp's enraptured re-

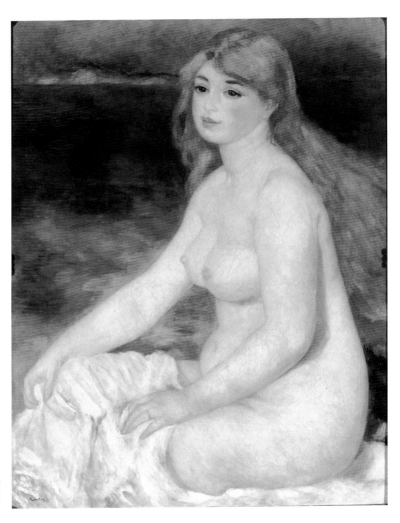

2 · Auguste Renoir,
Blonde Bather, 1881

sponse to it, pernicious both from a formal standpoint and in terms of what it represented.

My negative gut reaction to the sentimentalized, sexualized prettiness of the image, I might add, was shared by many critics at the time Renoir painted it but has been articulated with particular forcefulness by a contemporary feminist authority on nineteenth-century French painting, Tamar Garb. Garb, unlike Caroline Knapp, sees Renoir's many bathers, of which *The Great Bathers* is a large-scale example, as constructions designed to receive the desiring male gaze at a specific moment in history. Speaking of the slightly earlier *Blonde Bather* of 1881, Garb declares,

> From the 1880s on [Renoir's] ideal woman would be the personification of all that was wholesome, bountiful and sustaining to modern man, a nostalgic fantasy typified by the retardataire *Blonde Bather* of 1881. Her rounded forms, carefully licked by a loaded brush, her erect and high-lighted nipples mounted on full breasts, her remote expression fixed on some indeterminate spot in the distance, her flowing hair and rosy countenance would symbolize the eternal values of art and the unusual properties of Woman. Plump, pink and pliable, the blonde bather . . . represented a sexuality that was tangible in a

setting that was tantalizingly remote . . . Art was at the service of a femininity at risk from the corruption of modern life, and the nude, as reconceived by Renoir, was the perfect means for the reaffirmation of traditional values in art and traditional relationships between the sexes. The caress of a woman's body and the encounter of the brush with the painted surface had, as sensory experiences, an equivalence that only painting could articulate.[3]

Pliant, seductive, natural, Renoir's bathers embody a whole tradition of masculine mastery and feminine display which underpins so much of Western pictorial culture—and which was increasingly being challenged by feminists, social reformers, and the effects of the modernization Renoir increasingly despised. It is interesting that both Knapp, who loves the picture, and Garb, who scathingly demystifies it, see the picture in similar terms; they simply draw different conclusions. One might say their visceral eyes devour the pictorial material differently.

Yet even when I first became engaged with the painting back in 1990, at the time of an exhibition of *The Great Bathers* and sketches for it at the Philadelphia Museum of Art, I realized that although my gut reaction to it was strongly negative, I was aware of a certain ambivalence, a certain undertow of attraction. In the

lecture I gave on the occasion of the exhibition, in which I articulated a feminist position similar to Garb's, insisting on the dominance of the male gaze in the work of both painter and viewer, I was forced to speculate about the position of the putative *female* spectator—not the ahistorical anorexic posited by Caroline Knapp but a historically specific one: was there any position available to the female viewer of Renoir's painting, specifically the female viewer of Renoir's time? Long consideration and a too tight belt in Paris gave me a possible answer.

Perhaps Renoir's nudes enable a certain feminine fantasy as well as the more conventional male one, a fantasy of bodily liberation. It is difficult to imagine how women, especially ample women, condemned to the strictures of corsets and lacing, must have felt before this vision of freely expanding flesh, the pictorial possibility of unconstricted movement, of simply breathing deeply, of not having their breasts pushed up under their chins and their ribs and lungs encased in whalebone. The imaginary pleasure of lolling about with their uncorsetted flesh exposed to air and light in the epoch before sun was supposed to be good for you (though now of course supposedly it is no longer good for you) when well-brought-up ladies scrupulously covered their pale skins with parasols, veils, and long sleeves, not to speak of

long skirts and stockings, must have been considerable. Perhaps this aspect of openness, unfetteredness, and deconstriction might have appealed not merely to men, for obvious reasons that have been reiterated innumerable times, but, for the reasons I have just stated, by women as well. And obviously the image is still seen as appropriate to the self-enjoyment of women bathers, as a large-scale tile mural gracing the wall of the Ginseng Korean Baths, the pride of Sydney, Australia, attests.

Yet still another voice needs to be woven into this fugue of strong responses to Renoir's *Great Bathers,* this time a psychoanalytic one. Elizabeth Young-Bruehl, author of a biography of Hannah Arendt, then a teacher at Wesleyan University where I was lecturing about the painting four years later, now a psychoanalyst in the East Village, felt strongly enough about my interpretation and about issues raised by the painting to write me the following letter. It is dated October 9, 1991, and certainly constitutes a fresh and provocative take on what the scene addresses. Wrote Young-Bruehl: "You tended to dismiss any inquiry into the psychodynamics of male viewers of Renoir's painting . . . as though all that needed to be said on the topic of male voyeurism and the sub-topic of male voyeurism in relation to female homoeroticism had been said. So you turned your attention, instead, and in-

terestingly, to female viewers and the possibility that what they might have enjoyed in these paintings was liberated flesh, un-corsetted movement and so forth. I can see why you both felt 'enough already' about male voyeurism and why the liberated flesh theory was appealing, but I think there is a psychodynamic dimension that these approaches miss.

"What struck me very forcefully about the Renoir [continues Young-Bruehl], was the configuration of the women. There is not the classic (psycho-dynamically speaking) threesome, the ménage with two women—more or less bound to each other—and one male viewer, either in the painting or implied in the form of painter or viewer. Instead, there are viewers of the females in the painting, and these viewers are female. The lithe girl to the front right is [the] viewer [in] the main trio, and, in the rear a girl with her back to us [is] being stared at by a nearly submerged figure. These right side figures . . . are painted in Impressionist strokes (as you noted), very different from the shiny, hard-edged flesh-exaggerating strokes of the centerpiece trio. They are also thin, boyish in comparison to the voluptuous center trio, and pre-sented to viewers from the back, which in this context is also androgynizing. It seems to me that viewers, male and female, are being invited to identify with the female viewers in the painting.

Women are being invited to enjoy female nakedness in the role of boyish girls, and men are being welcomed not just as men, but as women as well, that is, in both the masculine and the feminine 'positions.' And female homoeroticism is, so to say, for everybody."

And now Young-Bruehl dives, quite literally, into the Freudian depths: "Let me put this matter another way. Women bathers are . . . precisely that, bathers—the medium in which they are and are to be viewed is water . . . Their medium is, symbolically, female. They are all bound by a female medium and men get to be participators. I think that the coy splasher [the 'viewer' in the triad] helps them along in the participatory side of this invitation: the splashing girls [in the foreground and background] are active, and they recall both the unending art history of male putti peeing from fountains and the common fantasy of female ejaculation (if one wanted to be *echt* Freudian, much could be said about phallic women, etc.)." She concludes about the painting, "From the female side: viewing naked women, like going to a swimming pool, allows a woman to enjoy masculine or boyish pleasures (I should say pleasures conceived or constructed as masculine) of gaze and activity—girls can be boys, while being girls."

But now Young-Bruehl goes on to generalize, boldly—and at times with an endearing lack of historical accuracy—about the

sexuality of a whole period of European history on the basis of her take on *The Great Bathers.* "What I see in the Renoir, and see as an outgrowth of his earlier crowd scenes in which the people are often so crowded together that their sexual identities merge, is the phenomenon that seems to me palpable across the whole of 1880s and 1890s Europe: the emergence into art and text of enjoyment of bisexuality, in all kinds of coded but nonetheless well-understood forms: the Oscar Wilding and George Sanding . . . of Europe. By the time men appear in the scenes—as with the morning-dressed Manet picnickers [fig. 17]—the imperative to play all the possible sexual parts at once seems to me to be loud and clear, for both men and women, though the emphasis is, with these male painters, on men. Cézanne [fig. 14], from this perspective, simply blurs the boundaries of identification more: sexual differentiation is transcended, and viewers are invited into a scene, which is like a polymorphously perverse jungle (it even includes the previously suppressed lying-ready rear-ends, presented for fantasy anal intercourse)." Young-Bruehl ends on a high note with her final words on Cézanne's *Large Bathers:* "It is so polymorphous and pansexual as to be almost unerotic, unsexual! (Hail to the 1960s!)"

With Renoir's *Great Bathers,* what I have started with, then, is neither representation nor practice, nor even a unified reading of

the painting in which I, the speaker, lay out the task with the understood assurance that from my position of superior knowledge I will pull it all together at the end. What I am proposing instead is a kind of piecemeal deconstruction, an interpretive collage, as it were, appropriated from the readings of differing, strong-willed, and—it must be emphasized—*female* viewpoints. How do I reconcile these views? I don't. If, as Theodor Adorno believed, all works of art are by definition mysterious, then even such a seemingly obvious one as *The Great Bathers* must remain ambiguous in its address, impervious to any reductive solution. Think of *The Great Bathers,* then, as Orpheus and my multiple female interpreters as the Thracian women laying into the artist's body with a vengeance. Like Humpty Dumpty, all the king's horses and all the king's men will never put it back together again.

But I have another point to make. I deliberately began this lecture with my subject as a vision of corporeal plenitude seen through the eyes—and desires—of lack: the anorexic eye. I wanted to make the point that eyes—and psyches—are located in specific bodies, and I am referring to the eyes of both artist and viewer. The art historian, in this case myself, no less than Renoir or the late Caroline Knapp, is a corporeal being, seeing through the very body whose representation was put in crisis during the

nineteenth century and was further and more radically destabi-
lized during the twentieth.

For there is history, of course: the corporeal eye, the visceral
eye—all eyes are located not merely in bodies but in historically
specific bodies and can thus be viewed within a history of repre-
sentation and a history of practices, a social history, in short, that
can thicken up our responses to *The Great Bathers*.

On the surface of it, nothing would seem less problematic
than the late-nineteenth-century bather. It seems to be a natural
"given" of art history: timeless, elevated, idealized, and as such
central to the discourses of high art. Yet of course, it has become
obvious already that the bather theme is anything but a given, the
opposite of natural. On the contrary, it is a construction particu-
lar to a certain historical period, though based on and attaching
itself to a long artistic tradition; and far from being natural, it is a
highly artificial and self-conscious construction at that.

I am now going to continue my attempt to problematize this
apparently unproblematic and "natural" subject by putting the
bather, and bathing, back into the history of social institutions,
practices, and representations from which Renoir and most of the
"high" artists of his time abstracted them. The point of this part
of my investigation is not so much to discover anything new

about Renoir's *Great Bathers* but rather to consider what it has excluded: what about bathers and bathing during our "bathtime" of the late nineteenth century has the painting occluded?

"Bathtime" was the title of the lecture I gave on *The Great Bathers* in 1990, and I had a reason for choosing it—the reason was history. The title was meant to imply a study focusing on a certain historical period in France, and the project of my research was to locate Renoir within a historically specific discourse of the pool, bathers, and bathing, a discourse both visual and textual, extending from approximately 1850 to the fin de siècle.

The Paris Salon of 1887, the year when Renoir completed his *Great Bathers,* exhibited at least twenty-five representations of female bathers, all indistinguishable in theme from Renoir's painting, except perhaps for the relatively daring *Bathers* by Frédéric Dufaux, with its half-dressed contemporary figures slipping in and out of the water. The bather was a perennial favorite in the Salons of the nineteenth century, a theme increasingly secularized and generalized as the century progressed and as earlier classical or biblical pretexts—Dianas, Susannahs, or even the more up-to-date orientalist Sarahs—vanished, giving way to the newer bather subject of preference: the "bather" *tout court.*[4]

Why, at a certain moment in the history of French art, did the

naked female figure, alone or in company, in water or near it, become so important?[5] Viewed from a historical vantage point, Renoir's *Great Bathers* may be said to belong to a particular moment of bathtime: that of the artistic *rappel à l'ordre* of the 1880s (a recall to order presaging the better-known one which took place in France after the First World War).[6] After the bold attempt of Impressionism to create a modern art, contemporary in both its formal strategies and its subject matter, certain artists in the group, most arduously Renoir, attempted to restore a sense of permanence, timelessness, and harmony to the openness, instability, and vivid contemporaneity characteristic of High Impressionism.[7] Renoir espoused high-minded reasons for his project in *The Great Bathers*. Yet it is important to see that in it he returns not merely to the traditional sanctions for the bather subject provided by Raphael and Girardon, whose work has often been cited in relation to the formal and iconographic specificity of the work, nor even to the precedent of such minor artists of the eighteenth century as Jean-Baptiste Pater, who specialized in semiprurient bather fantasies deploying semiclothed female bathers in imaginary settings of great piquancy, nor to the example provided by his teacher, the long-suffering Charles Gleyre (fig. 3).[8]

More importantly, perhaps, Renoir returns to the kitsch sensi-

3 · Charles Gleyre,
Bathers, c. 1860

bility of his own milieu—to works like *L'Espièglerie* (Teasing), of which there are versions from 1849 and 1867, mass-produced lithographs replete with lesbian overtones (Elizabeth Young-Bruehl was certainly on the right track), in which the theme of mischievous, naked bathing girls, teasing and splashing one another, is archly frozen in place for the pleasure of a male viewer. The standard range of poses and physical types, the gamut of complexions and ages, the sense of savoring the delectable details of the youthful bodies and their titillating playfulness—all these features are shared by works as different in ambition as Renoir's *Great Bathers* and the popular lithographs of the period.[9]

This, then, is the construction of the female bather within a convention that may encompass a variety of practices, from mass culture to high art, from the site of erstwhile vanguard production to that of the most conservative "official" specialists in the nude, like Adolphe-William Bouguereau. All of these bather paintings are replete with what I would call "the aesthetic effect"; they are smooth, fetching, playful, relaxed, and strenuously removed from any context that would suggest either contemporaneity or the realities of urban existence, including the existence of the opposite sex (fig. 4).[10] There are rarely any men in these pictures aside from an occasional faun or satyr. The pastoral idyll

represents only the naked female: the male presence is an absence; or, rather, it is displaced to the understood position of the creating artist and the consuming viewer, not to speak of the potential buyer of the work.

But what has been less investigated is something quite different from the representation of bathers: the practice of bathing and swimming that was coming into being during the bathtime under consideration, a time a little earlier than that of Renoir's *Great Bathers* but certainly contemporary with other artists' highly idealized and aesthetically specific constructions of the bather motif, a practice whose representation has, for the most part, been left unstudied by traditional art history, with its consistent neglect of all forms of visual representation that cannot be considered "high" art.[11] I refer to evolving popular practices and representations of bathing and swimming—water sports and water amusements in general, specifically as they involve women—that mark the nineteenth century as a whole and its latter half in particular.[12] Not that Renoir was ignorant of the swimming of his day. Indeed, in his representations of *La Grenouillère* done in company with his friend Monet in the late 1860s, he had kept a lively record of the activities of contemporary bathers off the island and on it.[13]

4 · Adolphe-William Bouguereau,
Bathers, 1884

The Impressionists, with Renoir prominent among them, at this early point in their existence as a group, were calling into question the traditional practices of the high art of their time by representing bathing, as well as sailing and rowing, as a contemporary activity, carried on in bathing suits and bonnets, in a context of urban (or, more accurately, suburban) social relaxation rather than an elevated, classical topos represented by artificially posed nudes in idealized pastoral landscapes. Recalling those days in later years, Renoir remembered them with great nostalgia, choosing to envision this period as an idyllic, preindustrial pastoral era rather than the period of vigorous urban modernization that it was. He told his dealer and friend Ambroise Vollard that "in 1868 I painted a good deal at La Grenouillère. I remember an amusing restaurant called Fournaises where life was a perpetual holiday . . . The world knew how to laugh in those days! Machinery had not yet absorbed all of life; you had leisure for enjoyment and no one was the worse for it."[14]

But in addition to such revolutionary paintings of the sixties—revolutionary in their synoptic style and vivid broken color, which is part of the modernity of their subject—there exists an unexplored archive of visual alternatives to those provided by the Salons and by the later Renoir's idyllic versions of the bather

theme. This is the whole realm of representation, produced by the nascent mass media, focused for the most part on Paris itself, although in some cases on the Parisian suburbs, and dealing with contemporary swimming and swimming pools. There, one found female bathers beneath the notice of the sort of elevated artist and conservative yearner for the simpler, more natural verities of the past, a persona Renoir was increasingly affecting by the decade of the 1880s.

As early as mid-century, Honoré Daumier was engaging with bathing and bathers, male and female—but in Paris, not in the country; clothed, not naked; ridiculous, not elevated.[15] One can only think, in looking at such caricatures as his *Naiads of the Seine*, that he was pillorying not merely his victims but the high-art bather theme itself, as it existed in endless dreary Salon representations of his time: the naiads, Dianas, Susannahs, and just plain bathers whose ranks cast a pall of boredom over the art experience, year after year. Daumier's lithograph plays on the oxymoronic humor of this juxtaposition of terms (fig. 5). There cannot be serious naiads of the Seine, Daumier implies, because, like Marx, he believes that antiquity can be repeated in modern times only as farce. The present-day Seine gets the bathers it deserves, those who are appropriate to bathtime today: bathing-

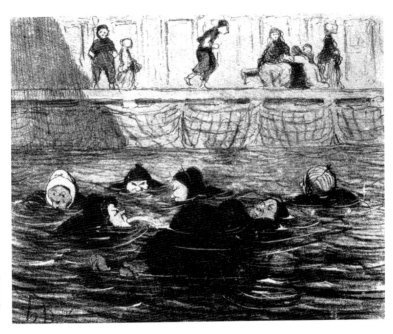

5 · Honoré Daumier, *Naiads of the Seine*, 1847

suited, spindle-shanked, frowsy-headed, anticlassical in figure type. His bathers are grotesques of the Seine, but living, breathing contemporaries, not classical nymphs or goddesses.

Here, the connection between the female bather and the world of nature is severed, revealed for the farce that it is: nothing could be less natural than these bathers and their baths. Modern life, es-

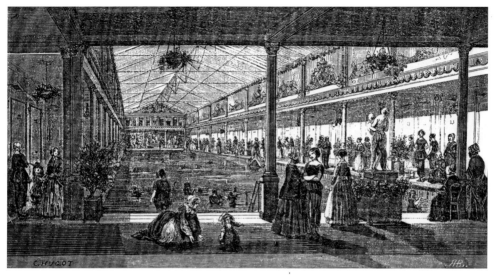

6 · C. Hugot, *Bains de Paris,* 1844

it is the best of gymnastics; they are also recommended for both by all the doctors, but only on condition that the water in which they are taken is healthy and salubrious—that is to say, as pure as possible."[17]

Using as its major illustration a print based on the original by Hugot which had appeared in the 1846 *Illustration,* the article goes on to praise the qualities of the Seine where the Bains Lambert are located—at a point where the river has not yet received

the "tribute of filth" *(tribut des immondices)* from the great city. Elegance, decorum, and amenity are emphasized by the often repeated and varied visual representations of the interior—the classical columns and pediment as well as sculpture suggesting the baths of antiquity. It is noteworthy, in the interests of decorum, that the only nude female body represented in the prints is that of classical sculpture: all the contemporary ladies are properly dressed. A maid is prominently featured in the foreground, and bathing costumes are as concealing and unseductive as possible. Propriety, good morals, decent hygiene, and healthfulness are the primary characteristics stressed by these visual representations of the female bather. Nudity exists only as a sign of elevation, establishing the credentials of the pool as a site of upper-middle-class recreation, strictly segregated by sex as well as class.

Yet this is only one view of women's bathing establishments and their *habituées* during France's nineteenth-century bathtime. Other draftsmen or journalists figured the subject quite differently. Notions of sexuality, voluptuousness, and seductiveness haunted the imagination of the commercial artist who designed this print of women at the Bain des Lionnes. Memories of the odalisques of Ingres and his prototypical Turkish bath are roused by the languid poses and the intimate crowding together of fe-

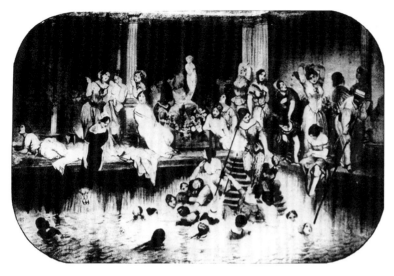

7 · Negrier,
Le Bain des Lionnes

male bodies. Despite the reassuring presence of the *maître-nageur*
and the contemporary bathing costumes, the print stirs up a cer-
tain uneasiness connected with sexual exoticism. "Low" or popu-
lar art, it is clear, can no more be viewed monolithically than high
art: here, too, there are different voices, different tasks the image
is intended to perform, with different audiences in view. The na-
ked classical statue seems more a reference to the near-nakedness
of the swimmers and their lack of *tenu* (decorum) than to bour-

geois decorum and elevation. Indeed, many accounts of women's swimming pools stressed the unfortunate presence in them of ladies of the theater and, even worse, smoking and drinking and carrying on "like men."[18] Women on their own enjoying themselves without the benefits of male companionship or protection then, as now, inspired suspicion, sexual innuendo, and often gross satire.

Ultimately, the discourses of bathing and swimming must be understood in connection with other regimes of reglementarianism—official government regulation—connected with the body and its practices, regimes brilliantly analyzed by Michel Foucault and by Alain Corbin in his studies of prostitution, smells, and garbage, as well as by Georges Vigarello in his histories of cleanliness, sports, posture, and deportment training.[19] Bathing and its representation must be viewed as part of a more generalized politics and policy of "putting the body in its place": a policy that had its origins during the later eighteenth century and was associated with Enlightenment ideals of control, hygiene, and civil order. As with the discourses of prostitution, sanitation, and wet-nursing, to which the discourses of swimming and bathing are related in that all are concerned with the body's products, comportments, or employments, there is an evolving official government code of regulations, stipulating prohibitions, and approving practices in

the realm of swimming and bathing. This official regulationism is accompanied by a stream of propaganda extolling the physical and social benefits of swimming and bathing and, at the same time, by a contradictory plethora of irreverent satire aimed at the foibles associated with water sports.

In none of this material, however, is the critique aimed at naked goddesses lolling about on the banks of classical or Edenic shores, but rather at modern women emerging from locker rooms, learning the strokes and the dives, taking showers before and after, and eyeing one another in bathing suits. Nakedness and the elevation of the nude is never an issue here, but rather the ludicrous effects of contemporary bathing costumes on less-than-perfect bodies. Popular art tells a story of mundane dangers and down-to-earth (or down-to-water, more accurately) triumphs.

The Parisian *piscines* (municipal swimming pools) are viewed as democratizing where men are concerned, and perhaps somewhat equivocally when it concerns women.[20] What might be perceived as a beneficent temporary mixing of social milieus in the case of male swimmers had different overtones in the case of female ones, as *demi-mondaines, grisettes,* dancers, and actresses mingling with respectable girls and women might well be a corrupting influence.[21]

Crowding, jostling, and loss of control over the urban river-

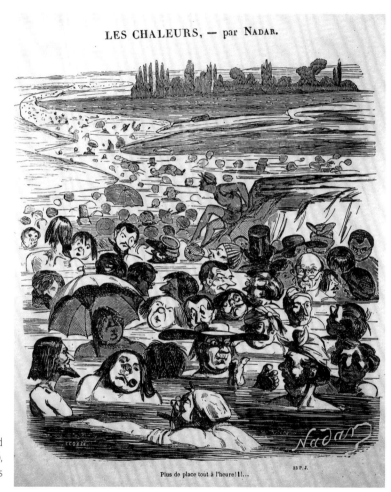

8 · Nadar (Gaspard Félix Tournachon), *Les Chaleurs*, c. 1860s

space, especially in the case of the cheap *bains à quatre sous* ("nickel baths") was perceived as a real issue, whether represented humorously, as in Nadar's *Les Chaleurs,* or more objectively, as in an 1880s photograph of the Seine viewed from the Louvre, showing the area around the Pont Neuf encumbered with floating wooden pools.[22] Swimming pools had become very popular by the decade of the 1880s. In 1884, the year of the grand opening of the Piscine Château-Landon, one of the first swimming pools to be constructed *away* from the Seine, 200,000 people visited the pool, of which 1,000 learned how to swim.[23]

Sophisticated posters began to appear, advertising the attractions of the various municipal pools. What I find interesting about a poster like the one published by Emile Levi in 1882, advertising the Bains Bourse, is, in comparison to Renoir's almost contemporary *Great Bathers,* its modernity (fig. 9). I am not talking about quality here—the poster, although it has a certain pizzazz, makes no claims to aesthetic excellence—but rather the way the image engages with commodity, how it catches the eye of the spectator, male or female, and keeps it focused on what is at stake: the pool, the bodies, the prices. Segmented in its construction, combining print and illusionistic representation as boldly as a much later cubist collage, the poster assigns each part a spe-

9 · Emile Levi,
Poster of Bains Bourse Pool,
1882

cific task to perform, a task of commercial communication. The deeply receding space of the pool, emphasizing its amplitude, is decoratively related to, yet, in terms of signification, separated from, the segment communicating prices and amenities (the print section), which in turn is separated from the two "come on" fig-

ures—the *commère* and the *compère,* as it were—connecting the viewer with the possibilities offered by the image. The woman is someone we know from the ads of our own day: sprightly, up-to-date, come-hither, her sexuality already functioning as a visual sign of exchange-value in much the way we take for granted in modern advertising. Color is flat, outlines simplified, the easier to get the message across and the cheaper to print up multiple copies. It is in the "low" art of the *piscine* poster that visual representation and modernity intersect, in a way utterly foreign to Renoir's enterprise.

Of course high art had its own counter-discursive strategies during bathtime: that campaign of subversion from within which art history has always identified with Modernism itself. In both Courbet's *Bathing Women* of 1853 (fig. 10) and Manet's *Déjeuner sur l'herbe* of ten years later (the latter originally entitled *Le Bain;* fig. 17), the traditional elevation of the bather theme is called into question with a "shock of the new." In both cases, although differently, a disconcerting combination of alienation and the reality effect is involved. In the Courbet, "reality" is signified by the coarse fleshiness of the fat body and the presence of abandoned clothing; but the meaninglessness of the gesture calls into question the naturalness of the topos itself and invokes alienation. In

10 · Gustave Courbet,
Bathing Women, 1853

RENOIR'S GREAT BATHERS

the Manet painting, abandoned clothing as well as the presence of modern, fully dressed men signify, once more, contemporaneity; but the formal language in toto refuses the natural as a possibility of representation.

This was a subversion from within which Renoir, as an Impressionist, had actively participated, as his interesting, disturbing, not wholly successful *Nude in Sunlight* of 1876 reveals (fig. 11). But by the 1880s and 1890s, things had changed within the avant-garde itself. It was not just Renoir who was fleeing immediacy and contemporaneity but other vanguard artists as well, most notably Gauguin, who actually left France itself in search of more timeless, universal, indeed eternal values inscribed on the bodies of naked, dark-skinned females (fig. 12).

Earlier, I made the assertion that Renoir's *Great Bathers* might belong to a certain subcategory or moment of bathtime—that of the *rappel à l'ordre* of the 1880s, when certain artists, most arduously Renoir, attempted to restore timelessness and high-minded harmony to late Impressionism. I should now like to suggest, very sketchily, why this should be the case, and to indicate the various overdeterminations mediating the construction of *The Great Bathers* and other works of this period.

I would like to make clear that I consider *Great Bathers* an am-

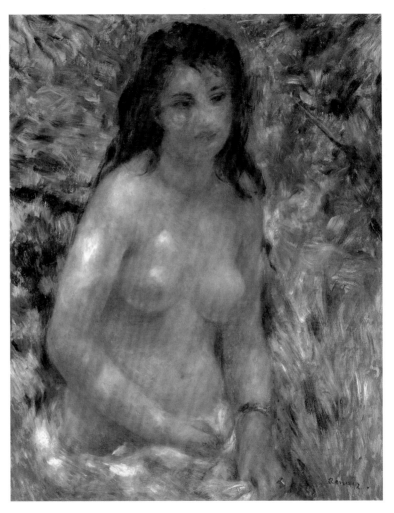

11 · Auguste Renoir,
Nude in Sunlight, 1876

RENOIR'S GREAT BATHERS

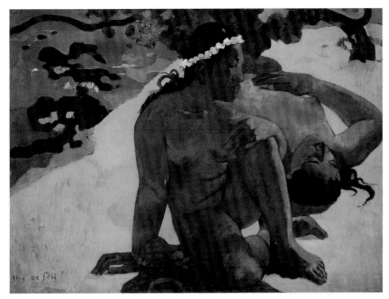

12 · Paul Gauguin,
What, Are You Jealous?
1892

bitious but badly flawed painting rather than a masterpiece—a
record of conflicting desires, intentions, and practices, and inter-
esting as such. It is certainly not a painting that either innovates
or summarizes. These contradictions, I maintain, exist not merely
on a formal level, as at least one authority has contended, but are
the inscription of much more complex conceptual and ideologi-
cal muddles.[24] *The Great Bathers,* with all its ambiguities and fail-

ures, constitutes a response to a multitude of pressures during the period preceding its creation, including:

(1) Growing demands on the part of women for rights, education, and subjecthood within industrial society, a sign of "progress" that Renoir increasingly found dangerous and to which he reacted with longing for the "good old days" when women—and everyone else—knew their place.[25]

(2) Market forces demanding specialization and individualization of artistic production.[26] This, in a way, might be considered part of the same objectionable "progress" that Renoir so disliked, and he complained bitterly about it in his letters. Nevertheless, he understandably did his best to succeed within the dealer system and through the cultivation of wealthy clients. Increasingly, during the 1880s, each artist had to be positioned as a unique (almost invariably male) hero of creation and self-creation. Renoir and his fellow artists felt, not incorrectly, that Impressionism's brief communal enterprise had blurred and blunted the uniqueness of individual styles and personalities. Viewers had difficulty, for example, telling the difference between Monet's and Renoir's versions of *La Grenouillère.* Now, by the decade of the 1880s, stimulated by the dealer system and a competitive market extending as far as the United States, the unique artist was encouraged to pro-

duce identifiable objects: it was no longer a question of "Impressionist works" but of "Monets" or "Renoirs."

One might call it "bending to the market" or "opportunism," but that is to imagine that at all times an artist like Renoir is consciously catering to the wishes of others and would, on his own, do something quite different. On the contrary, I would say that, most of the time, producer and consumers shared similar values, and it is a question not so much of bowing to market pressures as interpellating (to use an Althusserian term) in the realm of cultural institutions: certain positions and formations gradually emerge which call into being subjects who will fill them. "The artist" by the 1880s was already positioning himself as a specialist and a genius—not a *representer* of modern life but its opposite, an *inventor* of timeless, aestheticized realms of value, beginning perhaps with experience but transcending it. Monet became a specialist in series, Renoir in bathers, Gauguin in Tahitians, and so on, with styles that could not be confused with those of other artists.

Sticking to the city and to an interchangeable style, Cézanne (of whom more later), but especially Seurat and the Neoimpressionists, offer a counter-example to this more general trend of the 1880s and 1890s. Yet even they, like Renoir, rejected the fluidity

and experiential ephemerality characteristic of Impressionism at its high point in the 1870s. Renoir's *Great Bathers*, then, is part of the history of that retreat from experience, from daily life, from urban subject matter, and from social engagement which defines one strand—perhaps the dominant one—of Modernism until the advent of Cubism. The question is, of course, to what extent can such a painting be associated with the Modernist enterprise at all.

In Renoir's case, I think certain special factors are at work in the *rappel à l'ordre*. Impressionism, and Renoir in particular, came in the late 1870s to be associated not only with the inchoate, the momentary, and the transient but, at the same time, with the quintessentially feminine in both subject and style. In other words, I believe a hidden, and probably an unconscious, gender agenda is at work here. There is a way in which, in *The Great Bathers*, Renoir may be said to be ridding himself of what was considered "feminine" formlessness and the triviality of a "feminine" style.[27]

Renoir, who could hardly but be aware of this effeminization of Impressionism in the critical texts of the period generally, and particularly those critiques directed toward his own production, took harsh steps to remedy these "flaws." Earlier, he had engaged with the rest of the Impressionists in constructing a painting of

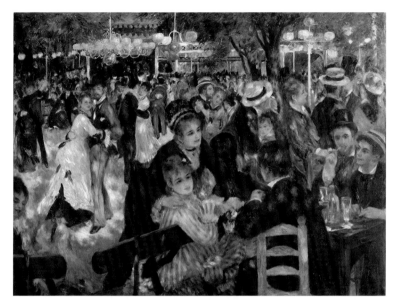

13 · Auguste Renoir,
Le Moulin de la Galette,
1876

daily life, of city or suburbs where men and women interacted as social beings within the milieu of historical experience, even if this might be a Utopian world of desire and pleasure, as it was in *Le Moulin de la Galette* of 1876 and other works of that period.

Now, in 1887 with *The Great Bathers,* the male is positioned outside the world of the painting, as desirer and viewer rather than participant. The representation is no longer social and con-

crete but reduced to a "timeless" realm of women's bodies in a vague, natural setting. History and social hierarchy are occluded in order to produce an atemporal, natural realm in which a masculine subject views a feminine object.

The end of Impressionism, viewed from the vantage point of gender, coincides with a (possibly unconscious) rejection of the "feminine" toward the end of the century, and a return to "solid" values on the part of a certain fraction of the avant-garde. The nude, specifically the bather, inscribed in the order of the "natural," stands for the return of value in art itself. Nowhere can this mythology of the return of solid values to art be so convincingly deployed as in the case of the ambivalently approached *female* body. It is here that aesthetic goals can coincide most productively with unconscious psychosexual factors, and these unconscious impulses in turn erased, modified, or sublimated. The bathers, freed from contemporary specificity and historical narrative alike, are now understood to be the primary realm of pure aesthetic—of course, masculine aesthetic—challenge.

And what of the other painter of large bathers, Cézanne? One might begin by observing that in his work, modernity intersects with the female nude in terms of a language, a pictorial construction, not a subject matter. Cézanne's "doubt," as Maurice

Merleau-Ponty labeled it, calls into question both subject and object: the painter's vision, his powers of inscription, the naked body, and the space-surface within or upon which it must exist.[28]

In terms of perspectival construction, Cézanne's decentering of the pictorial point of view relates both to desire and sexuality in the construction of his bather paintings. Cézanne refuses Renoir's obvious, single, centered viewpoint in his *Large Bathers* of 1906, and, by shattering one-point perspective, destroys the understood presence of the desiring individual male as the painter/spectator's point of view (fig. 14).

In emphasizing Cézanne's famous doubt, a doubt of which the signifier is revealed *process,* I should like to compare it with Renoir's doubtfulness, an uncertainty veiled by the harmonious stasis characteristic of a *product.* For Renoir, of course, has doubts, too; or rather, he has troubles about the validity of his art, especially about the everyday subjects, impermanently painted surfaces, and the unstable compositions—in short, the processive structures—characteristic of High Impressionism. And, from a different standpoint, like most female nudes of the nineteenth century, his bathers as subjects of representation are sites of contradiction and uncertainty, inscribing anxieties and their repression.

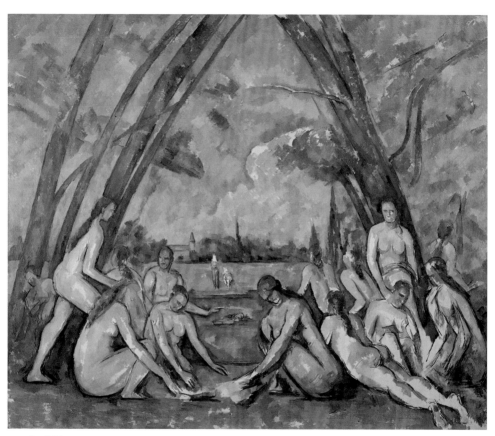

14 · Paul Cézanne,
Large Bathers, 1906

Cézanne's bathers, unlike Renoir's, do not bathe or play or talk. There is no longer any sensory illusion, or narrative pretext, as in Renoir's: no splashing, drying, or *espièglerie* (teasing). The specific qualities of the body—not just the seductiveness of the female or its fearsomeness and power but its very anatomy, its proportions, its ability to support itself, and perhaps most especially its *boundaries*, that which separates the body in its integrity from that which is not the body (the so-called background), boundaries which, in the form of contour, were so carefully and lovingly maintained by Renoir and the academicians of the day—are here disregarded, suppressed, or made ambiguous. Perhaps most importantly, the very signs of sexual difference themselves are erased or made to seem inconsequential in the late *Bathers.* In short, Cézanne's *Large Bathers* of 1906 constitutes a heroic effort to escape from the dominion of the sexual-scopic implicated in the traditional masculine gaze on the female sex, as well as the heavy-breathing sexual violence or equally disturbing repressive strategies characterizing his early work, not to speak of their inscription of the personal, the contemporary, the concrete—and the popular.

What Cézanne is erasing is as important as what he is constructing. He is erasing a traditional discourse of the nude, en-

coding desire and the ideal as well as its opposite, humiliation and awkwardness (the historical turf of naturalism as well as piety); above all, in the *Large Bathers* he is erasing the codes constructed for the purpose of maintaining gender difference from classical antiquity down through the nineteenth century, and in some way negating his own relation to such difference. As much as the postermaker or the caricaturist or mass-media printmaker, although with diametrically opposite ends in view, Cézanne is a destroyer of traditions of visual representation, a reinventor of the body for a public which gradually learns to appreciate his practice as a kind of analogue to the modern epistemological dilemma itself, and which finally might be said to fetishize it as such.

The beached, blubbery whale-women in Renoir's *The Bathers* of 1918 are of course, without question, antifeminist icons, an insult to the feminine mind and body. Positioned historically, they are the postcoital sequel to Courbet's scandalous lesbian *Sleepers* of 1866 (fig. 16), the two lovers now satiated and languorously awake, the blonde woman lying back in the traditionally seductive hands-behind-the-head pose, the dark-haired "dominant" nude apparently meditating in the classical "thinker" pose, if one can associate anything as coherent as thinking with this monstrously corporeal creature. But they are also positioned histori-

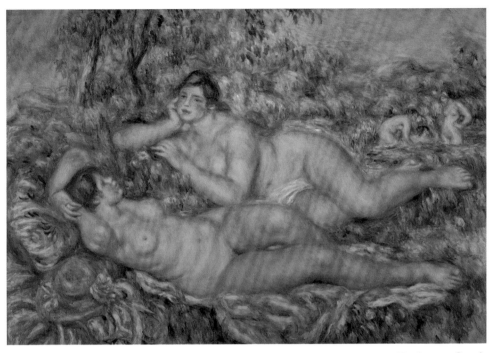

15 · Auguste Renoir,
The Bathers, 1918

cally at the end of the First World War, and at the end of Renoir's
life itself. Despite their rolls of fat (perhaps an inspiration for the
Michelin Man), these figures did not appeal to Caroline Knapp,
our anorexic viewer—too much of a good thing, perhaps.

But I, and you, can see it differently. One might say that in his

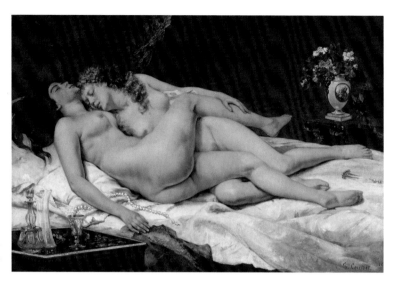

16 · Gustave Courbet,
Sleepers, 1866

old age, Renoir finally allowed himself to go literally over the top: over the top of Impressionist visual verism, over the top of the kitschy classicism of *The Great Bathers,* into a visceral dreamland, the dreamworld of the *Informe.* The nude has expanded, liquefied, deboned itself into a viscero-visionary icon of pneumatic bliss. Brushstrokes loosen and lose their thickness, plasticity, their substance, merging figure and background.

Indeed, the word "icon" is too firm, too enclosed to account for

what we see here. I suppose we can think of it as an old age style, whatever we mean by this suspect term, if we think of old age as accompanied by arthritis, the dissolution of bone and connective tissue, experienced painfully by Renoir. Horizontality is the direction. These nudes lie down for the most part, succumbing to the downward pull of the flesh, to gravity, and the better to demonstrate the enticing abjection of the flesh. Yet even if they maintain their status as "nudes," their flesh has been transmuted by a kind of reverse alchemy into some lower substance, a sort of aestheticized gunk. They predict, in their antihumanism—materialist, brutally anti-idealist—a host of inventively macerated bodies to come: those of Picasso at his most paroxysmic, perhaps, but even more those of Dubuffet and De Kooning later in the twentieth century. I am speaking of course not of Renoir's intentions—who knows what they were, and how much is due to sheer infirmity; we can be certain he had not read Georges Bataille on the *Informe*, at any rate—but of what exists on the canvas as form and substance.

In concluding, I should like to say once more that in studying a major nineteenth-century theme like bathers, serious attention needs to be paid to alternative points of view, to other modes of visual production rather than the high art studied by con-

ventional art history. Advertising, mass media prints, cartoons, and so on exist not just as undifferentiated, visually indifferent "sources" for high art but, on the contrary, as alternatives, and, often, as adversaries of it. As alternatives, they have very different work to do and from time to time enter into a positive dialectical relationship with the practices of high art, while at other times, into an equally important relationship of fierce rejection or negation with it. It is only through an understanding of such relationships and the cultural struggles through which they are manifested in all their complexity that we can begin to construct an inclusive and truly social history of nineteenth-century visual representation, a history in which works like Renoir's *Great Bathers* will be viewed not as either a masterpiece or a sorry failure but rather as the result of certain kinds of practices, the product of a particular shifting structure of cultural institutions at a particular moment of history.

At the same time, the interpretation of a work of art also exists within history, and no one voice is entitled to iterate its "meaning." Indeed, it has, I hope, become clear that there is no single way of understanding *The Great Bathers,* that its meanings are multiple, construed differently, often at cross-purposes by different viewers and interpreters. It is not a case of "anything goes"—

if someone were to insist that Renoir in this painting is creating an allegory of the Second Coming of Christ, I would reject it out of hand. Yet the range of relevant interpretations is broad, no matter how far afield from Renoir's purported intentions in creating the work, or even how far they may stray from the contexts and interpretations of the historical period in which it came into being. Before there was a disease called anorexia, before there was a feminist movement, before Freud, Renoir's *Bathers* could not "mean" what it does today. It is only by allowing new interpretations that works of art—in our case, representations of bathers, but also bathtime itself as a cultural entity—can be more fully understood and remain a living, sometimes unruly entity rather than a respectable corpse.

Manet's *Le Bain:*
The *Déjeuner* and the Death
of the Heroic Landscape

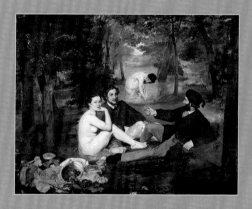

\mathcal{T}HE BEAUTIFUL in nature is history standing still and refusing to unfold," declares Theodor Adorno in his great critique of the aesthetic, entitled *Aesthetic Theory.* "Those works of art which are justly known for their sensitivity to nature tend to incorporate this notion," he continues.[1] The identification of the eternally beautiful—the quintessence of the ahistorical—with the realm of nature was traditionally viewed as the function of landscape painting, especially (ironically) landscape in its highest manifestation, the *paysage historique,* also known as the *paysage composé.* It was the task of Manet's *Déjeuner sur l'herbe* (Luncheon on the Grass) to annul that identification, to introduce the instability of the historical process into the realm of the natural. And in so doing, it signaled the death knell of this time-honored genre,

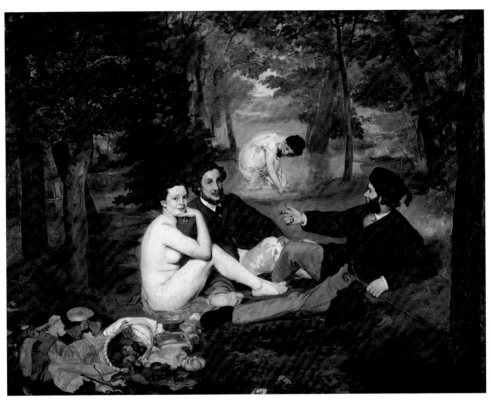

17 · Edouard Manet,
Déjeuner sur l'herbe, 1863

already, I must add, considered moribund by the most advanced critics of the time.

First, I would like to examine the *Déjeuner* within the context of the artist's personal and professional history, as well as within the history of similar paintings of his time. Manet's *Déjeuner sur l'herbe* started off its notorious career as *Le Bain* (The Bath). It was first shown under this title in the 1863 Salon des Refusés; and it was as a bathing scene that it was pilloried by indignant critics and, more rarely, praised by enthusiastic ones at the time of its first appearance.[2]

Antonin Proust, Manet's childhood friend and later his biographer, remembers the origin of *Le Bain/Déjeuner* in an actual experience he and Manet had shared in the country. "Right before he painted the *Déjeuner sur l'herbe*," Proust reminisces in 1890, "we spent a Sunday at Argenteuil, stretched out on the river bank, watching the white yawls making a wake in the Seine, striking a light note on the dark blue of the water. Some women were bathing. Manet fixed his eyes on the flesh of those who came out of the water. 'It seems,' he said to me, 'that I have to make a nude. Okay, I'll make them one. When we were in the atelier I copied Giorgione's women, the women with musicians. It's dark, that painting . . . I want to redo it and make it in the transparency

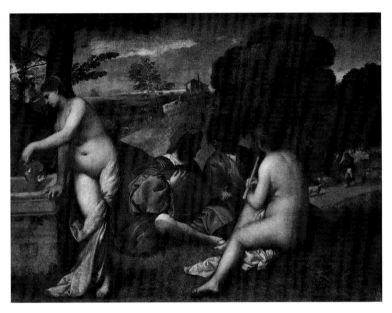

18 · Giorgione,
*Concert in the Open
Air (Fête Champêtre),*
1508–1509

of the atmosphere, with people like those whom we see over there.'"[3]

In recalling Manet's remarks on that occasion, Proust, writing thirty years later, conveniently combines the artist's vision of a group of contemporary women bathing with his ambition to filter the scene through a painting in the Louvre (fig. 18). This is almost certainly too good as art historical explanation to be true.

For the contemporary art historian, and especially for the social historian of art, all such myths of origin based on the personal experience of the artist—and above all those narrated by a supposed eyewitness to the event with an aesthetic axe to grind—are to be regarded with suspicion.

It might seem, then, that the first step in establishing the significance of the *Déjeuner* would be to locate the work historically: to set it within the contemporary context of bather representations generally, that is, within the framework of synchronic history, rather than enmesh this painting in a myth of personal origins. Indeed, as we have seen in our discussion of Renoir, the time when Manet produced *Le Bain/Déjeuner* might well be called "bathtime," so popular was the theme of the bath in both the high art of the Salon and the low art of the burgeoning mass media.

In 1863, the very year that Manet showed his painting, at least twenty-six bathers or bather-related paintings appeared in the Salon, including Cabanel's exemplary *Birth of Venus* (fig. 19). Thirty-two had appeared in the Salon of 1861, and no fewer than forty paintings with bather themes were presented in the Salon of 1864. Among the bather paintings of the Salon of 1863 were such works, now lost and forgotten, as Caillou's *The Bathers,* Chatard's *Suzanne at Bath,* and Conninck's *Bathers of Capri.*

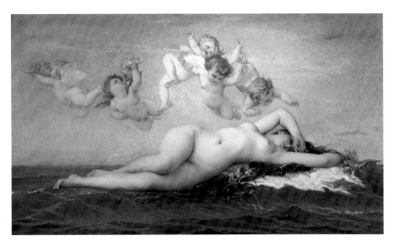

19 · Alexandre Cabanel,
Birth of Venus, 1863

All these bathers were of course female and were deployed in classical, biblical, or at least in atemporal versions of bathing. Male bathers were few and far between; certainly, despite some exceptions, they had never been a popular subject. The definition of what constituted a bather picture was rather fluid. Any naked woman, or group of women, near any body of water—spring, stream, brook, beach, lake, or, *faute de mieux,* bathtub—could constitute the topos. And the bather topic, with its combination of nature with naked women, was popular in mass-produced art as well. Works like the popular lithograph *L'Espièglerie* (Teasing)

of 1867, analyzed in a pioneering article devoted to the bather theme by Beatrice Farwell many years ago, are indeed virtually indistinguishable from many of the high art versions which appeared in the Salon; kitsch is the common term that can be used to account for both.[4]

Like Daumier in *Naiads of the Seine* (fig. 5), Manet in *Le Bain/Déjeuner* is making a statement about the possibility of painting classical bathers in modern times. He too refuses to redo classical formulae; but unlike Daumier, he animates his rejection-transformation of the past by means of an appropriation of it, drawing on no less than two works featuring a bather theme: Giorgione's *Concert,* which he himself talks about having copied and which supplies the erotic topos of clothed male and nude female figures in a landscape, and the river god portion of Marcantonio Raimondi's engraving after Raphael's *Judgment of Paris,* which Manet fails to mention (fig. 20).

What no one has pointed out, as far as I know, is *Le Bain*'s perverse, gender-bending relationship to another sixteenth-century Venetian work, Titian's *Three Ages of Man,* in which it is the female figure that is clothed and the male figure nude (fig. 21).[5] If this is a *blague*—a joke—which indeed it is, it is a *blague* on a grand scale, with major ambition.[6] It is for this reason that *Le Bain/*

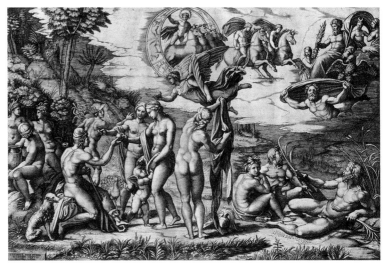

20 · Marcantonio
Raimondi,
Judgment of Paris,
1510–1520

Déjeuner stands apart from all contemporary representations of the bather theme. If we consider it as a total work, a unique signifying presence, and not merely as a member of a class of *thèmes à la mode,* it is like none of them. The process of contextualization can account for *Le Bain's* existence at this moment in history. It cannot account for the uniqueness, the singularity of this work—surely one of the most singular in the history of Western art.

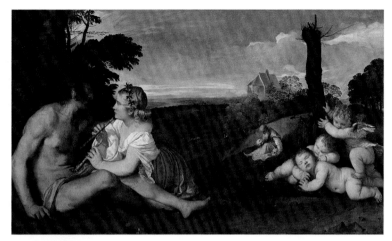

21 · Titian,
The Three Ages of Man,
1513–1514

To account for the specificity of *Le Bain,* I would like to turn
back to Manet's original bather memory, that myth of origins I
rejected so precipitously when I first connected the painting with
bathing and bathers—something seen and experienced by Manet,
apparently, and which impressed him in combination with his
memories of Giorgione's painting (fig. 18). I prefer to think of
Manet/Proust's reported experience as a sort of screen memory,
an internal clue to both Manet's desire and his ambition at the
moment, and as such an important piece of evidence that over-

22 · Edouard Manet,
Surprised Nymph,
1859–1860

23 · Edouard Manet, study for *Surprised Nymph*, c. 1859

rides the question of whether the incident actually took place or took place in the particular form recounted.

The image of the bather haunts Manet's early work. Both the *Surprised Nymph* of 1859–1860 and the so-called large study for the *Surprised Nymph* (which is probably a sketch for the *Finding of Moses*, when Pharaoh's daughter comes down to the Nile to

24 · Edouard Manet,
Fishing at St. Ouen
(*La Pêche*),
1861–1863

bathe) are basically variations on the bather motif.[7] Several draw-
ings, such as the *Seated Bather* and *After the Bath* of 1858–1860,
as well as an etching, *La Toilette* of 1861–1862, bear witness to the
young Manet's engagement with the bather theme. But before its
apotheosis in *Le Bain/Déjeuner* of 1863, there is another impor-

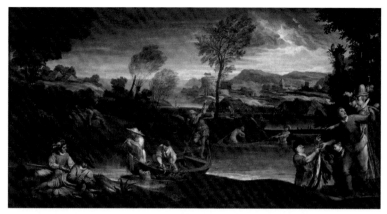

25 · Annibale Carracci, *Fishing,* c. 1585–1588

tant multifigured work in which Manet grapples with the dual is-
sues of tradition—especially the tradition of the nude, and spe-
cifically the nude in the landscape—and the representation of
modern experience, in conjunction with the bather motif. That
work is *Fishing at St. Ouen (La Pêche)* of 1861–1863, a relatively
small canvas, now in the New York Metropolitan Museum, which
is at once Manet's most personal and most pastiched work of the
period.

Clearly modeled on Annibale Carracci's fishing scene of c.
1585–1588 in the Louvre, Manet's modern equivalent, actually
a wedding portrait *en travesti,* replays the Renaissance scenario

with personal references to his own life and times. The figure of the little boy fishing becomes Leon Koella, probably his own son by Suzanne Leenhoff; the wealthy customers buying fish are transposed into Manet and his wife, although probably with the help of Rubens' self-portrait with Helena Fourment in his *Landscape with the Castle of Steen.* Manet's painting abounds with allegorical or mock-allegorical references of the most traditional sort, almost rebus-like in their obviousness: the dog for fidelity, the church spire for the sanctity of the rite of marriage, the rainbow for happiness, the crossed trees for the loving couple whose lives are now intertwined—these last two borrowed from Rubens' landscape with a rainbow in the Louvre. Here, in *Fishing at St. Ouen,* created on the eve of the *Déjeuner,* so to speak, one can see the disjunctive scenario characteristic of allegory still at work; the fragments must work separately to convey the separate meanings allegorized in each section of the picture.

What clearly remains from Carracci's prototype is the centrality of the image of the fishermen in their boat. Yet Manet has made a small but telling change at this point. Behind Carracci's boat are two seminude fishermen with nets. Manet has transformed these seminude fishermen into totally nude female figures and buried them in a sheltered glade in the depths of the river

bank to the right. *Fishing at St. Ouen,* this "real allegory" of Manet's life and ambitions in the early sixties, is thus haunted in its shady heart by the memory of bathers: the real ones he is supposed to have glimpsed, and Giorgione's.

In his major work of 1863, the bathers come out of the shade, or at least one of them does, and both tradition and modernity are inventively subverted by a pictorial language that is frankly artificed—and Modernist. The boat and the second bather are relegated to a secondary role. The major nude figure is clearly a studio model; two contemporary male figures have been added to the scene, which is a *bain* with little bathing, a picnic where nobody eats, an icon of the meeting of modernity and Modernism, tradition with its antithesis in an image both solemn and parodic.

Yet Manet is doing something even larger than vying with the bather topic, past and present, in *Le Déjeuner:* he is, in effect, calling into question the whole French landscape tradition itself, most specifically its noblest branch, the so-called *paysage composé:* the heroic landscape-with-figures motif established as a precedent by Poussin and Claude in the seventeenth century. In a way, the bathers of the mid-nineteenth century that we have been considering could be thought of as a subcategory of this larger tradition—a subject to which we will return momentarily.

26 · Edouard Manet,
*On the Beach,
Boulogne-sur-Mer,*
1869

Manet soon abandons the stunning tension between appropriation of the past and reference to the present that marks his major work of the 1860s. His later bathers are quite different: wholly contemporary in theme, overtly nontraditional in structure. His *On the Beach, Boulogne-sur-Mer* of 1869 is a panoramic, additive view of modern life, piecemeal in its thematic juxtapositions, anticlassical in its composition; *On the Beach at Boulogne* of 1868, relaxed and charming, is simply a representation—sketchy, evanescent, transparent—of young women disporting themselves in modern bathing dress at the seashore.

27 · Edouard Manet,
On the Beach at Boulogne,
1868

His last recoup of this theme is frankly funny: a little watercolor of 1880, constructed from imagination, of his young friend Isabelle Lemonnier preparing to dive while she is on vacation at the seashore. There is not an iota of tradition in this affectionate caricature, perhaps funnier to Manet, one imagines, than to the recipient. Already stricken with his fatal illness, condemned to relative inactivity, Manet, at a time of difficulty, records the splashy pleasures of summer bathing in his letterhead, mixing memory and desire in an image light as air, evanescent as the posture of the diver.

Now I would like to go back to the history of the historic landscape, and to the end of that history, which, I have suggested, is inscribed in the parodic play or—more strongly put—the tense opposition Manet establishes in the *Déjeuner* between contemporaneity and tradition, between flatness and depth, between the personal and the universal, between what Charles Harrison, in his important article "The Effects of Landscape," has called effect and effectiveness.[8]

Much has been made of Manet's formal innovations in this work; its mysterious subject and its relation to its illustrious prototypes, works by Giorgione and Raphael predominantly; the gender relations established by its clothed males (Manet's brother

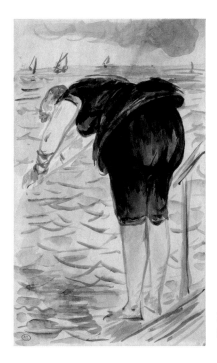

28 · Edouard Manet,
Isabelle Diving, 1880

and the brother of Suzanne Leenhoff) and nude female (his
model, Victorine Meurend); its narrative implications or its posi-
tive lack of such implications; its allegorical references or lack of
them.[9] And I have just set the *Déjeuner* within the framework of
the contemporary bather motif and located it within the context

of Manet's own sequence of works relating to baths and bathers.[10] Little, however, has been done to position the painting within a context I believe to be equally important: that of the French heroic landscape. In the understandable attempt to situate Manet's modernity within a discourse of the figural—or more accurately, a discourse that deconstructs the traditional solidity and seriousness of the figural in terms of what might be called parodic appropriation of the visual past—Manet's parallel subversion of the traditional French landscape protocol has been neglected as a locus of his modernity.

When, in 1868, Emile Zola wrote in his *compte rendu* of the Salon that "the classical landscape is dead, killed by life and truth," what he had in mind was the so-called *paysage historique* as it had been nobly established by Poussin and Claude in the seventeenth century, then continued and refined by such masters as Valenciennes and Michallon in the eighteenth and early nineteenth, and brought to a climax in the nineteenth century by some of the more ambitious canvasses of Corot.[11] Often known as the *paysage composé* and considered a much more noble and idealized genre than the mere landscape "sketch" (that first impression *en plein air* considered a mere "first step" toward authentic landscape creation), the heroic landscape of course included a justifying set of

29 · Pierre-Henri de Valenciennes, *The Ancient City of Agricentum*, 1787

classical or biblical figures, usually with moral overtones. Nature—idealized nature, redeemed by uplifting historical narrative—might constitute one definition of the "composed landscape" as it existed and continued to exist in Manet's time.

Could we not, within the context of the heroic landscape, read Manet's *Déjeuner* as a parodic deconstruction of the *paysage composé*—a sort of *paysage décomposé*, with figures separated from one another, from the landscape background, from traditional

narrative legibility, and above all from the tradition of moral uplift usually associated with this elevated genre? With its setting based on a Sunday outing to Argenteuil, the figures mockingly arranged to belie the high-toned mythological past to which they apparently refer, figures that are modern, all too modern in both their dress, their lack of it, and the lack of all traditional *bienséance,* or rules of good behavior, and their imperturbable, uncommunicative coolness, Manet's painting comes close to approximating, in visual language, the acerbic critique Baudelaire had made of the historic landscape in his Salon of 1846. Baudelaire described a "good" historic landscape ("un bon paysage tragique") as "an arrangement of patterns of trees, of fountains, of tombs and funerary urns. The dogs," Baudelaire continues, "are cut from the pattern of the Historic Dog; the Historic Shepherd may not, under pain of dishonor, allow himself other possibilities. Every immoral tree which has had the temerity to grow all by itself in its own way is necessarily cut down; every pond with frogs or tadpoles is pitilessly filled in."[12] Note, by the way, the presence of a grinning frog, prominent, if you know it is there, in the left foreground of the *Déjeuner.*[13]

History, in the *Déjeuner,* to paraphrase the words of Adorno with which I began, refuses to stand still but rather bursts upon

us with a vengeance in the destruction of the "natural" setting and the transcendent harmony of the figure/ground relationship. But the *Déjeuner* does not submit easily to a simplistic analysis of its relation to history either. It is neither flat (that is, totally present, in temporal terms, eradicating history) nor spatially illusionistic ("deep," evoking temporality, the passage of time, history) but both: the figures are deliberately flattened, but the wings of the landscape, the peripheries, reveal themselves as illusionistic, suggesting mysterious depth penetrating the picture plane. Yet neither depth nor flatness is really privileged, but rather both in different parts of the picture, so that the artifice of the pictorial construction is itself foregrounded.

It is interesting to compare the position of the female nude in *Fishing,* where the two little figures were relegated to the depth of the forest, part of and embraced by the natural order, and that of the female nude in the *Déjeuner,* who occupies center stage. Within the nature/culture pair figured so prominently by the formal structure of the *Déjeuner*—nature, the deep, evocatively brushy, mysterious wooded *coulisses;* culture, the up-to-date flattened human trio pasted on the surface of the canvas—it is landscape that figures the ahistoricity of the natural order, not the female nude. Victorine, the naked woman, and her clothed com-

panions, immobile though they may be, with that momentary, frozen stasis characteristic of the film still, paradoxically, in Adorno's terms, release the flow of history into the regime of nature itself. One might say that it is the sundering of the enforced harmony imposed by the traditional *paysage composé* that permits the entry of living (that is, unfolding) history into the scene. But this is not because the *Déjeuner* is, in any literal sense, a scene of contemporary life: its parodic oppositions make this impossible. Rather, it is history-as-modernity—unstable, ironic, ungraspable in terms of lived reality—that is at stake here.

At this point, in taking note of the *Déjeuner*'s anticlassical dissonances, we must account for the context in which the work was originally presented and made its scandalous impact, at the 1863 Salon des Refusés. There, the *Déjeuner* was enframed by two other large-scale Manet paintings—*Mlle Victorine in the Costume of an Espada* of 1862 and *Young Man in a Costume as a Majo* of 1863—so that it was seen as the centerpiece of a scandalous triptych (installation art before the fact) presenting the female nude as dramatically nonidentical with nature and doubling this antinaturalism with the same model *en travesti* in an adjacent painting.

Now, a woman in male clothing, a visual genre usually reserved

30 · Edouard Manet,
*Mlle Victorine in the Costume
of an Espada*, 1862

for the popular medium of print, has always been a potent emblem of the world upside down, of transgression.[14] At the same time, Victorine, obviously feminine, obviously dressed up and impersonating a man, may be said to embody what Terry Castle has called "the hallucinatory primacy of costume over 'identity,' the suspension of so-called 'natural' categories, sexual release, the

notion that anything is possible."[15] The proximity of *Mlle Victorine in the Costume of an Espada* to the *Déjeuner* at the Salon des Refusés suggests that Victorine in the *Déjeuner* is also playing a role—"undressing-up" as a classical nude in the same way that she was dressing up as a Spanish bullfighter.

Yet in demonstrating so decisively what might be called the nature/culture opposition in his *Déjeuner,* Manet is, in a certain sense, merely revealing the contradictions afflicting classical landscape theory from the start: that opposition between the study of nature and the imposition of the classical ideal which presumably the great landscape masters of the seventeenth century, most notably Poussin, had brought into transcendent harmony. In constructing his painting in such deconstructive terms, Manet reveals the contradictions at the heart of the historic *paysage composé* and its theory, contradictions which, I maintain, were there almost from its inception as a model genre and topic of one of the Prix de Rome contests offered by the Academy—a contest which, incidentally, saw its demise in 1863, the very year that gave birth to the *Déjeuner.*[16]

These tensions are evident in the major study of landscape theory and practice at the very beginning of the nineteenth century, Pierre-Henri de Valenciennes' *Elémens de perspective pratique, à*

l'usage des artistes, suivis de réflexions et conseils à un élève sur la peinture, et particulièrement sur le genre de paysage, published in Paris by Desenne in 1800. In this ambitious study, Valenciennes, on the one hand, urges the young artist to explore nature to the utmost, to go out and work in the heart of landscape. "Nature must be seized as quickly as possible, in order, above all, to capture the changeable effects of light . . . When [an] object is illuminated by the sun and when that light and its shadows change continuously by virtue of the movement of the earth, then it is no longer possible to spend a long time copying Nature without seeing the effect of light that one has chosen change so rapidly that one no longer recognizes the conditions under which one began."

At times, in the interest of empiricism, he urges his students "to paint the same view at different times of day, to observe the differences that light produces on the forms. The changes are so palpable that one has trouble recognizing the same objects." The student is urged to travel, to go to strange countries to observe differences in climates, aspects, and productions of nature. Visual exploration of the sea arouses all of Valenciennes' ravening appetite for empirical exactitude. His descriptions of the visual conditions of *brouillard,* what the sailors call *brume,* he explains, are minutely specific: "The sea water is gray and the color of the

atmosphere, above all when it is calm; but if it is rough, it takes on different tones: blackish green; greenish blue; brownish violet mixed with foamy white. The wave that comes to the shore and touches the banks is foamy and white, while in its depths it usually appears colored on the lighted sides by the sun." His discussion of seaside rocks and cliffs, which emphasizes the effect that water has on their tonality and substance, is followed by a long meditation on *clairs de lune* over the sea, during periods of both calm and storm, rich in romantic suggestiveness and realist specificity: "The waves that rise toward the sky, lit by the moon, look like crystal mountains. The abysses resulting from the height of the waves take on a mysterious and sinister color, a sort of blackish green, and an extremely pronounced intensity of tone. This tone, which contrasts with the silver light of the waves lit by the moon, becomes terrifying." This sounds almost like an Impressionist master giving advice to a disciple seventy-five years later, but it is typical of one aspect of Valenciennes' pictorial theory and practice.[17]

For the *Elémens* is riven by a kind of stylistic schizophrenia, a profound division papered over by the notion of "harmony," between the effort to capture the ever-changing and variable face of concrete nature and the higher demands of "le beau idéal" to be

embodied in the final canvas. After studying nature per se, Valenciennes maintains, the artist is then ready to embellish it "and to represent it on canvas with all the charm and sublimity of Ideal Beauty." Nature, too often, like a seductive woman, is no better than she should be: "Happy the artist who, surrendering to the charms of illusion, thinks he sees nature such as she should be, a nature too rare to meet in its perfection." The great artist builds his work not merely on visual accuracy but on great models. "When the man of genius wants to abandon his imagination, he reopens his eyes to nature; he contemplates it, he observes it, he seeks on every side models that can help him to paint that which his enthusiasm led him to perceive."

Valenciennes, in short, bewails that fact that nature itself is not grand enough for the greatest art, and he holds up the exemplum of Poussin as the ideal and model for this grand type of *paysage historique*. The highest type of painting, the sublime in art—the art of Poussin—must add to knowledge of nature an understanding of the human heart and the passions. "A landscape painting, which represents nothing but animals and people busy with the common occupations of life, generally pleases when it is the exact imitation of nature; but will it speak to the heart, like the painting of Arcadia? Will it appeal to the imagination like that of

Polyphemus? Will it inspire deep reflections like *The Burial of Phocion?* The inimitable Poussin, only he could at once be a faithful interpreter of nature and at the same time, give lessons in philosophy and virtue." Ultimately, it is the moral element that is lacking in the pure description of nature, and it is the moral element that differentiates the merely good painter from the sublime genius like Poussin.[18]

Peter Galassi, in his study of the early Corot, points out that by the time of Valenciennes, "the empirical and synthetic functions of landscape painting had become irreconcilable," and in his work and that of others the "tension between the new empiricism and the old landscape traditions took on an unusual and highly polarized form."[19] Although various compromises were made in the first half of the century, the tensions remained, until they were cracked open by Manet in the 1860s. Nevertheless, attempts to recast the elevation of the historic landscape in new and utterly novel forms continued throughout the century, most notably in the work of Cézanne, whose name, not coincidentally, has so often been united with that of the great exemplum of high landscape theory, Poussin.

Cézanne's *Déjeuner sur l'herbe* of 1870–1871 hardly seems to offer a response to the *beau idéal* of Poussin. On the contrary, in

31 · Paul Cézanne,
Déjeuner sur l'herbe,
1870–1871

this, the second of his thematic responses to the work of Manet (the first being *A Modern Olympia,* a more explicitly personal and outrageous variant on the older artist's brothel painting), Cézanne would seem, perhaps unconsciously, to be introducing the Freudian "uncanny"—the making strange of the everyday— into the unproblematic theme of the picnic. The contradiction here is less that between modernity and tradition than between the cheerful, everyday subject and the disturbing ambiguities of its representation. If, on the surface of it, it seems to be simply one of those works in which Cézanne aspires to be a painter of modern life in the earlier part of his career, an aspiration he shares with many of his Impressionist colleagues, on closer in-spection the painting reveals itself as both mysteriously personal, with the artist himself playing a leading role in the rather sinister goings on about the picnic cloth—a scene of modern life from Hell, as it were—and at the same time obviously related to the traditional topos of the *Judgment of Paris,* as well as overtly enter-ing into competition with the more recent *Déjeuner* of Manet.[20]

Yet it is in his later bathers, not his earlier work, that Cézanne's relation both to history and the *paysage historique* is most force-fully raised. On the one hand, a case could be made for interpret-ing these paintings, as Richard Kendall does in part, as scenes

of modern life: experiences particular to Cézanne, memories of youthful bathing parties.[21] On the other hand, there is no other subject in Cézanne's oeuvre in which the artist would seem to be so committed to the high ambition of the landscape-with-figure tradition of the French classical past, that of the *paysage composé*, and specifically to the highest peak of that tradition embodied in the great figured landscapes, or figures in landscape settings, of Poussin.

Of course, the whole Cézanne-Poussin relationship is fraught with controversy. Even the presumed ambition of the Aixois artist "to do Poussin from nature" has been severely questioned by the art historian Theodore Reff and others.[22] Yet Cézanne's intention to "vivifier Poussin sur nature" (bring Poussin to life in the presence of nature), to borrow the words of Charles Camoin, can be neglected only at our peril. Poussin, after all, represented the classic; and to the artists and critics of the nineteenth century, the "'classic' maintains a balance between found nature and made art"—exactly the balance that Manet had so blatantly rejected, revealed as "impossible" in his *Déjeuner*.[23]

Is it merely a coincidence that the very words of Cézanne, as reported by his contemporaries, seem to echo those of Manet vis-à-vis the nude, the outdoors, and tradition? Just as Manet had de-

clared that he wished to do Giorgione's *Concert* out of doors, so
Cézanne states his ambition to remake Poussin *en plein air*, as re-
ported by Emile Bernard:

> As you know, I have often done studies of bathers, both male
> and female, which I would have liked to make into a full-scale
> work done from nature; the lack of models forced me to limit
> myself to these sketches. Various obstacles stood in my way,
> such as finding the right place to use as a setting, a place which
> would not be very different from the one which I had fixed

upon in my mind, or assembling a lot of people together, or finding men and women who would be willing to undress and remain still in the poses I had decided upon. And then I also came up against the problem of suitable or unsuitable weather, where I should position myself, and the equipment needed for the execution of a large-scale work. So I found myself obliged to postpone my plan for a Poussin done again entirely from nature and not constructed from notes, drawings and fragments of studies. At last a real Poussin, done in the open air, made of colour and light, rather than one of those works thought out in the studio, where everything has that brown hue resulting from a lack of daylight and the absence of reflections of sky and sun.[24]

Although Cézanne may never have succeeded in painting his nude figures out of doors, his numerous bather paintings might well be thought of as the very redemption, in Modernist form, of the notion of the *paysage composé*. Despite considerable and correct debunking of a literal connection between the two artists, I find it interesting that Cézanne's name was so often connected, in the early literature at least, with that of Poussin, and that the idea of "doing Poussin from nature" (or, more accurately, bringing Poussin to life in the presence of nature) was seen in some sense

as the essence of his project. "I want to do Poussin from Nature"; "I wish to make of Impressionism something monumental like the art of the museums"—these clichéd pronouncements should not be rejected out of hand. They tell us too much about Cézanne's aspirations with respect to the heroic past of the *paysage composé* to be simply cast aside as simplistic formulae. It seems to me undeniable that Cézanne's reconstruction of both Poussin (and Impressionism) and his engagement with the tradition of the heroic landscape takes place not in the arena of landscape *tout court*, where he simply eliminates the figural element so essential to the Poussinesque tradition of the *paysage composé*, but rather in the monumental series of bathers. For in these works, on their entirely different terms, the seemingly irresolvable contradictions articulated by Valenciennes find a new kind of resolution.

Such general assertions of course leave out the all-important "how" of Cézanne's achievement: the constructive brushstroke, the reformulation of pictorial space, the sexuality displaced onto "innocent" structural elements—the whole project of Modernism his work so boldly engages. By removing the subject but retaining the human body; by erasing history but creating an abstract, atemporal monumentality; and then displacing the ambition of monumentality itself onto the seemingly modest plane of the

constructive brushstroke within the virtual (rather than illusion-istic) space of the canvas, Cézanne eliminates history from the historic landscape but inscribes it within the *process* of painting itself.

Still later, a painter like Mondrian goes so far, in his *Pier and Ocean,* as to remove landscape itself from its reduced scaffolding of marks on the surface of the picture plane. Nothing is left but the smile of the Cheshire cat; the marks that once referred to the grand and glorious ambition of harmonizing nature with reli-gion, or classical antiquity with profound moral meaning, now stand only for themselves, marks on a canvas.

But the fate of the *paysage historique* is not merely identical with Modernist teleology: I have, in effect, outlined a history of Modernism here, not a larger history of where the "history" in the historic landscape actually takes refuge. There are other ways that landscape can relate to history besides being—or not being—*paysage historique:* there is, after all, a more literal sense of "his-tory" in relation to landscape. What I am getting at is the increas-ing importance of national histories in the nineteenth century, and how they were projected into the landscape scenario.[25] Cour-bet's *Great Oak of Flagey* of 1864 literally embodies an important evidence of Gallic history in its sinewy trunk and densely painted

surfaces, its positioning on the canvas like an arboreal Virgin of Mercy with outstretched leafy arms, as well as referring to more up-to-date politico-archaeological controversies of his time about the actual site of the historic Battle of Alésia.[26]

The national presence of, say, Puerto Rico is now made manifest in Francisco Oller's *Landscape with Royal Palms* through natural forms and a title alone. National history may be inscribed in a tree, in a signifying rock, in a lake, in paintings in which such landscape objects provide forcefully concrete correspondences for national significance and historic roots. And if one might say that Manet's *Déjeuner* may be viewed as the beginning of a great Modernist trajectory, ending with the end of historic meaning and materiality itself in Mondrian, then the contemporary German artist Anselm Kiefer, in his *Tree with Palette* of 1978 (fig. 33), reincorporates both history and national identity—not to speak of a Courbet-like density of matière—to landscape with a vengeance. In the words of Simon Schama, who discusses this painting in *Landscape and Memory:*

He [Kiefer] needed a reinvention of traditional forms; above all, landscape and history painting. What he did was to collapse the one into the other, exactly reversing abstraction's metaphysical obligations to push the implications of painting beyond

33 · Anselm Kiefer,
Tree with Palette, 1978

and through the picture. Where Piet Mondrian had launched himself from the representation of a tree toward abstract essence, Kiefer returned to materiality, in one of the *Bilderstreit* paintings literally nailing his palette to an enormously magnified trunk whose texture fills and overwhelms the whole picture surface. Where Mondrian had transformed a tree into a grid whose lines extended toward infinity, Kiefer designed his paintings to return those compositional lines back to their narrative function . . . Abstraction prized lightness, flatness, the airy, and the cerebral . . . Kiefer turned back to German expressionism, for the raw texture, the gritty materiality, of historical truth.[27]

"The beautiful in nature is history standing still and refusing to unfold." The opposition between nature and the unfolding of history may not be as absolute as Adorno claims, as long as we remove the traditionally "beautiful"—*le beau idéal*—from the equation. With the advent of Postmodernist interventions into the teleology of the Modernist project, other potentialities hidden within the complex fabric of the *Déjeuner* have made their appearance: the seemingly steady progression from more and more to less and less reveals itself to be no less the illusion of a historical moment, no more an absolute than the timeless elevation once associated with the historic landscape.

Now as in the nineteenth century, landscape—the mythologizing and the demythologizing of nature—may serve as the stage for a vital and transgressive questioning of the meaning of history, the painting of history, and the relation of both to the problematics of representation.[28]

The Man in the Bathtub:
Picasso's *Le Meutre* and the
Gender of Bathing

\mathcal{C}ERTAINLY ONE of the most striking images of a man in the bathtub is the drawing titled *Le Meutre* (The Murder), one of two created by Picasso in 1934. It is clearly a variation on the theme provided by David's heroic painting of the *Death of Marat* (fig. 35). Unlike David, however, who eliminated the assassin Charlotte Corday from his pure scene of revolutionary martyrdom, Picasso reintroduces her with a vengeance. Indeed, the drawing embodies gender antagonism at its most exacerbated.

Picasso's drawing was exhibited in "Posséder et Détruire" (Possess and Destroy), the remarkable hyperfeminist exhibition organized in 2000 by Régis Michel, curator of drawings at the Louvre, accompanied by a brilliant and vitriolic catalogue essay by the curator. Michel's verbal pyrotechnics in the service of a relent-

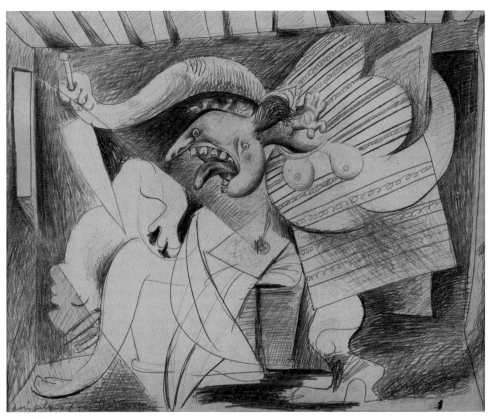

34 · Pablo Picasso,
Le Meutre, 1934

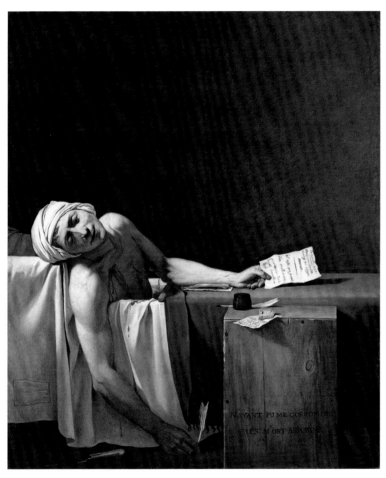

35 · Jacques-Louis David,
Death of Marat, 1793

less critique of post-Renaissance Western representation of the female subject reach a climax here. Rejecting the usual biographical references to Picasso's personal life as a source of the imagery, Michel's analysis of the drawing deserves to be cited at length.[1]

> Corday, according to Picasso: first of all a tentacle brandishing a butcher's knife whose size alone might make one flinch. Then the least graceful bric-a-brac surrounds the feminine body. Finally some organs in separate pieces which confound the laws of anatomy: an atrophied hand, two disjointed breasts, and, on a snaky neck decorated as if by chance by a tuft of hair, the most hideous of facial tumors. It is nothing but a gaping orifice provided with massive teeth, whose lingual appendage competes savagely with the nasal appendage. Two asymmetrical ocular globes, sunken into the mass of the head, fully complete the nightmare. The teeth, the nose, the tongue, not to speak of the cyclopean cutlass: the hysterical woman is a *phallic* woman. But these obvious virtues would scarcely be sufficient to sustain her monstrousness. Still more is necessary. And it is easy to figure out why: the criminal woman is a castrating woman. That is the point of her misshapen appearance. For her toothy mouth shamelessly crystallizes the archaic fantasy of the *vagina dentata* . . . Corday bursts into Marat's space like the unconscious in Pi-

casso's. Useless to reduce this monstrous effigy to the harsh re-venge of a furious lover. We scoff at these bits of sexual gossip. And at the intentions of the author. Or the tidbits of biography. The only thing that counts is the *thing* itself: the monstrous transformation-into-monster of woman.

Nobody could put it better: and certainly, the point of the im-age is the monster-woman with her hideous mouth-trap, phallic and castrating at the same time. Nevertheless, there are other is-sues at stake in this, Picasso's first, more finished Marat drawing that adds to its not inconsiderable interest. Although Corday may indeed burst into Marat's ambience like the Unconscious in Pi-casso's, it is interesting and relevant to take account of the fact that the figure sports not just any old *vagina dentata* but a very specific one, probably deriving from an Inuit mask of a swan and a white whale in the collection of none other than André Breton, where it occupied a prominent place (fig. 36).

The swan's head emerges from the muzzle of the whale, illus-trating some portion of Inuit legend and lending itself perfectly to Picasso's metamorphic ends, no matter how unconsciously motivated. There is no doubt that the mask, with its spiky teeth and dangling tongue (actually, the swan's head emerging from the

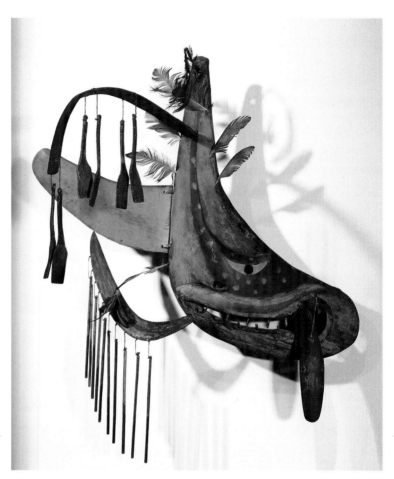

36 · Inuit Mask of
Swan and Whale

quite accurately depicted mouth of the whale), provided a source of visual inspiration. At the same time, the primitive mask, with its bold deformations and simplified forms, offers the most patent contrast to what might also be understood as a flying demon of bourgeoisified domesticity. The primitive head in *Le Meutre*, token of unconscious fears and forces, is attached to curving signifiers of Western, middle-class, feminine domestic life—tablecloth, high-heeled shoe, table, breasts. The female is a trap not just because she has a *vagina dentata* (primitive, unconscious) but also because she incarcerates the male—the hero, the artist—in a hideous web of bourgeois triviality.

For it is clear that Marat is not just a trope of the unconscious but that, as a Jacobin, he stands for more contemporary political ideals—the equivalent of a Communist martyr. His classical beauty and the simplicity of the lines that inscribe his profile are the opposite of the overly complex ones that define the female succubus, Corday, who embodies not merely feminine monstrosity generally but, as such, the forces of reaction, the Right, and its danger to the people. Yet this political reading is of course only one of many of this ambiguous if murderous text. On a more personal level, the victim bears an unmistakable resemblance to the blonde beauty Marie-Thérèse Walter, for whom Picasso was

just then abandoning his dark wife, Olga. The sexual identity of the "man in the bathtub is as ambiguous as the oppositional message is clear . . . Picasso's women are nothing but monsters—hysterical, murderous, castrating . . . in the silent cry of their obscene bodies, where the victim finally becomes the torturer."[2]

In some charming, much later photographs of Picasso in the bathtub, alone and with his last companion, Jacqueline, the relationship between man and woman is completely different. Jacqueline is positioned as the loving handmaiden devoted to Picasso's pleasure and comfort, not as a raging maenad or murderess. Women, according to a much-quoted apothegm of the artist's, are either doormats or goddesses (evil deities included, no doubt). Jacqueline, in this photograph at least, surely belongs in the doormat category. And Picasso, in the late David Duncan photographs, is not a wounded hero but a very old baby enjoying the pleasures of water.[3]

These photographs, incidentally, are among the relatively rare images of a *man* in the bathtub. The topos relates figure and water in a too passive, even abject way and is deemed unsuitable for the representation of the virile subject. The shower, preferably as a masculine, macho group activity, is the bathing process of choice: Kirchner totally phallicizes the military shower event: the

37 · Ernst Ludwig
Kirchner, *Artillery-
men*, 1915

stove in the center, red hot at its heart, suggests an erect penis paying homage to masculine power. Even an overtly gay artist like David Hockney prefers the upright, shower-taking male to the inert one in the bathtub, suggesting perhaps male sexual activity itself enjoined by the spurting water. And if men are depicted bathing, it is usually out-of-doors, in themes of athleticism or with token icons of virility provided, as in the wrestling couple in Bazille's otherwise relaxed and passive composition (fig. 38).

The quirky paintings of the recently rediscovered gay Swedish artist Eugène Jansson, subject of a major exhibition at the Musée d'Orsay a few years back, make a bevy of nude male spectators the focus of the artist's records of major athletic prowess. In *Scène de Bains*, a weird swan dive is captured in drastic foreshortening. In *Piscine* (1911), the diver enters the water with a great phallic flop to the right, creating a virile splash of paint (fig. 39). The spectators include a group of sailors in this record of the first Olympic swimming contests.

When Caillebotte creates a masculine equivalent of Degas' feminine bathers drying themselves (more about them later), he chooses an erect pose with vigorous toweling at its center, not the gentler, more curvilinear floating movement of Degas' female bather. Yet there are exceptions to the rule stipulating an active

38 · Jean Frédéric Bazille,
Bathers, 1869

male bather, and of course they are notable as such. Certainly, one of the most extraordinary representations of the man in the bathtub is the aquatint from the series of illustrations for James Joyce's *Ulysses,* which Richard Hamilton began in 1948 and then picked up again in the 1990s. The work titled *He Foresaw His Pale Body* represents the hero, Leopold Bloom, supine in the bathtub and is taken from the chapter in the "Lotus Eaters" episode of *Ulysses,* in which Joyce describes Bloom as "reclining naked, in a

40 · Richard Hamilton,
He Foresaw His Pale Body,
1990

womb of warmth, oiled by scented melting soap, softly laved."[4] The strange view from above—where could the spectator possibly be standing?—suggests that the representation arises from the intimate imagination of the subject looking down at his own body. The lethargy of the figure, the near symmetry of the composition, centered on head and penis which itself is opposed to the circular form of the drain, the soft wispy curls of the balding head, the dainty wings of the mustache, and above all the visual analogue the bath scene suggests between comforting womb and ominous tomb—"he foresaw his pale body"—all are present in this amazing print.

It is interesting to compare this masculine bathtub scene with a bathtub "self-portrait" by Frida Kahlo, *What the Water Gave Me*. Kahlo's is also a view from above, but in the absence of the subject's head we read the image as the body seen by the subject-artist herself. The bathtub as a site of self-knowledge is emphasized by a host of surreal toylike references to Kahlo's life and experience. As an added touch of self-referentiality, the headless body's toes are reflected back into the water of the bath. Pierre Bonnard's *Nude in the Bath Tub* of 1925 represents a similar bather's-eye view of the subject, but this time with the addition of the artist himself as part of the composition.

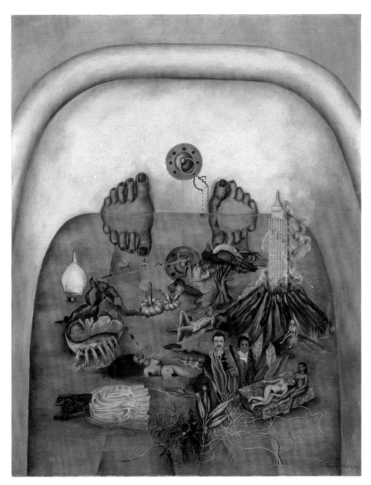

41 · Frida Kahlo,
What the Water Gave Me,
1938

But the customary occupant of the bath, and indeed the protagonist of the indoor toilette scene, is generally, almost universally, female. The visual tradition of the toilette—usually feminine in representation, though men must have made their toilettes, too—goes back to the eighteenth century. It is often a salacious topos, its erotic potential enhanced by the bathing or primping subject supposedly being unaware of the fact that she is being observed.

Watteau, in an exquisite little painting, *The Intimate Toilet (La Toilette intime),* intensifies the erotic impact of the toilette topos with potent overtones of mock sacrilege. A half-naked woman is represented being offered a sponge and basin by her servant. One can indeed, as Donald Posner has demonstrated in his study of Watteau, relate the image to "pornographic pictures of the time," although he hastens to assert that "Watteau has lifted it into the realm of high art . . . by charging this scene of everyday life with a ravishing erotic potency."[5] Yet Watteau has done this not by lifting the image out of the realm of pornography but rather by embedding his nude firmly within the context of pornographic discourse: he has made his toilette into a kind of religious icon.

One might say that only a painter who still believed, no matter how little, in sin and sacrilege could derive the full erotic charge

42 · Jean-Antoine Watteau, *The Intimate Toilet (La Toilette intime)*, c. 1715

from *The Intimate Toilet.* For what we have here is not a mere morning toilette but a mock religious scene: the worship of the female sex organ. The snowy bed is a kind of altar. The servant who stares in a trance of ravished contemplation at the revealed sex of her mistress proffers the sponge and water like an acolyte present-

ing the sacred objects at Mass. This is surely intended as a travesty of Christian worship, meant to intensify the pleasure of the (male) viewer who was the intended recipient of the erotic revelation.

For revelation is doubtless what Watteau's painting is about: a kind of erotic epiphany. Equally important to the work is the reference the image makes to just that contemporary pornography that Posner and other authorities assure us *The Intimate Toilet* rises above. Most directly relevant is another *Intimate Toilet,* a little anonymous eighteenth-century engraving, in which a half-clad young woman, a razor in one hand, a bidet on the floor at her feet, looks down with satisfaction at her newly shaven pubic area, revealed for the delectation of her lover and the potential consumer of the print. It is revelation on a variety of levels that seems to be at issue here. In Watteau's *The Intimate Toilet,* the ambiguous signs of looking and disclosing, desire and its satisfaction, play together, fragilely illuminated, within a setting of encompassing, unremitting darkness. "Pornography is not so much raised to a higher level here as it is diffused in its implications to include both the sacred, and, in its revelation of the scopic force of desire, the motivating force of art itself."[6]

The toilette theme, with its overtones of forbidden eroticism, is transferred to the Near East in the nineteenth century—not coin-

cidentally, when France's colonial enterprise was at its peak. Here, the latent or manifest eroticism of the bath scene is heightened by an exotic setting. Yet it is certainly Degas who comes to mind when we think of innovative representation of the bath motif in this period. Degas' bathers, as far as I know, are all feminine, the site of their bathing is contemporary Paris and for the most part (although, again, there are a few notable exceptions) indoors. The indoors-ness is a major factor in their construction, since it at once is implicated with the strangeness of viewpoint that characterizes them and at the same time connects them with the older, erotically charged theme of the toilette. Yet despite their relation to the time-honored toilette motif and their putative derivation from Degas' series of brothel monotypes, I would assert that Degas' representations of women taking baths, drying themselves, or brushing their hair are not overtly erotic scenes, not erotica at their most representative, but something quite different.[7] One might indeed characterize them as anti-erotic or asexual in relation to the traditional topoi and stylistic characteristics of pornography: precision and linear exactitude. Even in the brothel monotypes, with some deliberately coarse and provocative exceptions, Degas veils the erotic potential of his material rather than emphasizing it.[8]

Yet gender counts of course. If we compare Degas' *Woman Bathing in a Shallow Tub* of 1885–1886 (fig. 43) with Cézanne's *The Bather* (1885–1887) in the Museum of Modern Art, New York (fig. 44), we see just how much it counts, as does being out-of-doors rather than in the bathroom. Cézanne's bather heroically relates to, yet detaches himself from, the landscape. His inwardness is expressed within the context of a kind of triumphant verticality; his virility, if muted, constitutes a pictorial and expressive presence in the painting. Degas, on the contrary, emphasizes the grotesque, even abject aspect of the naked body.[9] Instead of putting the spectator at a seemly distance, we are thrust intrusively into the pictorial space of modesty and privacy. If the male bather is contemplative, the female one is totally preoccupied with her own bodily needs, unaware of the viewer, or much of anything else.

How seductive it is to compare Degas' bather with Cézanne's! A whole narrative of binary difference is effortlessly generated by the two images: female vs. male; indoors vs. outdoors; intimacy vs. distance; self-concealment vs. self-revelation; caressing, powdery surfaces vs. constructive brushstrokes. So powerful are these binaries that an artist can take advantage of them by foiling our expectations. Take the conceptual pair indoor/female vs. outdoor/male, for instance, established by the long-standing tradition con-

necting the female bather with the topos of the intimate toilet. Caillebotte certainly must have known this tradition and was thoroughly acquainted with its most modern manifestation in the work of his friend and fellow Impressionist, Degas, when he created his *male* version of this interior bather theme (fig. 45).[10] Indeed, the existence of such a tradition enabled the radically innovative Caillebotte to make a forceful impact, a striking difference, with his motif. There is nothing effeminate, or even androgynous, about his bather, who, even from the back, is unequivocally masculine in his energetic pose, his rosy, firm, muscular physique.[11]

One has only to look at a female bather in a very similar pose by Degas—*After the Bath, Woman with a Towel* of c. 1886 (fig. 46)—to see how adamantly Caillebotte plays on similarity (indoor bathing, back view, rubbing with the towel held across the back) to establish difference (male, masculinity) within the parameters of a time-honored (feminine) theme.[12] In addition, one should be careful not to make too drastic a binary opposition between male and female in the case of these works. Both reject the representation of the most overt signs of sexual difference, breasts and penis, in favor of a more neutral back view.

But to return to my original assertion about the irresistible opposition brought into play by the juxtaposition of Degas' and

43 · Edgar Degas,
Woman Bathing in a Shallow Tub, 1885–1886

THE MAN IN THE BATHTUB

44 · Paul Cézanne,
The Bather, 1885–1887

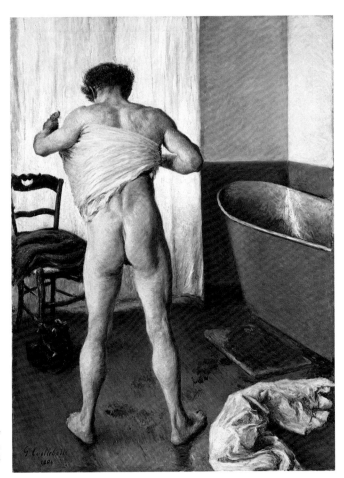

45 · Gustave Caillebotte,
*Man at His Bath,
Drying Himself,* 1884

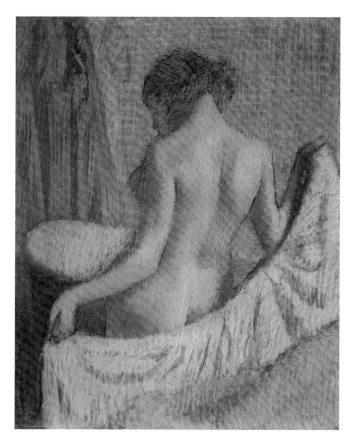

46 · Edgar Degas,
*After the Bath, Woman
with a Towel*, c. 1886

Cézanne's bathers. Such a meaningful comparative structure is of course built into the favorite medium of art historians, the slide lecture, with its endless binary comparisons (left vs. right) of similarity and difference. The methodology of the slide lecture creates two possibilities: "See how different A is from B" (they come from different cultures, dates, periods, genders); but more often, "See how similar A is to B," inevitably implying that influence is at stake, a favorite way that art historians account for the relationship of one work or one artist to another. Yet in the case of these two works by Degas and Cézanne, although they are united by belonging to the class "bathers," and even more united by being late nineteenth-century *French* bathers (the temporal connection is more precise than that: about 1886 for the creation of both *Woman Bathing in a Shallow Tub* and *The Bather*), the differences within this category are so marked that we do not really have to consider the insidious influence at all. Difference wins out.

Yet the mere construction of difference, though valid, simply won't do in approaching these works. In the first place, binary difference in art history seems to be constructed primarily in terms of contraries: black vs. white, rather than in terms of contradictories: black, not black. In terms of art historical categories, there are many contradictories that would offer a third term that would recategorize the Degas and Cézanne in more inclusive

ways. For example, neither figure is an Academic nude; neither proposes a classical or biblical theme. Although non-"idealized" in the usual sense of the word, neither of them is a caricature in the sense that Daumier's bathers are caricatures, emphasizing the grotesque deviations from the norm characteristic of individual figures. And although each of these figures is nude, or nearly so, neither of them can be assigned to the category of pornography or erotica. They do not emphasize the sexually provocative or arousing aspects of the human body.

Although calling attention to other categories or potentialities of the nude or nearly nude body available to these artists at a particular moment, this third, weaker term of comparison—the contradictory (what each bather is not)—does not imply that the two bathers are for this reason substantially similar. Yet we must nevertheless acknowledge the broad, general critical categories that contain them both. For both are what we might call avant-garde nudes; both of them relate to the category of Impressionism in its broadest sense; indeed, both of them, Degas more consistently, Cézanne more rarely, showed in the Impressionist exhibitions. And both of them propose new ways of articulating the representation of the human body: they are vanguard images in the most literal sense of the term.

In addition, each of these images has too much to tell us, in-

scribes its own history of representation and desire too deeply, for a simple binary analysis to exhaust its meaning. First, in the case of Degas' *Woman Bathing in a Shallow Tub*, it is tempting to consider this a view based on the purest perception. Degas, of course, invites us to do so in his own writing. He talks about seeing things as they have never been seen before, from above, or below. Writers about the bathers have talked about "keyhole vision," referring to the apparently unposed appearance of the models in question, as though these were real bathers caught unaware. But along with the apparent perceptual immediacy, we must, above all, and as a kind of antidote, consider the heightened role of invention in these works. How could one get such a glimpse of a figure through a keyhole? More to the point, where could one get such a glimpse of the figure at all, under any circumstances?

The bending bather and the "background"—the blue draperies, the transparent curtain and the oddly intrusive fragment of red chair, the carpet, the white bed linen to the right, the towel on the carpet, its angularity foiling the roundness of the tub—are not deployed "realistically" as they would be in some Academic-naturalist version of the same subject. One can only think of Japanese prints, which Degas collected, in considering such visual bravado in confronting the intimate. Degas is making strange not

just the woman's body, not just the articulation of the piecemeal space that surrounds her, but the act of seeing itself.

On the one hand, Degas makes that most familiar thing in the world—the human body—unfamiliar. That which is closest, the head, the very locus of human identity, is distanced through that alienating point of view. The strangeness is especially forceful for the female viewer, who can identify most easily with the body in the picture. The pose projects both intimacy and hiddenness, self-containment and display. Such a pose demands almost complete abandonment of the classical ideal of the body. Historically, the bending-bather pose goes as far back as Raphael's tapestry cartoon. As a bodily trope, the bending single female bather traces its ancestry to Rembrandt's *A Woman Bathing in a Stream* of 1654–1656 in the National Gallery, London, but the actual pose was established by the two figures drawing in the nets in Raphael's tapestry of *The Miraculous Draft of Fishes* of c. 1519 in the Vatican. It may owe its longevity as a pose at least in part to the challenge it presents to the skill of the artist in terms of foreshortening. The bending-bather pose is picked up in the nineteenth century, outdoors, in the bending-bather figure in Manet's *Le Bain/Déjeuner*. And in the twentieth, it is spectacularly reworked by Picasso in his endlessly inventive series of grotesque variations

on *Le Déjeuner,* which to me, at any rate, owe just as much to Degas' bathers as to Manet's.

Yet, while such tracing of the motif tells us about its long-term endurance and the challenge it offers to succeeding generations of artists (head low, long expanse of back, foreshortened view), it does not help us with the more difficult task of *interpreting* this image, of accounting for its vividness and seductive complexity. Degas' bather confronts us neither with the moral beauty of what Kenneth Clark once referred to as the "alternative convention," the nude body of the Gothic north, nor the measured proportions and surface harmony of the classical tradition. What is at stake here is the defamiliarization of the female nude. For women viewers in particular, Degas makes that most familiar object in the world, her own body, unfamiliar, strange. That which is most known, the face, is distanced through the odd viewpoint. The body is, surprisingly, supported on a "tripod" of two feet and a single arm.[13] One can make a thrilling topographical journey over the surface of the bending model, starting with the hair of the head that hides its face (and suggests the equally hidden sex of the model; continuing with the upthrust hips and buttocks, moving to the tucked-in left arm and the out-thrust left hip, moving down the broad, highly articulated expanse of the back; down the

spine, across the right shoulder bone into the concavity of the central back and the left shoulder, where more local color variations and patterns of striation attract our attention. Throughout, the reference is not to underlying anatomy but rather to the body as surface, articulated through variations of texture and the way the light falls. The roundness of the tub itself intensifies the forward projection of the figure.

What can we find to say about this? Much as I dislike psychobiography, with its constant reversion to clichéd notions of childhood trauma and family relationships, one is tempted to say, in Degas' case, since his mother died when he was still a child, that the bather figure registers the obsessive quest for the absent mother, a quest in which the son is always denied access to the maternal body. In Degas' work, the body is bent, briefly captured in motion, the face rarely available. In other words, the female bather always turns away, turns inward, like the ungraspable memory of the maternal body and the fantasy of pre-Oedipal comfort.

It was Joris Karl Huysmans, a not unsympathetic critic, who emphasized the monstrousness of Degas' bathers. This may be going too far for the modern viewer, who, after all, has been subjected to far worse—Picasso, Dubuffet, John Currin. And yet, one

must appreciate the powerful inscription of abjection inherent to the motif of the bent female bather, an abjection which goes as far back as the beautiful, eloquent nude of the woman being dragged to Hell by her hair in Rogier van der Weyden's *Last Judgment* in Beaune.[14]

Nothing could be less abject than Cézanne's representation of the single male nude. Granted, such singleness is relatively rare in Cézanne's oeuvre, certainly deployed much less frequently than in the case of Degas. But how confidently the figure dominates the outdoor space, the ground on which he treads, the distant mountain, which he dwarfs. How confidently he steps forward into the water, his body erect, his hands on his hips, his arms akimbo, gently thrusting into the sky which surrounds them. Indeed, as Meyer Schapiro pointed out many years ago, this figure measures the natural world: his torso, head, and upper body are congruent with the sky; his thighs with the mountain, his forward-stepping lower legs and feet with the water in the foreground. And yet there is nothing arrogant or domineering about Cézanne's *Bather.* On the contrary, there is a kind of restraint, a modesty, even, about his pose and position in the pictorial world Cézanne has constructed. His eyes are cast down, his arms marked by an unassertive and awkward frailty, the blueness behind his legs securing

them to the watery medium rather than the solidity of the ochre earth. No more than Degas' bather is Cézanne's a product of mere vision: in fact, even less, for we have the photograph upon which Cézanne must have based this work; or if he did not base it in its entirety on this photograph, and used a model in addition, at least it was part of his preparation of the bather painting.

Despite the fact that the bather is striding forward, that his left foot touches the border of the canvas, presumably bringing the figure into our space, our access to his painterly being is blocked, distanced by his complete enclosure in the world of the painting, a prisoner, as is so often the case in Cézanne's work, of the non-negotiable demands of the canvas. If there is an aura of intimacy established between the viewer and the bent back of the Degas bather, no such aura connects us with that of Cézanne, no sense that the next step will take this figure into our world. It is as though a pane of glass runs down from the lowered head, past the torso and the angled arms, over the thigh and the protruding foot, keeping them all on a single plane.

Can we think of psychoanalytic drama here, the family romance gone astray, for example? It is hard to feel that Cézanne is searching for a lost father-figure in this painting: he seems to have gotten Cézanne *père* out of his system fairly early in life, with two

considerable portraits, among the frankest exposés of the Oedipal drama in the history of art—especially the early one, where his father appears as an ogre reading a newspaper, constructed of ferociously bulging spare parts, squeezed up against a blood-red background of tiles (fig. 90). Rather, one thinks of the brother here, a meditation on a body like one's own but not quite one's own, the other who is not the self but known to the self—like a brother. In fact, Cézanne had no brother, though in his youth he had close friends, near-brothers—Zola, for instance. Yet by the time he painted this work he was already having problems with other men, fellow artists. Already he was muttering about people "laying their claws on him," grabbing him, and forcing their unwanted attentions on him.

Leaving Degas and Cézanne behind, I would now like to turn to the most significant twentieth-century painter engaged with the theme of the female body in the bathtub: Bonnard. Although most of his earlier bather pictures featured the so-called *bain partiel*—portable basins and ewers, as in his lovely image of a standing nude silhouetted against the background of a toilette space—his most memorable pictures feature a nude woman in the bathtub. And a single, obsessively painted woman, his companion, later wife, Marthe.

By 1925, the date of the first of these representations of the nude in the bathtub, Bonnard had settled in Le Cannet in the Midi in a villa he named Le Bosquet, married his longtime companion, and no doubt installed a bathroom in his new residence.[15] Works in this series of nude women lying in the bathtub include the truly radical *Nude in the Bath Tub (Nu dans la baignoire)*, which relates back to the early *Man and Woman in an Interior* of 1898 in that these are the only two canvases in which Bonnard represents himself with the nude model. In the 1898 work, both Marthe and the artist were naked, suggesting the aftermath of love-making. In their bath scene of 1925, the situation, both pictorial and sexual, is quite different (fig. 47). In the first place, the heads of both figures are absent: Bonnard looms up on the left in a bathrobe, columnar torso with a palette in his hand. Marthe, even more radically fragmented, reduced to an up-tilted pelvis and legs, floats in the tub to the right, startling and spectral, her amputated form set off by the brilliant red-and-yellow pattern of the rug to the left of the tub and the evanescent gold of the floor, as well as by the varying violets, pink stripes, and blue drapery marking the background.

A work as brilliantly perverse as *Nude in the Bath Tub* makes one wonder if the originality of Bonnard's work can really be laid

47 · Pierre Bonnard,
Nude in the Bath Tub,
1925

at the door of some sort of perceptual quirkiness, whether his pictorial achievement can really be attributed to particularities of sensation and perception, as John Elderfield maintained in his Bonnard catalogue essay.[16] Can such a picture really be reduced to the revaluation of peripheral vision, the rejection of traditional perspective organization, or any such relatively simple causal factor? Obviously, perception, the perception of concrete qualities of light, color, shape, and texture, play a large role in Bonnard's pictorial imagination, in this canvas as in many others. But so does a willed and complex formal structure, a structure as deliberate and rigorous as that of any Picasso, spiced by the intrusion of a sardonic, muted wit and (unconscious?) sexual references. The conjunction of the decorative and the grotesque, so characteristic of many works of this period, one might add, goes back to the brilliant productions of his Nabi phase.

Another startling bath scene is *Leaving the Bath Tub (La Sortie de la Baignoire)* of c. 1926–1930, where the exaggeratedly elongated, seal-smooth brown body, face veiled in violet shadow, leaps from the bath with an energy and dynamism utterly uncharacteristic of Bonnard's generally passive images of Marthe (fig. 48). This figure is absolutely streamlined! Her bent body's trajectory of movement is played against the energetic patterning of the green lozenges of the tiled floor and the variegated wall tiles, as

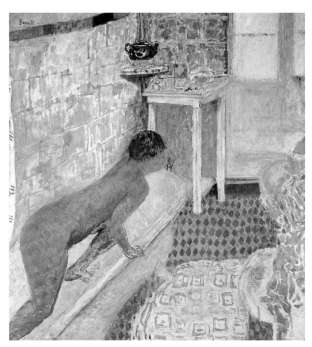

well as the violet shadow under the table she leaps toward. Here again, we cannot attribute the slithery mobility of this leaping figure to the vagaries of perception. Rather than toward Marthe in her bath, perception theory, or even the example of Degas (whose late bathers cannot, however, be entirely excluded as a source of inspiration), one might do better to look toward so-called primi-

tive art: the bison of Altamira, the African painting and sculpture on view at the Musée de l'Homme, or, most of all, the iconography of primitivism's supposed modern avatar, Josephine Baker, whose sleek brown body, veiled only by a string of bananas, had been made widely available in the popular press.

It is the sign of death, not dynamism, however, that marks Bonnard's last great series of bathers, created mainly in the 1930s and 1940s, in which the bathing figure, seen from a high viewpoint, is simply stretched out horizontally in the long tub. Passivity is the essence of the pose in an early version of this subject. In the Tate Gallery's *The Bath,* a work of 1925, the image is somber and austere, reduced in color. Indeed, the most intense tonalities are reserved for a narrow area of red floor and colored tiles in front of the bath and the four rectangular tiles on the wall behind the bather. Marthe herself, and her bathwater, are thinly painted in low-keyed blue-green: her funny face emerges from the surrounding watery unclarity with a startling, almost caricature-like vividness. The whole composition creates a sense of expansion and constriction at once: expansion in the elongation of the forms, constriction in the tomblike isolation of the tub shape itself.

Tomb/womb: the bath as a motif is both constricting and sheltering, suggesting at once the beginning and the ending of life,

interuterine bliss (or the baptismal font) and the coffin. David's resonant image of the martyred corpse of Marat, displayed to the Revolutionary public in the tub in which he was murdered, is perhaps the most famous bathtub painting of all time, although rarely considered in the context of the bather genre. (It is interesting to note that the reclusive Marthe, like Marat, suffered from some sort of malady which required her to spend long periods of time soaking in the bathtub.)

In the case of the outstretched female bather, woman, and water, however, it is hard to avoid the association with sensual enjoyment and its eventual punishment—or self-punishment. Gauguin's *Loss of Virginity* of 1890–1892 might be considered a parallel case, in which death and sexual enjoyment are conjoined in an image of decorative intensity, without the water, of course. But it is Ophelia that one thinks of as a general precedent: Ophelia in her watery grave represented as variously as in the bronze version by Préault of 1876, which is gorgeously decorative, a dying fall of spreading, waterlogged pleats floating on the metallic liquid of the relief, tilting the doomed body onto the surface in much the same way as Bonnard does in such works as the Tate *Bath* of 1925 or *Nude in the Bath (Nu à la baignoire)* of 1936.[17]

In terms of color and luminosity, Bonnard's 1936 painting is one of the richest and most complexly conceived of the en-

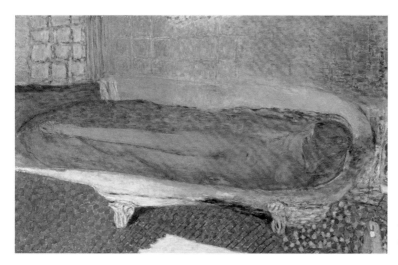

tire series of outstretched bathers, beginning with the Tate *Bath*.
The image is veiled in a dazzling carapace of golds, violets, and
more evanescent, less definable tones, melting down the geo-
metric precision of the individual background tiles in a unify-
ing counterpoint of colored radiance. Only a violently mixed
metaphor can do justice to Bonnard's vibrant intermingling of
colors and shapes in this instance: one feels the need for Albert
Aurier, or some other hyperbolic *symboliste* critic, to create a ver-
bal equivalence of the painterly pyrotechnics. Even here, though,
there is some art-historical reminiscence of tradition available to

those who look for it: the dots of gold in the foreground can call to mind either the pointillism of Neoimpressionism or the gold coins showered on Danae in the paintings by Titian and Rembrandt.

Bonnard's final version of the bather theme, *Nu dans le bain au petit chien* (Nude in the Bath with Small Dog) of 1941–1946, finished after Marthe's death in 1942, constitutes a memorial to his companion, wife, and model of almost half a century. There is a visionary quality to this canvas, a fantasy of pattern and color, blue-violets, oranges, and reds, with Marthe ensconced in a "magical place of opalescent splendor," to borrow the words of Sasha Newman.[18] Color flickers from purples to browns to yellows in the background tiles; the bath is painted in glittery greens and paler ones where the water covers the body, greens tinged with purple, the bather herself melting into anatomical dissolution, the head, and especially the face, completely rubbed out. Even the bathtub seems to melt a little, curving into the corner with a shell-like sinuousness. The commemorative implications of this multicolored, evanescent, variously patterned image is sealed by the central position and faithful brown clarity of the little dachshund on his mat, a revenant from the 1932 *Nude in Bathroom*, in which the dog also played a starring role. Bonnard, then, is far from being a mere recorder, albeit a splendidly origi-

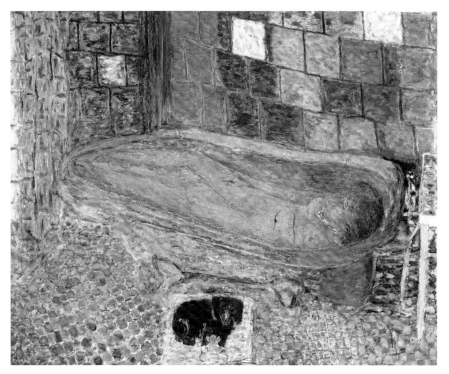

50 · Pierre Bonnard,
*Nu dans le bain au
petit chien*, 1941–1946

nal one, of the data of perception. This is just a way of categoriz-
ing him in opposition to the more "intellectual" Picasso or the
more abstractly sensual Matisse, of confining him to his little
niche of pure, naive sensation.

But wait! These are not my last words on Bonnard's bathers,

apt as they might be for an elegiac grand finale. As a woman, and as a woman who is a feminist, I must say I find something distasteful, distressing, painful, even, about all that mushy, muzzy, abject flesh. Yes, I am being naive, abandoning my art-historical objectivity, but certainly contradictory intuitions have a place in one's reactions to a work of art. I deeply admire, indeed at times am passionately seduced by, the pictorial rhetoric of Bonnard's bathers. Yet at the same time, and with equal intensity, I am also so repelled by this transformation of woman into thing, such melting of flesh-and-blood model into the molten object of desire of the male painter, that I want to plunge a knife into that delectable body-surface and shout, "Wake up!" "Throw *him* into the bathtub!" "Get out of the water and dry off!"

It is true that, late in life, Bonnard also sees himself as an object of pathos in a remarkable group of self-portraits—but how differently! In works like *Self-Portrait in the Mirror* of 1939 or *Self-Portrait* of 1945 he confronts his spiritual and physical depletion head on. If the extraordinary *Boxer (Self-Portrait)* of 1931 "reveals him almost as an old samurai with a head like a bruised plum, emaciated body with fists clenched to expose a poignant anger at age, and a realization of immanent exit," as Graham Nickerson so eloquently puts it, this is in fact an image of extreme ambiguity:

51 · Pierre Bonnard,
The Boxer (Self-Portrait),
1931

the pose itself would seem to suggest aggressiveness, but the effect
of the image is one of hesitation, timidity, of the masculine ego at
bay.[19] Yet all of these questioning, sardonic late self-portraits, de-
spite their pathos, still mark the masculine self as the controlling,
creative subject. The image of Bonnard does not melt into incho-
ateness, literally become part of the background, as does that of
Marthe in so many of the bather paintings.

Two contemporary artists have reinvented the motif of the bathtub—but, strikingly, without any human presence, either male or female. Rachel Whiteread, a contemporary British artist, in her cast series of bathtubs, as in her series of cast rooms, mattresses, or spaces under tables and chairs, constitutes a solemn and enigmatic memorial to what has been left behind with the departure of the human body, if not the aura of human presence. Basically, these cast sculptures attempt something exceedingly difficult: the materialization of absence, the solidification of what is not there.

In *Ether*, the plaster cast of the space around a Victorian bathtub creates an uncanny, coffinlike monument, as to the dead.[20] Indeed, Whiteread's bathtubs, like all her cast objects, may be described as death masks of ordinary objects. There is nothing "minimal" or geometric about these simple forms, which turn out to be less simple than they at first appear. For example, in her untitled square sink, the projected volume between the sink and the floor maps the trace left behind by the sink for the viewer's contemplation. The bathtubs—empty, eloquent materializations of ordinary household objects—repay earnest contemplation with all sorts of associative connections: memory, childhood, life, death. Particular bathtubs and their occupants may

52 · Rachel Whiteread,
Ether, 1991

float through the observer's head, touch odd chords of feeling. At times, the cast material is jewel-like plastic (mixed with resin), the surface slightly uneven, delicately modulated, and the bathtub glows warmly from within, casting an uncertain light about itself. What is important in this series is of course absence and remem-

bered presence, space and its transformation into base material. Constructed from pieces that need to be reassembled, the imprecisions matter, the gaps between one element and another create a structure of impressive and subtle formal beauty.

Robert Gober's production of constantly metamorphosing sinks—surrogate bathtubs for the purposes of this discussion—should be thought of less as a series and more as theme and variation, rather like Bach's *Goldberg Variations*. Some of the sinks are quite moving in their humble verisimilitude: few of them have spigots, some of them have eyelike holes where the spigots are supposed to be. Some are long and narrow, others quite deep and boxy. Many are slyly funny.

Unlike Whiteread's bathtubs, which are all cast and therefore indexical, Gober's sculptured sinks are carefully constructed of plaster, wood, wire, and semigloss enamel paint. None, like Duchamp's prototypical plumbing piece, the *Fountain* (1917), is a found object (in this case, a urinal). Indeed, at times Gober's formal mutations force us to ask how far one can go with varying, or playing with, or distorting the form of the sink and still have it recognizable as a sink. When does a sink-representation leave the realm of the sink and tremble on the brink of turning into something else?

53 · Robert Gober,
Subconscious Sink, 1985

By 1985 Gober was performing the most daring operations on his basic subject. Wilder flights of fancy are visible in works like the *Subconscious Sink,* in which the splashboard splits in two to form a Y-shape. The flight from the utilitarian continues in works like *Split-Up Conflicted Sink* or *The Sink Inside Me.* At other times,

54 · Robert Gober,
Untitled, 1993–1994

55 · Robert Gober,
Untitled, 2001

the aspirations of high modernism are evoked, especially in cases where the sinks are inserted into corners, bringing the daring reductions of Russian Constructivism to mind.

Although the series was supposed to come to an end in 1986–1987 with the motif dead and buried as an outdoor tomb in *Two Partially Buried Sinks,* that was not the last of the sinks. Echoes of this ever-malleable theme still reverberate in his untitled corner

piece of 1993–1994, a work representing a woman's lower body, spread legs cut off at the knees (shades of Courbet's *Origin of the World;* fig. 82) extruding from its sex the hairy shod male leg that, like the sink, has haunted Gober's imagination over the years. The woman's splayed thighs and cut-off torso are reminiscent of a metamorphic sink folded into a corner, even down to its gently glowing, semigloss surface (fig. 54).

In its final metamorphosis, the sink comes back as a bathtub/basket (fig. 55) and the lost body has returned, is back in the bath, or bath-equivalent, with a vengeance: except it's a torso, not a whole body, lacking arms, legs, head; and it is neither a man in the bathtub, nor a woman, but both, or neither, a kind of post-mod hermaphrodite; and it is real, oh is it real, more real than any body in your wildest dreams or nightmares; and you, the viewer, can have it all, mommy/daddy, boyfriend/girlfriend, son/daughter. But of course it is unreal, or really made of cast plastic, beeswax, hair pigment, and cedar, and its reality as such is made evident by the crumpling and gentle folding of the waxen matière, as though this is a little present emerging from its Christmas wrapping. As such, it makes a fitting conclusion to this essay on the issue of gender, the bath, and the bather.

Monet's
Hôtel des Roches Noires:
Anxiety and Perspective
at the Seashore

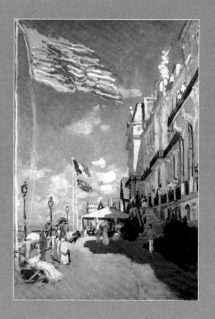

A subtitle for this chapter might also be "Surface and Depth." In one sense, surface and depth might refer to the formal structure of this painting, which offers exaggerated versions of both. Monet's amazing canvas, *Hôtel des Roches Noires, Trouville* of 1870 plays with the exaggerated perspective offered by the elegant vista in the foreground, yet frustrates our spatial expectations by blocking off the expected plunge into depth with the tentlike portico and the building in the background, as well as the white-clad woman with a parasol approaching us from the rear. Rather than being projected into space, we are kept firmly on the surface by the thick, complex, creamy verticals of the architectural structure of the grand hotel itself and by the social activities enclosed in the foreground space, defined on the right by a bold

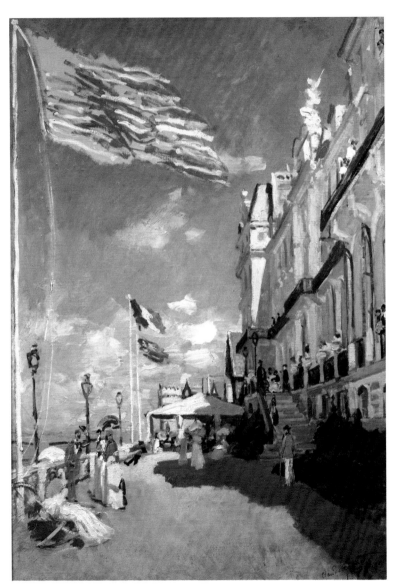

56 · Claude Monet,
*Hôtel des Roches Noires,
Trouville,* 1870

swathe of uneven shadow and on the left—and indeed through-out—by the social interactions of the elegant clients: hat-tipping, conversation, observing the passing scene, relaxing on folding chairs. Looking at these synoptic figures, one recalls that Monet started out life as a caricaturist, and here he still remembers how to sum up a generic type with a few synoptic strokes of his brush. Although nothing explicitly states it, we are meant to infer that the woman in white, veiled in shadow, deftly brushed, is lovely.

But it is the paint itself that keeps us on the surface—in the disjunctive wind-tossed striping of the flags of all nations, with the American Stars and Stripes perhaps dominating the fore-ground as an unstable *repoussoir;* in the thickly scuttering clouds; the linear intensities of the lampposts; the reiterated forms of the balconies; the off-geometric shapes of the light and shadow play-ing on the pretentious façade of the building; the density of the empty area in the front center. Although the would-be perspec-tival rush suggests grandeur and spaciousness, we cannot aban-don ourselves to spatial recession but are held to surface intima-cies and their palpable pleasures of both sight and touch. Monet brilliantly frustrates the very expectations he sets up in *Hôtel des Roches Noires.*

By "surface," though, I propose a more general engagement

with the nuts and bolts of the painting: who these people were; the history of Trouville; when the picture was painted; and what the implications of this seaside resort scene might be for Monet and his audience—leaving a more complex interpretation of the painting, and the representation of the sea more generally, for later investigation.

Seabathing, the pleasures of the shore and the beach, and the luxury hotel in Normandy were class-specific, fairly recent, and hardly unequivocal in 1870 when Monet created his painting. The Hôtel des Roches Noires itself had a specific aura of *arrivisme,* high sleaze, and international hanky-panky, as did Trouville. It was the newest and grandest of the resort hotels; and as a British travel writer of the time asserted, it was worth seeing as the "resort of the most gaily dressed of the loungers." She continues, "There was not so much as a beggar to destroy the illusion. Truly Trouville would have seemed a paradise to that Eastern philosopher who wandered about in search of happiness; and the paradise would last—perhaps till he was called on to pay his hotel bill."[1] For a French observer, the Hôtel des Roches Noires was "the king of the Normandy coast." "Constructed during the second half of the Second Empire, on the edge of the beach, facing the bay of the Seine, its somewhat pretentious façade imposes, with

its carcass of bricks inserted into the stone, its Corinthian columns supporting an entablature mounted on a circular pediment, its flight of steps, its balconies, its thousands of windows, its superb and immense dining room, its grandiose salon measur[ing] three hundred square meters."

Still in 1929 considered "the great classical palace," it was frequented by "the great names of American millionaires, side by side each night with representatives of the English aristocracy, financiers from the City, and the magnates of German heavy industry."[2] Today, it is a condominium, whose main claim to fame is that the writer Marguerite Duras lived there, and a movie starring Jeanne Moreau based on Duras' waning days—writing, drinking, making love to a much younger man—was filmed on its premises.

One of the most truly awful novels of the nineteenth century was devoted to the Hôtel des Roches Noires and its denizens. Despite the novel's unlikely plot and impossible characters, it gives some sense of what Trouville and its leading hotel stood for in the contemporary imagination. This is Adolphe Belot's *Les Baigneuses de Trouville: Suite des mystères mondaines* (The Bathers of Trouville: Series of Worldly Mysteries), published in Paris in 1875. The characters and plot of this romantic potboiler are so excessive and

complicated that I would need hours to describe them, but a synopsis is useful in suggesting the underlying anxieties, ambitions, and fantasies of the motley crew of the rich and famous, and the would-be rich and famous, who flocked to Trouville at the time to seek if not fame then at least fortune. The heroine of the book has neither wealth nor beauty, but she is obsessed by both, and especially by the beauty she so ostentatiously lacks. When her father takes over as seasonal proprietor of the resort hotel, Carmen is suddenly exposed to a world of elegance and luxury—a Madame Bovary of sorts, but with a redeeming wit and irony. She proves expert at manipulating the hotel's socialite clients, whose orbit she navigates, especially one sinister Mme Vitel, a member of the *haut monde* with a past, who artfully disguises Carmen by dyeing her hair blonde, covering her unsightly features with makeup, and providing dim lights to enable her to entrap a handsome tenor who is the ugly girl's dream man. Declares Carmen, "I am a bather like all these ladies, but a bather who does not bathe," and for a good reason: she doesn't want to expose her bony body to broad daylight.

In the end, all the plotting, scheming, and disguising are for naught. The novel ends with a violent speech in which Carmen commits herself to a life of wickedness and the destruction of her

fellow human beings. If Madame Bovary, faced with the dissolution of her ideal, attempts a romantic death, Belot's Carmen, on the contrary, sets out to destroy all romance and beauty in life.[3] Defeat in Trouville's world of intrigue is absolute and, the author suggests, can have nefarious results.

The transformation of Trouville from a simple fishing village into a high-class resort for the snobbish and ambitious took place rapidly, over the course of about twenty years, and was due in no small part to the publicity provided by writers and artists like Charles Mozin, who specialized in views of the beach, the fishermen, and ultimately the bathers and tourists who repopulated the Normandy coast. In his memoirs, Alexandre Dumas names Charles Mozin as the discoverer of Trouville.[4]

When Mozin first represented them, the baths of Trouville were still relatively modest and undeveloped (fig. 57). Mozin helped popularize this untouched seaside paradise by showing his works in the Salons of the thirties and forties. Writers took note of the transformation of Trouville. "It used to be a real sea-port, with a scattering of houses behind a quai enclosed by cliffs, with drying nets stretched out on the oars, with fishermen in red caps and sailors in white jackets. Today it is, as they say, the rendez-vous of good society. There you see Parisian women in beautiful

57 · Charles Mozin,
Trouville, Les Bains,
1825

outfits, elegant yellow gloves, English grooms, liveried coachmen
and riding teachers," declared Flaubert in an account of his travels
through Normandy with Maxime Du Camp in 1853.[5]

Now-forgotten writers like Alphonse Karr, in his *Promenades
au bord de la mer* (Walks by the Seashore), published in 1874 but
written well before as a series of articles, helped popularize the
seaside resort, while at the same time bewailing its lost virtues

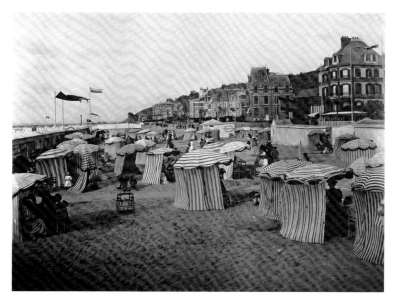

58 · *Trouville-sur-Mer,* c. 1860s

of simplicity and purity. So did Albert Blanquet in his *Bains de mer des côtes normandes: Guide pittoresque* (Bathing on the Normandy Coast: Picturesque Guide), published in 1859, in which he declares that Trouville is the "Boulevart [sic] Italien des plages normandes" (Italian boulevard of the Normandy beaches), and notes, nostalgically, that "thirty years ago, Trouville did not exist; that is to say, it was not known . . . It was the refuge of simplic-

ity and innocence; the world and its so-called excitements had not yet blown upon it the wind of disappointing ambitions and unappeasable desires. Dumas has been called the Christopher Columbus of this oasis of Lower Normandy; but," Blanquet declared, anticipating Dumas' own conclusion, "it was really Charles Mozin who discovered Trouville."[6]

Of course it was not merely these inadvertent public relations men who transformed Trouville from a tranquil fishing village into an international resort. Government financing of the famous casino, speculative investment and building, both public and private, and, above all, the development of mass transportation in the form of the railroad and steamboat enabled tourists to spend as little as a weekend enjoying the seaside amenities—as long as they did so in a hurry. Weekend tourists were a constant source of verbal and visual satire, in the form of cartoons and acerbic articles. Karr has great fun at the expense of what he calls *les plaisiriens,* sleepy-eyed denizens of the special train that, having left Paris the night before, "vomits" its passengers out in the early morning hours of the weekend at Sainte-Adresse. "They are dressed up, tired, cranky, their eyes are heavy and swollen. They only jump around so much and scream so much to fight against the sleep that invades their bodies. But they don't stay at Ste.

Adresse; steam boats await them . . . to take them to Honfleur, to Trouville, etc.; another takes them out to sea, just opposite Etretat." But most of the passengers become deathly seasick; even when they come back to land there is little relief.

"What is this troop," Karr asks, "or rather this horde whose savage cries can be heard from afar? Those who compose it have peajackets and red sashes and shirts with big blue linen collars spread over their shoulders. They are Eugène Sue sailors, or rather, this is a detachment of sailors from Asnières, redoubtable boatsmen of the Seine and Marne. The poor weekend tourists are forced to miss Sunday dinner at the beach because they must catch the early train back to Paris, the poor devils, and eat their Sunday dinner on the train. They have iron constitutions," declares Karr, with scathing sarcasm.[7]

Yet it was Monet, along with his mentor, Eugène Boudin, not the pioneering Mozin, who created the images of Trouville we remember: the fashionable crowds, the cabins, the bathing machines, the nuances of clouds, sea, and weather, in the case of Boudin; the elegantly clad young woman in Monet's work. His image of a mother with nurse or older companion—the absent child's presence indicated by the deftly painted adumbration of little slippers drying on the empty chair—is painted with utmost

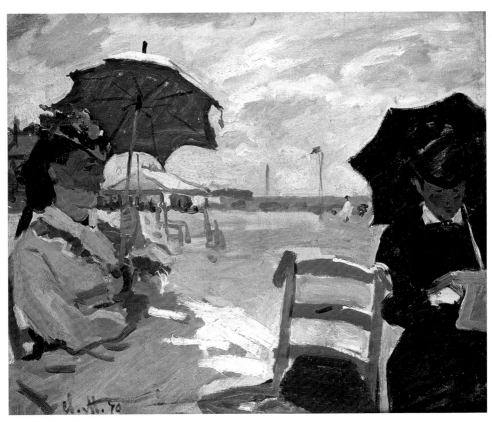

59 · Claude Monet,
The Beach at Trouville, 1870

bravura, the entire surface inventively activated by synoptic or piled-up strokes of paint, despite the tranquillity and sedateness of the protagonist: Monet's wife, Camille.

Yet the sea was not simply the site of peaceful pleasures and their representation, of course. Shipwrecks were frequent and had served as the subject of romantic melodramas by specialists like Joseph Vernet in the eighteenth and early nineteenth centuries. And only a year earlier, in 1869, Courbet, painting in nearby Etretat, had emphasized the sheer power of the sea, with little or no human presence, the material weight and energy of the mighty wave occupying the entire surface of his canvas. Indeed, in the earlier days of seaside resorts like Trouville, seabathing itself was considered hazardous—something to be done for medical or psychiatric reasons, with innumerable precautions taken, rather than for simple pleasure.

Blanquet, in a long appendix to his Normandy guide to bathing in the sea, the *Petite guide pratique du baigneur,* insists on the moral and physical effects of seabathing, the cold bath above all. It is for the doctor a precious cure because of its energy-giving properties, although a neglected cure, due to ignorance. "Brusque immersion is preferable—go in all at once; if you can't swim, have yourself plunged headfirst by the guide. Two baths of three min-

utes are preferable to one bath of six minutes." The advice is end-less, as are the salutary effects recorded: "Sterility is often van-quished by seabathing—pregnancy and nursing can only happily profit from it," declares Blanquet.[8]

Yet Blanquet is short-winded and restrained in comparison to the real medical expert on seabathing, its happy effects, and above all the precautions to be taken. Dr. Jules Jean Baptiste Le Coeur's two stout volumes of *Des bains de mer: Guide medical et hygienique du baigneur* were published in Paris in 1846. This curi-ous work is divided into four parts—theory, applications, hy-giene, and varieties—with endless subdivisions whose precau-tions to the wary seabather are exhaustive. There is no such thing, in Dr. Le Coeur's world, as just putting on a bathing suit and jumping into the water. Heaven forbid! A long list of diseases and afflictions susceptible to the medicinal properties of bathing is followed by a lengthy list of bathing costumes and accoutrements: choice of cloth, cut, length, head gear, bathing shoes, belts, cloaks or peignoirs, clogs. Pages are devoted to entering the water (grad-ually or brusquely), behavior during the immersion, movement in the water, jumping and gymnastics during the bath, swimming and its advantages, receiving the wave once in the surf, choosing the lifeguard or swimming guard (*guide*). One finds advice about

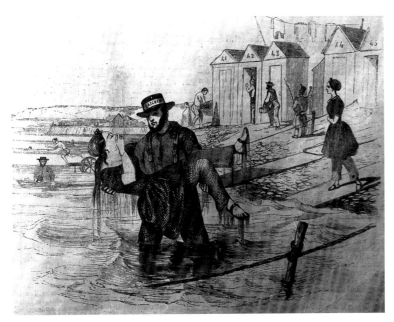

60 · *Baigneur faisant prendre la lame* ([Master] Bather Making Woman "Take the Wave")

how to carry sick people down to the sea, and what to eat and drink while seabathing (white meats, roasted or grilled, fish, and green vegetables are preferred; use of wine, coffee, liqueurs should be moderate; avoid flat water, drink seltzer). Don't stay up late dancing at the casino, Dr. Le Coeur warns, and for men of letters he recommends the cessation of all work.[9] Obviously, seabathing

was not something to be undertaken lightly, but required careful preparation and safety measures.

Yet along with the "scientific," the nostalgic, and the satiric representations, literary and visual, of the theory and practices of seabathing at the new resorts, a potent vein of misogyny was unleashed by the prospect of women cavorting in the surf—as at the prospect, it might be said, of women doing anything outside of minding the children and looking attractive. Any form of novel, independent behavior on the part of women was an occasion for male vitriol. Indeed, the mere existence of women seems to have both inflamed and irritated the *hommes du monde* of the Second Empire and Third Republic, as a perusal of the Goncourt diaries reveals. Pillorying the vanity of the "fair sex" was almost a requirement of boulevard journalism in those days, and women's prominent self-display at the new beach resorts provided an ideal occasion for such satire.

Karr was in tune with the times in his misogynistic journalism. In his *Second Promenade,* written in the 1870s, he devotes himself to the problem of women bathers and the related centrality of dress in the life of women. "Women," he declares, "are becoming the strong sex." He continues: "It is scarcely seven in the morning, and already, women pour in from every direction to bathe in the

surf. Men do not bathe this morning—it is not warm enough, but women have a heroic energy for whatever amuses them." Then he goes into the real reason for this heroic energy. "A woman who has a pretty bathing costume would bathe in the winter, bathes in the stormiest sea; cold and fear no longer exists for what gives her pleasure. Our education for the last few years has been extraordinary: men abandon exercise and curl their hair; women put their hair in headbands, swim, ride horses and do gymnastics. Thanks to these . . . tendencies, they will become the strong, robust sex."

Karr soon drops the mockingly positive view of women as the strong sex for a more generic antiwoman tirade: "Women can't be friends—they only unite to attack a third woman, they are invariably catty to and about each other," etc., etc. In a section devoted to the influence of clothing in women's lives, he remarks that "in the life of women, everything results in a change of dress, everything is determined by a dress, every circumstance in feminine life is marked by a dress . . . it is always the dress that is the important point." In short, Karr maintains, in a striking *bon mot,* "La femme est un animal qui s'habille, babille et se déshabille" (Woman is an animal who dresses, babbles, and undresses), as succinct a bit of misogynistic wisdom as one could wish for in the mid-nineteenth century.[10]

Yet interesting as the history and folklore of Trouville and other nineteenth-century bathing sites may be, I have other paths to follow, quite different from the "surface" account where I began. That path leads to what might be considered the issue of depth—in this picture and in painting in general. What I will be concerned with in the rest of this chapter is an interpretation of the sea and its representation involving depth and perspective as instrumentality and metaphor, an interpretation in which both my own childhood memories of the sea and Freud's "oceanic feelings" will play a role.

When I talk about depth in Monet's *Hôtel des Roches Noires* or any other, I am of course speaking figuratively. All paintings are nothing but surface. A Rembrandt portrait has no more depth than a Matisse. One might talk about "effects of depth," of course, created by a skillful deployment of shadowy glazes over the eyes or deftly placed impasto on a nose or cheekbones, but painting, despite minute relief variations, is basically a flat surface covered with colors deployed in a certain order, as Maurice Denis declared many years ago. All our references to depth—either spiritual or physical or spatial—are basically figures of speech, metaphors.

The same is true of the discourses of human psychology or psychosexuality. Sometimes we talk as though the ego, the id, and

the superego were deeply embedded in the human persona, the id of course most deeply, the superego more superficially, and so on. We even once talked of "depth psychology," as though probing the unconscious involved a literal sort of digging. To say of a person or a work, at least until recently, that he or it was "deep" or "profound" assumed a kind of literalness, although, again, it involves metaphoric language: implying hard to get at, complex, hidden "beneath the surface." To say of someone that she is superficial, all surface, implies that the personality in question is frivolous, obvious, trivial.

We can say the same of perspective in painting. We speak of it as though it literally pushes or pulls us back into space even though we know this space creation is merely virtual, the result of surface manipulation and well-placed signifiers. "Back"—that is, "depth" in the land of the vanishing point—is really "up" on the surface of the canvas, nearer to the top. In, for example, his *Seaport with the Embarkation of the Queen of Sheba*, Claude, in a sense, tries to literalize the movement into depth through canny illusionism, pulling our eyes "back" with the aid of aerial perspective as well as the linear variety, skillfully deploying transparent glazes to suggest light at the vanishing point on the horizon, where the livid sun sinks or rises, as the case may be (fig. 61).

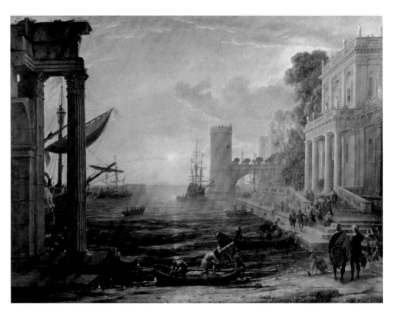

61 · Claude Lorrain,
*Seaport with the
Embarkation of the
Queen of Sheba*, 1648

The seaport as a subject lends itself particularly well to the project of perspectival control: the orderly harbor with its imposition of rational human rule in the form of architecture on the disorder of nature is an ideal subject for linear perspective which is at once geometric and adroitly illusionistic. Monet, in his *Beach at Trouville* of 1870, utterly rejects this literalization, despite the exaggerated diagonal of his perspective construction; on the con-

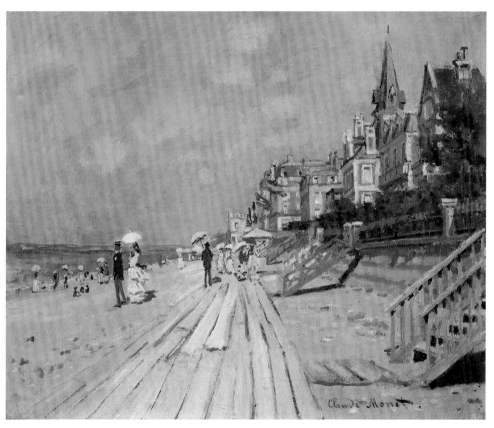

62 · Claude Monet,
Beach at Trouville, 1870

trary, the image literally clings to the surface due to the thickening up of the pigment, our awareness of paint, the allure of individual brushstrokes, the cartoonish cast of characters, the light and shadow congealed on the canvas instead of melting in the putative distance.

I would also say that Monet's *Hôtel des Roches Noires* engages with a new kind of anxiety, but an anxiety that has always lain at the heart of perspective construction. In other words, I connect perspective with anxiety from the start, with the need to control that which seems to get away from us through the instrumentality of reason and illusion. Why else would one-point linear perspective loom so large in the Renaissance, particularly in the early Renaissance, when it was developed? Linear perspective, however complex and overdetermined its genesis, is connected with the secularization of vision at the expense of the visionary in representation. Anxiety about control, individual control, lies at its heart, for letting things go spatially means a plunge into the inchoate, the unknown, or a melting into infinity, ultimate loss of self. For the visceral eye, perspective might be envisioned as a way of coping with death, the inevitable movement away from the viewer—implying movement through time as well as space.

Monet's painting, like Claude's, deploys architecture, but com-

pared to the seventeenth-century painter's use of it, *The Hôtel des Roches Noires* is deprived of perspective thrust, wobbled, desubstantialized, the human figures no more or less architectonic than the buildings. The blowing flags, the air, the light, the sense of process—including the process of seeing, itself—dissolve the severe thrust of perspectival recession and the stability it involves. This indeed is anxiety-provoking business precisely because it is so risky. It refuses the sureness and stability of the traditional modes of organizing space and perception.

Or to put it another way, Monet and his contemporaries accept anxiety and instability, the processive and the changeable as the price of what they treasure as personal, unmediated vision—indeed, its very hallmark. The fact that the viewer can "read" the *Hôtel des Roches Noires, Trouville* as the product of direct vision depends on its author's presumed refusal of the mediation of perspectival control, among other things, and its opting for irregularity, revealed touch, asymmetry, rubbery synoptic figures, and a sense of sun and shade eating away at the solidity of form—vision, in some sense, perched on the brink of catastrophic chaos and making visual sense out of it, vision testing the borders of anxiety.

Needless to say, this state of affairs could last only a short time.

To generalize about Monet's, or Impressionist, space in larger terms, I would say that between Renaissance one-point linear perspective and the Modernist grid lies the phenomenological spatial mapping of Impressionism, an attempt not so much to impose order on the inchoateness of spatial experience as to attain visual coherence through the "lived-in experience of perception itself," to borrow a phrase from the French phenomenologist Merleau-Ponty.[11]

The beach is a good place to think about perspective and anxiety. You can trace this fear of uncontrolled distance back to childhood angst about the disappearance of a loved, caring person into the fearful infinitude of the ocean. For the gaze of the child, the beloved parent-figure must be protected from potential disappearance in a threatening distance. A bit of poetry expresses this quite simply:

> . . . At Neponsit Beach
> I would cry when my grandfather
> Vertical, steady, relentless
> Swam too far out to sea.
> "How far" you ask "is too far?"
> Any distance away from me

Is too far:
That is the definition
Of too far.[12]

The term "vanishing point" can only be a signifier of extreme
danger for the child in relation to the protective adult.[13] Thus, I
can think of the construction of perspective in the Renaissance
not (as it has usually been considered) as a sign of (masculine un-
derstood) individualistic *control* of the visual field from the point
of view of the triumphantly dominating viewing subject, but
rather the childish attempt, fraught with irrevocable angst, of the
uncertain viewer to secure, however phantasmally, with whatever
frail threads at her command, the presence of the beloved parent-
surrogate from disappearance into limitless space or, even more
concretely, from drowning in the depths of the sea. From this
vantage point, perspective can be read as an always already-imag-
inary construct protecting the secular subject from disappearance
into the infinite, those depths or heights beyond visibility and
reason: a kind of representational whistling in the dark. Or to put
it differently, perspective can be construed as a net to hold noth-
ingness in check—an imaginary net, woven of threads of reason
and desire, warp and woof, to hold firmly against the ever-present

threat of annihilation. The terrible force, the rigidity and symmetry of early Renaissance perspective can be understood at least partially as a sign of such anxiety in the youth of perspective construction itself.

More specifically relevant to our subject of the sea and perspective, swimming out to sea is itself a trope of death, often self-willed and particularly attached to women. One thinks of the tragic fate of the heroine in Kate Chopin's *Awakening.* Swimming out to sea and to her doom—death by drowning—is generally positioned as a feminine choice (but not always, think of Hart Crane leaping from the boat), starting with Ophelia, picked up in Victorian representation by George Frederic Watts in *Found Drowned,* redeemed by Modernism in Brecht's "Drowned Girl" or Stevie Smith's "Not Waving but Drowning," or in real life, as Virginia Woolf meeting her watery fate with stones in her pocket. Another example can be found in Jane Campion's *The Piano,* though the heroine pulls back at the last minute. The pleasures of the beach, of immersion in water—sensual, delicious, liberating, surely to some degree sexual in their thrilling bodily immediacy—are all too often, in literary or visual representation, associated with some sort of retribution, where women are concerned. Letting go, plunging oneself into the water, swimming away, that

oceanic feeling, the opposite of linear perspective and its adamant control over the vastness of space and the sea—are particularly dangerous to women. No, of course I am not proposing another learned historico-theoretical version of the origins or development of perspective. This is not even speculation but something different: a kind of phenomenology of feeling when confronted by the ocean or its representation, which no evidence can subvert or substantiate apart from personal experience, fantasy, memory, pain, and desire. Yet it infuses the artistic imagination of the nineteenth century, when the figures on the shore are confronted by the vastness of the sea.[14]

The romantic association of ships going out to sea with the infinite, with death, so different from Claude's confident port scenes, are vividly evoked by Caspar David Friedrich in his paintings of watchers by the seashore. Here, in the misty, darkening atmosphere of the coast, the topos of figures with their backs to us gathered on the shore contemplating the departure of ghostly, high-masted boats into the beyond is inevitably allegorical in its connotations.

It is when the artist leaves the disquieting boundary of the beach, linked however precariously with the stability of familiar ground and firm footing, and sails out on the open sea that anxi-

ety is transformed into terror, allegory into actuality. Such is the case in the most famous representation of maritime disaster, based on contemporary fact and linked to antigovernment politics: Géricault's *Raft of the Medusa* of 1819. Here, we are confronted with a narrative of betrayal, brutality, and suffering, the melodramatic storyline embodied in the carefully plotted figural grouping of the final version, which refers back to specific elements of reportage. Indeed, so careful, so predigested, so detailed is this final version that it somehow lacks the visceral impact, for modern eyes at least, of many of the preparatory sketches. In the sketches, the condensation of the action, and above all the displacement of the agitation from narrative to brushwork, is more effective in its expression of emotion than the rather frozen and overworked final composition. It is more like an early film, or a *tableau vivant*—too premeditated to be completely effective.

The *Medusa* had been the flagship of a convoy carrying settlers to the French colony at Senegal. Due to the incompetence of its captain, it ran aground off the west coast of Africa in 1816. Some of the passengers got into lifeboats, the rest clambered onto an improvised raft, which was cut loose, leaving 150 people, including one woman, adrift on the high seas. The terrible events of this voyage, later recounted by two survivors, Corréard and Savigny,

63 · Theodore Géricault,
Raft of the Medusa, first oil sketch, 1819

an engineer and a doctor, included an attempted mutiny, canni-
balism, and triage of the worst-off passengers, including the only
woman. Only fifteen men remained when they were finally picked
up by the British frigate *Argus.*

This account of the tragedy, published in 1817, accused the
French government of hiding the evidence of incompetence in-
volved in the shipwreck and inspired Géricault to create his 16 ×
23 foot canvas.[15] The *Raft* caused a scandal at the Salon of 1819
and met with a generally negative reaction. Géricault, to make up
for this critical rejection in France, later toured the work in Brit-
ain. In 1820 more than 40,000 British visitors saw it in William
Bullock's Egyptian Hall in London, making the visit a financial as
well as a critical success.[16] Indeed, the *Raft* deserves comparison
with a Cecil B. DeMille film in its effectiveness at summing up a
melodramatic event. Horror is deployed in the foreground, sug-
gesting all the trauma that has gone before, but a faint ray of hope
animates the scene in the form of a ship, still a distant speck on
the horizon, and the gradual realization on the part of the survi-
vors that rescue may be at hand. Spatial distance, the extent of the
sea separating raft from tiny rescue ship, suggests both past hor-
ror and future redemption.

Far more effective in conveying a sense of anxiety on the open

sea, in unequivocally modern terms, are Manet's two versions of *The Escape of Rochefort,* probably intended, in final form, as a "sensational" picture for the Salon of 1881. Like Géricault's *Raft,* Manet's Rochefort paintings were probably inspired by a text, this time a novel, Henri Rochefort's *L'Evadé,* published in June 1880. Then too, Manet could have based the work on the political prisoner's nonfiction account of his escape from exile in New Caledonia, as a consequence of his purported criminal behavior during the Commune. Rochefort had escaped with five other political prisoners, including his comrade Olivier Pain, and was met in Nouméa harbor by an Australian clipper ship, later returning to Europe and finally to Paris, where he published *L'Intransigeant* and became a thorn in the side of the Third Republic, which he considered insufficiently radical. Still later, at the time of the Dreyfus affair, he became a virulent anti-Semite.[17]

But it is less the story of Rochefort that interests me—intriguing as it is as a political painting by Manet—than the extraordinary *lack* of narrative detail the artist deploys, in both versions, to convey that this painting *is* a political painting. Indeed, it is impossible to deduce from the visual evidence that this is a painting with any specific storyline at all, and not just a group of friends out for a boat ride (rather scarily, it is true) on the open sea. In-

64 · Edouard Manet,
The Escape of Rochefort, signed version, 1880

MONET'S HÔTEL DES ROCHES NOIRES

deed, ever since 1968, when I first became involved with the painting in the course of writing an article called "The Invention of the Avant Garde" for the *Art News Annual* of that year, the painting, especially the smaller "final" (signed) version, has haunted my imagination. At that revolutionary moment, I interpreted *The Escape of Rochefort,* both small and large versions, as an unconscious or disguised self-portrait, where the equivocal republican leader, hardly a perfect hero, is represented in absolute isolation from both nature and his companions. Indeed, in the smaller version, one can hardly make out his presence.

The romantic hero, so brilliantly diagnosed by Lawrence Eitner in his famous essay on the open window and the storm-tossed boat, has now disappeared completely in a telling synecdoche of his public fate.[18] No trace, in either version by Manet, of the contrast between the controlled serenity of the hero/protagonist and the passion of nature, embodied by Delacroix's earlier paintings of Christ on the Sea of Galilee. And indeed, the open brushwork and the vague Chaplinesque silhouette of Rochefort holding the rudder in the larger version introduce once more into these pictures the evanescent specter of *blague,* a kind of transcendent jokiness that haunted both the *Déjeuner* and the *Olympia* earlier in Manet's career. Here, the isolation that marks these sea images,

as it does in so many of Manet's late works—the single asparagus stalk, the solitary rose in its vase, the single jar of pickles—is not merely the registration of a particular historical circumstance. Rather, it serves to figure in an original and pathetic manner what it is to be an artist, what it is simply to be in the world.[19]

That was what I said back in 1968. Today, it is the absolute isolation, the total alienation projected by the final version that haunts my imagination. I now realize that it epitomizes what I have chosen to call, in this chapter, "anxiety and perspective at the seashore"—because there *is* no seashore in this image, and no perspective either, not even a horizon in the signed final version, where the surrounding sea, flat, up-tilted, agitated, limitless, is the true protagonist of the image. I think I can see why Manet abandoned the more comprehensible narrative and perspectival composition of the earlier version: the later one is far more anxiety-producing in its anonymous emptiness. The role of narrative is reduced to the merest diminuendo, the human figures dwarfed, rather than trumpeting their pathetic history, as they do in Géricault's gigantic canvas.

Now I have always connected this version, and my reaction to it, with Freud's memorable phrase "oceanic feeling," even though I sensed that something was amiss with this connection. For the

longest time I did not want to know that Freud meant something quite different in using that term, almost the opposite of my anxiety at being enveloped by, sucked down into, the ocean, lost at sea—in short, my association of "oceanic feeling" with alienation and death, as embodied in Manet's *Rochefort.*

I finally looked up Freud's ideas about the "oceanic feeling" articulated at the beginning of *Civilization and Its Discontents,* published in 1930. The "oceanic feeling" was, in fact, not Freud's idea at all but that of his friend, the novelist Romain Rolland, and indeed it referred to a very different kind of feeling from the one I had projected onto it. It was a notion about the origin of religion, and Freud himself was extremely skeptical about it. Here is what Freud had to say about oceanic feeling:

> Romain Rolland wrote to me after having read "The Future of an Illusion," to say that he entirely agreed with my judgment upon religion, but he was sorry that I had not properly appreciated the true source of religious sentiments. This, he says, consists in a peculiar feeling, which he himself is never without, which he finds confirmed by many others, and which he may suppose is present in millions of people. It is a feeling which he would like to call a sensation of "eternity," a feeling as of something limitless, unbounded—as it were "oceanic." This feeling,

he adds, is a purely subjective fact, not an article of faith; it brings with it no assurance of personal immortality, but it is the source of the religious energy which is seized upon by the various Churches and religious systems, directed by them into particular channels, and doubtless also exhausted by them. One may, he thinks rightly, call oneself religious on the ground of this oceanic feeling alone, even if one rejects every belief and every illusion.

Freud, it must be said, admits that he cannot discover this oceanic feeling in himself. From his own experience, he could not convince himself of the primary nature of such a feeling, and hence cannot envision it as the *fons et origo* of the whole need for religion.[20]

At first, I was disconcerted to find that I had missed the point, that the "oceanic feeling" was attached to something positive, unifying the individual with the universe. For me, the sensation of "something limitless and boundless" suggests not eternity but a submerging of the individual, isolation from all known, substantial material reality—things in the world, people, the ground beneath my feet. Like Freud, I can only say that I cannot discover this proto-religious sort of oceanic feeling in myself. Manet's painting is the very epitome of my very different alienating

and frightening version of it—"alone, alone, all all alone, / Alone on a wide, wide sea," to echo Coleridge's *Ancient Mariner.* That to me is still the "oceanic feeling."

An amazing real-life postscript—and a fulfillment of my misprision of Freud's oceanic feeling—is provided by a conceptual and performance artist who died young (in 1975) in the course of a performance piece involving sailing out to sea in a small fragile boat. The artist—who had a revival of sorts in the late 1990s—was Bas Jan Ader, and he was born in the Netherlands in 1942 but lived and worked mostly in California, where he was a member of the University of California, Irvine, art faculty. It is often said, one critic of Ader's art declared, "that performance artists—performers, in the field of conceptual art—get lost in their artistic performance. Usually, that's a kind of positive, reassuring metaphorical statement about the depth and seriousness of the artist and his work. Not in the case of Bas Jan Ader, however; a Dutch performance artist of the early seventies . . . Bas Jan Ader was literally lost during his last performance, he was lost at sea at the age of 33. He died while undertaking the second installment of a proposed three part work entitled 'In Search of the Miraculous.'"

The first part consisted of still photos of the artist wandering the freeways, hills, and coastline of Los Angeles by night, armed

65 · Bas Jan Ader,
*In Search of the
Miraculous,* 1975

with a flashlight. The next stage was an attempt to sail from Cape
Cod to Falmouth, England, in a thirteen-foot sailboat, a voyage
he estimated would take about sixty days. The whole journey was
to be photographically documented (fig. 65). He took off on July 9,
1975, but three weeks later radio contact failed. His brother, Erik,
tells it like this: "On about April 10 [1976], a Spanish fishing
trawler found his boat about 150 nautical miles west-southwest of
Ireland. It was two-thirds capsized, with the bow pointing down.

Judging by the degree of fouling, it looked as though the boat had been drifting around in this position for about six months."[21]

As the critic Bruce Hainley points out in an article written on the occasion of an Ader retrospective in 1999 at the Sweeney Gallery at the University of California, Riverside: "Allowing Ader's metaphorical navigations to make their fullest journey, 'In Search of the Miraculous' may evoke earlier myths of explorers risking the earth's flatness and falling over its edge, punishment for their pride." Falling, it must be noted, was one of Ader's favorite moves in his repertory of repeated gestures. He rolls off a roof in *Fall I, Los Angeles* (1970). He jumps out of a tree in *Broken Fall (Organic)* (1971) and rides a bicycle off a bridge into the water in *Fall II, Amsterdam* (1970). Hainley notes that "in one of his notebook entries, Ader jotted an idea for a postcard: 'Greetings from Beautiful Ader Falls.' More ominously, he wrote, 'All is falling.'"

Yet, as Hainley points out, "for all the postwar effects of macho heroism pervading LA during Ader's time there—he mentions Bruce Nauman, Paul McCarthy, and Chris Burden, among others—the tonality of his project is entirely different." Brad Spence, curator of the 1999 retrospective, talks about "a sense of tension in Ader-the-director and Ader-the-actor in the production of his own tragedy; he dramatizes the exalted elements of self-intention and self-destruction." He took a gentler, less macho approach

than the other male performers and conceptualists of his time. One of his notebook entries reads, "My body is practicing to be dead."[22]

Bas Jan Ader's project *I'm Too Sad to Tell You* (1971) began as a series of ideas in Ader's notebook: "Short film 'I'm too sad to tell you' drink tea sadly and begin to cry / Postcard of me sadly crying. On back: 'I'm too sad to tell you' / 'The space between us fills my heart with intolerable grief' / The thoughts of our inevitable and separate deaths fill my heart with intolerable grief." He went on to make a photograph, a film, and the postcard edition. Says Jody Zellen in a review of the retrospective, "There is no denying . . . a certain sadness or sense of loss in all of Ader's works." In his film *I'm Too Sad to Tell You* (1971), he "simply cries for the camera." "The words 'I'm too sad to tell you' address the extent of his despair."[23] Even more to the point, it addresses his skill as a performance artist, despairing or not. For Ader was concerned with how to document, either in language or visually, any performance or action, whether deeply felt or simply enacted. In a way, the point of 1970s performance art was to question the opposition between sincere, motivated acts and performed ones by recording them as they happened.

Unlike Manet in the *Rochefort* painting, Ader was literally

rather than metaphorically the subject of his piece; and unlike Manet, his record of his artwork is indexical, photographs rather than paintings. Yet like Manet's *Rochefort* images, the work was never quite finished, different though the reasons may be for this. Significantly, both Manet's and Ader's works enact my nightmare vis-à-vis the oceanic feeling, and this text serves as my "perspective," as it were, those frail lines staving off the inchoateness beyond the vanishing point, giving shape to nothingness.

With Bas Jan Ader's performance piece, we have come to the end of our voyage, from Trouville in the nineteenth century to Cape Cod in the twentieth; from surface and depth to sailing and death; from painting to performance and photography; from perspective and anxiety to anxiety as the enactment of an existential condition. All through, I have been haunted by Freud's oceanic feeling—my version of it, that is—a guiding misunderstanding in my thought on the subject of the seashore, the self, and the sea. It has taken me far from my original undertaking, and from art history itself. So be it; it has been a voyage of discovery for me, leaving the purported subject as mysterious—and seductive—as it was when I started out.

Real Beauty:

The Body in Realism

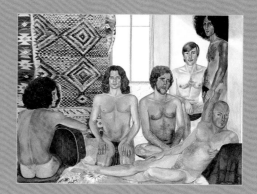

\mathcal{M}y TITLE SUGGESTS a certain intentional ambiguity. Let me clarify: I am not going to be talking about Beauty, what really constitutes it, how we define it; that is to say, I am not going to talk about aesthetics as such. Rather, I will be talking about the realist body and its relation to—or more often, rejection of—conventional beauty. I will position "real" beauty as "realist" beauty, and therefore as a kind of antibeauty. By this I do not necessarily mean ugliness, although I might at times. But a contrary is not a contradictory. And all nonbeauty is not ugliness: there is a wide range of possibilities, including attractiveness (no, she's not beautiful, but she is attractive), piquancy, sensuousness, elegance, and so on. As to the antibeauty which is involved in the realist project, we might think, for purposes of argument, of realism as a vertical continuum, with the sublime, whether Longinian or Burkean, at

the top, the concrete, the contemporary, and the ordinary in the middle, and the abject or the grotesque—the latter especially in antibeauty's more recent, Postmodern manifestations—at the bottom.

The production of the realist body as I figure it is impelled by two quite different impulses: that of magic and that of critique. Realism as magic is the time-honored quest for the bodily presence of the absent, or the dead, as a bulwark against danger and dread. Examples include the Florentine *boti* of the Renaissance, life-size wax effigies of church donors, dressed in their own clothes, suspended from the ceiling of churches. They appeared in such vast numbers that, as Aby Warburg pointed out, visitors to the Church of the Annunciation, for example, were endangered by their falling on them. As Tom Crow has recently noted, "The portraits of the living and the dead Florentines that populate Ghirlandaio's Franciscan fresco cycle in Santa Trinita, were, for Warburg, just one step removed from this barely paganized rite."[1] Or as Philippe-Alain Michaud puts it, "The hyperrealist and superindividuated wax portrait carries the deep trace of the myths of safekeeping, iconic armor against annihilation and death, which gains new dignity and intellectual power in the painted Renaissance portrait."[2]

Equally compelling in its quasi-magical power to preserve the bodies of both the dead and the living is the nineteenth-century daguerreotype (fig. 66). From its silvery, unfathomable depths rises the body in all its poignant indexicality, the very earmark of the technique and token of its singular magic potency. Like the wax images of the Renaissance, or the death mask, the early daguerreotype had the task of preserving the image of the dead, but it was easier to produce. Like reliquaries or personal shrines, daguerreotypes were often kept in little cases, like little personal altars for reflection or worship, secular *andachtsbilder*. And since the daguerreotype played the role of magic body provider to those in need, it is not surprising that one of the first markets this magic medium serviced was for erotica and outright pornography—where else was the presence of the "real" body more necessary, the fantasy possession of female bodies more desirable?

Realism as critique involves the rejection of the normative, generally classically based ideal of the body on the grounds of its fraudulence and of the larger social and ideological orthodoxies that such idealism depends on. I would like to reiterate that realism is not merely a question of accuracy nor a certain category of subject matter. In some ways, it is better accounted for in terms of what the realist rejects—harmony, poncif, the ready-made ges-

66 · Alphonse Bon
Le Blondel, *Man at
the Bedside of His
Dead Child*, 1850

ture, universal ideals of beauty. Realism at its best is a critical
practice in terms of both formal language and viewpoint.

Courbet, for instance, takes over Ingres' smooth, distanced, yet
seductive backview and brings it closer to the viewer, interrupts
the smooth surfaces with bumps of muscle and rolls of fat. In-

deed, one might say that the closeup view is characteristic of Courbet's realism, just as the distanced one is typical of Ingres or Cézanne. In both Courbet's version of *Stone Breakers* (1849; fig. 67) and John Currin's perverse reiteration of the theme in *The Gardeners* (2001; fig. 68), there is the same forceful rejection of classical pushes and pulls, a deliberate fragmentation of body parts. Antibeauty, or a beauty founded on awkwardness and disharmony, can range from the banal and everyday subject on one side to the horrific and grotesque on the other. In both Courbet's painting and the Currin work that references it, a social critique is implicit in the realist treatment of the body.

The power of Diane Arbus's trenchant realism lies not just in her unglamorous subjects but even more in her compositional predilections. In formal terms, her photographs deliberately ally themselves with the "bad composition" examples of "how to" photography manuals: figures are overwhelmed by trivial objects, visual attention is constantly being diverted by meaningless details. As such her work constitutes a critique of the compositional conventions of the good or "artistic" photo and, at the same time, implies a questioning of the social conventions governing such conventional representation.

Weegee's documentary photographs of crime scenes in New

York and the boroughs during the 1940s and 1950s represent an-
other important aspect of realism: "This is how it is"; "Get real";
"This is the way things really are." That peeling off of the smooth
surface of social good behavior to reveal the violence, ugliness,
and horror beneath is the earmark of so-called objective report-
age, and the project of a great deal of documentary photography.
As in Courbet's case, choices of body type, pose, and composition
give form to social critique.

There is a strong connection between synecdoche (the substi-

68 · John Currin,
The Gardeners, 2001

tution of a part for the whole) and the psychoanalytic notion of fetishism—entrancement by a specific body part, like a foot or leg, or what clothes it, a stocking or a shoe. Realism has its own grammar of signs, its tropes and figures. We can usefully trace the realist impulse in one of these visual tropes: the relation of the body to the cloth that covers it. It is no accident that, when it comes to the representation of the clothed body, realists favor the

wrinkle—the accidental crumpling or displacement of cloth (especially in the days before permanent press and synthetics) which suggests the unidealized, the everyday, the unbeautiful, dare one say the "natural" way cloth behaves. The wrinkle may be opposed to the elegant rationality of classical drapery folds—at once indicating the outward pressure of the body *against* the cloth and the opposing downward pull of gravity *on* the cloth in a harmonious and unifying sculptural gesture—or the overt artifice of the pleat, gridding the surface of the body with the script of fashion, of the moment (though of course that too might constitute a certain kind of realism). Indeed the trope of the wrinkle may be said to constitute a critique of the "untruthful" and deceptive beauty of the classical drapery fold. Courbet might well have commented, as he did about angels, that he could never paint a drapery fold, as he had never seen one. Indexicality—getting at the concrete, visible facts of what is out there—is essential to realist representation. Yet, in truly interesting, indeed great, realist work, a sensually enticing demonstration of the equal reality of the *means* of art must be involved, whether it be seductively minute brushstrokes or a passionate slathering, slashing impasto. It is no wonder that the dull, pedestrian surfaces of so much run-of-the-mill naturalist work, much less their banal harmonized compositions, must be rejected as realist in the sense I mean.

What is realism, then? It can be thought of in many ways, most helpfully as a term in a binary structure, announced or understood, opposing realism to some form of non- or antirealism, be it idealism, formalism, abstraction, expressionism, and so on. Or it can be positioned as part of a conceptual family in which some members are more purely realist than others, or envisioned as a spectrum of styles leading from realism to its Other, with many mutations between. In 1973 I unpacked, at great length, the social and formal implications of such a binary structure in a two-part article called "The Realist Criminal and the Abstract Law." And I began the article with a citation by André Breton: "What is really important is that the criminal is at the very heart of the law. It's obvious: the law could not exist without the criminal."[3]

As a historical phenomenon, Realism with a capital *R* dominated art and literature in the West for about three decades, from the mid-nineteenth century until the 1880s. But there were realisms before there was Realism. In its various guises and metamorphoses—naturalism, social realism, magic realism, Neue Sachlichkeit, certain aspects of surrealism, and the various New Realisms of the present—realism has survived, been revived, and been reinvented continually. Realism is, of course, a mode of artistic discourse, a style in the largest sense, not, as its enemies would have it, a "discovery" of preexisting objects "out there" or a

simple translation of a ready-made reality into art. Like other artists, realists must create a language of style appropriate to their enterprise; they may or may not reject previous nonrealistic or antirealist styles; often their work modifies or adapts them. Yet on the whole, realism implies a system of values involving close investigation of particulars, a taste for ordinary experience in a specific time, place, and social context, and an art language that vividly transmits a sense of concreteness. Realism is more than, and different from, willful virtuosity, or the passive reflexivity of the mirror image, however much these may appear as ingredients in realist works.

Whereas the nonrealist may work through distillation and exclusion, the realist mode implies enrichment and inclusion. Realism has always been criticized by its adversaries for its lack of selectivity, its inability to distill from the random plenitude of experience the generalized harmony of plastic relations, as though this were a flaw rather than the whole point of realist strategy. The "irrelevant" distractions characteristic of realist styles are not naive mistakes in judgment but are at the heart of metonymic imagery, the guarantors of realist veracity. Irrelevance is indeed a prime feature of the intractable *there-ness* of things as they are and as we experience them.[4]

In realist works, details often consist of substituting the part for the whole, not because they have any "meaningful" relation to the larger whole—on the contrary—but merely because they are a part of it in the realm of things as they are. As Roman Jakobson has pointed out in a brief but suggestive article, "The Metaphoric and Metonymic Poles," "Following the path of contiguous relationships, the realistic author metonymically digresses from the plot to the atmosphere and from the characters to the setting in space and time. He is fond of synecdochic details. In the scene of Anna Karenina's suicide, Tolstoi's artistic attention is focused on the heroine's handbag."[5] The deliberate attention lavished on P. J. Proudhon's shoes in Courbet's well-known portrait of the philosopher, the painstakingly delineated double- or triple-cast shadows in the Master of Flemalle's *Mérode Altarpiece,* the minutely depicted rosewood grain of the furniture in William Holman Hunt's *The Awakening Conscience,* the individually drawn hairs of beard stubble in Jan van Eyck's *Man in a Red Turban,* or in Chuck Close's portraits based on photos, different as they may be, are all at the very heart of the realist enterprise. They are far from being, as antirealist criticism would have it, a misreading of aesthetic priorities.

In terms of my own history as an art historian, my interest in

realism was as much inspired by politics as by aesthetics or taste, or rather I might say that in my case, during the McCarthy era of American history the two were inseparable. I first approached Courbet in the context of a paper on the impact of the 1848 Revolution on art: I wanted to know, rather naively at first, how political and social commitment could have an effect on art—not just on the subject matter or iconography but on the formal language as well: in short, how politics could shape a style. In studying Courbet, I found out. Courbet looked to popular imagery, the art of the people, for his inspiration. For example, he took the composition for his painting *The Meeting* from a popular image of the Wandering Jew meeting two burghers of the town, an image published by his friend and supporter the critic Jules Champfleury in his book on the *image d'Epinal.*

Courbet's strict interpretation of realism and the startling concreteness and contemporaneity of his image of, say, rural labor is apparent if one compares his *Stone Breakers* with a labor scene by his contemporary Jean-François Millet, who might also be considered a realist of a less rigorous sort.[6] Both artists were obviously concerned to create a valid image of hard times in the country. Yet if one compares Courbet's painting with *The Gleaners* (1857), it immediately becomes apparent why Millet's work

69 · Jean-François Millet,
The Gleaners, 1857

was much more widely and quickly accepted than Courbet's. Millet's composition implies something beyond the fact of specific nineteenth-century peasants performing a routine task—an extremely low one even by farm-labor standards—and conveys a comforting suggestion of the timeless, quasi-religious validity and moral beauty of labor in general.

These implications and suggestions are conveyed by the formal

configuration of the painting: the grandeur of the panorama that stretches out in the background; the reiteration of the bent forms of the three women, themselves emblems of human effort and backbreaking labor; the hazy indications of productive human activity near the horizon—all these carry the spectator beyond the realm of immediate experience to that of transcendent value. The figures themselves are idealized, generalized, and, in comparison to Courbet's, traditional in their poses, articulation, and dress. It is obvious that Millet steeped himself in Virgil and the Bible: there are intimations, in *The Gleaners,* of classical antiquity as well as suggestions of Ruth and Naomi in the fields of Boaz.

Courbet's *Stone Breakers,* on the other hand, despite its monumental scale, implies nothing in formal terms beyond the mere fact of the physical presence of the two workers and their existence as painted elements on the canvas. There are no reassuring reiterations of meaning in the richly detailed landscape, which, because of its very substantiality and lack of aerial perspective, seems to rise up ponderously behind the figures rather than fade away poetically into some infinite distance behind them. This sense of the concrete matter-of-fact contemporaneity of each of the figures is increased by their stiffness, awkwardness, and lack of articulation, which has to do with Courbet's meticulous nota-

tion of the specific details of their dress, and, at the same time, with the artist's rejection of traditional ways of generalizing and idealizing the human body. In fact, he hides major points of articulation and transition.

Just as his compositions are not organized according to traditional principles, so Courbet's figures (often pilloried by contemporary caricaturists as stuffed dolls, scarecrows, or toys on wheels) are not articulated according to conventional precepts. Unlike Millet's, they lack the time-honored poses, the generalized contours, the suave transitions from part to part of traditional figure styles. It is no longer a question, in Courbet's *Stone Breakers,* of figures expressing some idea or emotion about manual labor, but figures that are themselves formal equivalents of certain qualities considered inherent in manual laborers: awkwardness, stiffness, taciturnity, for example. Much the same can be sensed in the early realist style of Van Gogh, who, though more directly influenced by the humanitarian impulse of Millet, exhibits a like concern to embody the pathos and hardship of manual labor in what Meyer Schapiro termed an earnest, crude, effortful drawing style.[7]

It is not on the work of the "classical" Realists of the nineteenth century upon which I want to focus but rather the more contro-

versial ones of the twentieth and twenty-first centuries. I am now going to turn to specific artists—case studies in an examination of more recent or contemporary representations of the realist body.

I came upon the work of Philip Pearlstein in the context of a show I was organizing at Vassar in 1968 called "Realism Now." I was intrigued by his bold rejection of abstraction and idealization. Like all stylistic innovations, Pearlstein's canvases constitute a challenge to the status quo, forcing a confrontation with the reigning ideology of reductionism and flatness. Since this was not done with tongue-in-cheek coyness, like Pop, or with funky Neodada destructiveness but quite seriously, Pearlstein's work demands a reappraisal of contemporary standards.

Cool, close-up, large-scale, scrupulously empirical, Pearlstein's paintings certainly do not look like traditional Realism; one would never confuse a Pearlstein nude with one by Courbet. One might say that reality itself, in the largest sense, changed in the twentieth century. Certainly, an artist's notion of his or her relation to reality was altered as other representational modes, especially photography and cinema, intervened between vision and imagery. But also, the artist's self-awareness of what he or she is doing was heightened over the course of the century. Perception, once

70 · Philip Pearlstein,
*Two Models on Kilim Rug
with Mirror,* 1983

an absolute, is, for the contemporary artist who bases his whole enterprise upon it, the most fluid, relative, and elusive of phenomena. "Il faut être de son temps," the moral imperative of nineteenth-century Realism, is, for the highly conscious realist of today, simply a statement of how it is to be an artist. One can *only* be of one's time; there are no alternatives for the painter, who, like Pearlstein, must rely on looking at things in the world for his art.

It is in his insistence on the probity of the artist, that moral dimension of honesty, chosen at the price of grace or chic, that Pearlstein comes closest to his nineteenth-century forebears.[8] While Pearlstein's nudes may not depend on any specific prototypes, they are very much in the realist mainstream, in which ugliness or at least nonbeauty is the correlative of honesty, the result of recording with deadpan awkwardness the *terra incognita* of visual discovery rather than the smoothed-over map of explored terrain. Equally realist is his insistence upon truth-telling at any price, his ruthless acceptance of things as they are, visually and metaphysically, as constituting *all* that there is for the artist. Anti-imaginative, antisociological, antisymbolic, antiexpressionist, Pearlstein is one of the most articulate contemporary spokesmen for the antirhetorical mystique at the heart of realism.

And, of course, a very American realist precedent for a figure

71 · Thomas Eakins,
*William Rush and His
Model*, 1907–1908

and portrait painter like Pearlstein, though in no sense a stylistic influence, is Thomas Eakins. With Eakins's work, a controversial issue that has recently haunted the discussion of realist styles is immediately foregrounded: the use of the optical device.[9] In the case of Eakins, there is no question that he employed photographs, took photographs himself (as did members of his circle), and actually projected magic lantern slides on the canvas for

some of his drawings. Yet I propose that the power and realist probity of his pictorial style is little affected by particular devices. When he painted the nude for his 1908 version of the sculptor William Rush and his model, it matters little if he used a photo or not. It is the pathos and vulnerability of a nonclassical, flawed, unprepossessing, and totally "datable" rather than "timeless" body that constitute the realist enterprise here (fig. 71).

In 1968 something unusual happened: I literally became a realist body, along with my husband, Richard Pommer. The painting was commissioned as a wedding portrait, and we are both wearing the clothes we were married in, very sixties, very hip: Dick, white linen trousers and a blue shirt; Linda, white dress with a bold blue geometric pattern. We are represented sitting in Philip Pearlstein's studio in Skowhegan, illuminated by the cold light of dentist's lamps, sweating in the heat of a Maine summer.[10]

The painting engages a long process of creation and an afterlife of experience. Temporality is necessarily involved, whether in the seemingly endless and discomforting—at times even agonizing— sitting for the portrait or, equally important, in living and aging with it after its completion. In the beginning we thought we looked old; but a time came when we overtook the painting and looked back on it as a record of a moment when we were in fact

quite young. There was never a time when we looked at it and said, "Ah yes, that's us, exactly."

All portraits are related to the history of portraiture as much as to the subjects they portray. In Pearlstein's wedding portrait, this relationship is conceived as a rejection of most aspects of the portrait tradition as constituted by such practitioners as Rembrandt, Sargent, and Degas, though there is something of Degas in the indifferent cropping. The accoutrements of social position and ·the probing of character or personal psychology are for the most part absent. In few previous portraits is the existential condition of simply sitting for the artist registered as overtly as it is here. It is not merely that depth and psychological profundity are avoided; they do not seem to have existed even as possibilities for representation. This is a painting of surfaces alone. It is as a construction of surfaces that the painting makes its most intense impression. In a certain sense, it might be thought of as the work of a willful and determined camera, although Pearlstein never uses one. The texture is complex and dryly perverse. At the bottom of the canvas, triple-cast shadows play out an intricate relationship with a vigor that the human figures, isolated in their torpor, cannot summon. The wrinkles in our clothes, the various slight protuberances and indentations of our flesh, incised by variations of

cold light and colder shade, the strange and previously unknown excessiveness of a shoe strap or an eye pouch—the *Unheimlichkeit* of a body you had thought you knew and was yours in a space you had taken for granted—are recorded with obsessive fidelity. All the painting's liveliness is in the details, the fragments. We, the sitters, are put to death, or at the very least into a state of suspended animation, for the sake of truth to the detailed surface.

The year 1968, more than a quarter of a century ago, was an important one in every way. It was a year of political and cultural revolution, a year when canons were obliterated, assumptions swept away. Flatness, abstraction, formalism, patriarchy, racism, cultural authority of every kind—all were called into question. The portrait, for me, was part of the end of the simple acceptance of what art was about and had to be. The next year, "Women's Liberation" made its dramatic entry, with a whole new set of revolutionary rejections and innovative projects, including the women's movement in art. The portrait, then, simply by being painted when it was painted, in the realist style in which it was painted, became a kind of talisman of change and new beginnings; realist critique as I defined it at the beginning of this talk, despite its apparent representation of stasis, is resonant with a certain mental

energy, poignant with the congealed memory of lost hopes and achieved desires.

Women artists have turned to realism since the nineteenth century, through force of circumstance if not through inclination. Cut off from access to the high realm of history painting, with its rigorous demands of anatomy and perspective, its idealized classical or religious subjects, its grand scale and its man-sized rewards of prestige and money, women turned to more accessible fields of endeavor: to portraits, still life, and genre painting, the depiction of the everyday, realism's chosen arena.

Like the realist novel—another area in which women have been permitted to exercise their talents since the nineteenth century—genre painting, and realist art generally, has been thought to afford a more direct reflection of the woman artist's specifically feminine concerns than abstract or idealized art, because of the accessibility of its language. Yet one must be as wary of reading "feminine" attitudes in, or into, realist works as into abstract paintings.

In the field of portraiture, women realists have been particularly active, both in the past and today. This hardly seems accidental: women have, after all, been encouraged, if not coerced, into making responsiveness to the moods, and attentiveness to

the character traits (and not always the most attractive ones), of others a lifetime's occupation. What would be more natural than that they should put their subtle talents as seismographic recorders of social position, as quivering reactors to the most minimal subsurface psychological tremors, to good use in their art? For the portrait is implicated to some degree at least—whether artist, sitter, or critic wishes to admit it or not—in "that terrible need for contact" to which Katherine Mansfield makes such poignant reference in the pages of her *Journal*. Unlike any other genre, the portrait demands the meeting of two subjectivities: if the artist watches and judges the sitter, the sitter is privileged, by the portrait relation, to watch and judge back. In no other case does *what* the artist is painting exist on the same plane of freedom and ontological equality as the artist herself or himself, and in no other case is the role of the artist as *mediator* rather than dictator or inventor so literally accentuated by the actual situation in which the art work comes into being. This is particularly true of the representations of relatives, friends, or kindred spirits—rather than commissions—and of course, of self-portrayal, characteristic of the best twentieth-century portraiture.[11]

Most prominent among the portraitists of our time, and working in a vein of what one might call incisive realism, is the late

73 · Alice Neel,
*The Family (John
Gruen, Jane Wilson
and Julia)*, 1970

Alice Neel. Far from being merely witty or clever—although to be so is itself no mean achievement—Neel's portraits form a consistent, serious, and innovative body of work. Progressively, over the years, she invented an idiosyncratic structure of line, color, and composition to body forth her vision of unmistakably contemporary character. Fifty years hence, looking back at the exposed thighs, the patent leather polyphony of the shoes, the world-weary individualism of the Gruen family (1970), or the casual yet somehow startling *rapprochement* of self-exposure and self-containment—of pose, color scheme, and personality—achieved in *David Bourdon and Gregory Battcock* (1971; fig. 74), we will be forced to admit, sighing, blushing, or wincing as the case may be, "So that's the way we were!" This was the realist body of our times.

Livid, bandaged, trussed, sewn, and scarred, visibly drooping yet willing himself to a ghastly modicum of decorum after his near assassination, Neel's *Andy Warhol* (1970; fig. 75) reminds one somehow of Van Gogh's intention, in painting the melancholy Dr. Gachet, to record "the heartbroken expression of our time." Yet it is not so much a question of derivativeness in any of Neel's work as it is simply a fact that few of her subjects have escaped the inroads of contemporary anxiety—often a peculiarly New York brand of it—each, of course, in his or her own particular fashion. Nobody is ever quite relaxed in a Neel portrait, no

74 · Alice Neel,
*David Bourdon and
Gregory Battcock*, 1971

75 · Alice Neel,
Andy Warhol, 1970

matter how suggestive of relaxation the pose: some quivering or crisping of the fingers, some devouring patch of shadow under the eyes or insidious wrinkle beneath the chin, a linear quirk, a strategic if unexpected foreshortening dooms each sitter-victim to premonitory alertness, as though in the face of impending menace.

This lurking uneasiness is not something Neel reads into her sitters; rather, it has to do with the peculiar phenomenology of the human situation. This is how Neel sees us, how we actually exist for her, and so it is there. Or rather at times she does not so much *see* it that way as record it—in the same way that Courbet once, without realizing what he was painting, is said to have recorded a distant heap of sticks by simply putting down what he saw until the paint strokes revealed themselves to be what they were. In 1973, when I was sitting for her, Neel said to me, genuinely puzzled, "You know, you don't *seem* so anxious, but that's how you come out." Of course, one might say that a person's exterior, if it is keenly enough explored and recorded with sufficient probity, will ultimately give up the protective strategies devised by the sitter for facing the world. Neel felt genuine regret, perhaps, that this was the case; nevertheless, since it was, to paint otherwise would have been merely flattering rather than truthful.

76 · Alice Neel,
Linda Nochlin and Daisy,
1973

The male nude portrait is the rather unusual genre favored not only by Neel but by another woman realist of our time, Sylvia Sleigh. Her work also raises the issues involved in a woman artist's representation of the naked male, until recently a rare situation except within the confines of the life class. Sleigh's male nudes are all portraits, and, so to speak, portraits all the way, down to the most idiosyncratic details of skin tone, configuration of genitalia, or body-hair pattern. Sleigh has stated that her interest in male fur and its infinite variety, while partly due to delight in its sheer decorative possibilities, was also determined by a reaction against the idealizing depilation of the nude body decreed by the academic training of her youth.

As did Manet in his *Olympia* or his *Déjeuner sur l'herbe*, Sleigh often relates her nudes to the Great Tradition, both as an assertion of continuity in scope and ambition and at the same time as a witty and ironic reminder of values that have been rejected, or in her case deliberately stood on their heads. Her reinterpretations of traditionally female nude group scenes permit her to carry to its ultimate pictorial fulfillment her responsiveness to the generic appeal of male sensuality while expressing each man's distinctive type of physical or psychological attractiveness.

In *The Turkish Bath* (1973), a large painting freely based on

77 · Sylvia Sleigh,
The Turkish Bath, 1973

prototypes by Delacroix and Ingres, the wonderful pink and blond tenderness of Lawrence Alloway's recumbent form is played against the piercing blue intelligence of his glance, and his horizontal image against the swarthy, svelte, romantically aquiline verticality of the adjacent figure of Paul Rosano. In the same fashion, the richly hair-patterned torso of the dreamily relaxed John Perrault is nicely paired off with the stiffer, more frontal glabrousness of Scott Burton kneeling beside him, and the delights of these contrasts themselves are set off by the richness and coloristic brilliance of the decorative patterns against or upon which they are set.

The ironies of her work, of course, reveal the reality of the gender situation. If we compare Sleigh's male harem scene with Ingres' *Turkish Bath,* we see that she has actually dignified her male sitters by stipulating through portrait heads and distinctive physiques that they are differentiable human beings. The faces of Ingres' women are as close to being bodies as they can possibly be without suffering a complete metamorphosis, like Magritte's body-head in *Rape;* they are as devoid of intelligence or energy as breasts or buttocks. This depersonalization is a prime strategy of what Susan Sontag has called the pornographic imagination—indeed, a token of its success in sexualizing all aspects of experience

78 · Jean-Auguste-
Dominique Ingres,
The Turkish Bath, 1862

and rejecting anything that might divert from this single-minded goal. Sleigh's wit is at once a weapon and a gesture of her humanity; instead of annihilating individuality, she envisions it as an essential component of erotic response. Instead of depersonalizing the heads of her sitters, she not only accepts their uniqueness but goes still further and intensifies the uniqueness of their bodies as well.

Today's young realist painters are pushing the boundaries of the category, at times to the brink of what may be thought of as realism itself. Perhaps we need a new or redefinition of the term for Postmodern realisms, like those of the British painter Jenny Saville. The immediate visual impact of her work is one of excess: gargantuan naked bodies, mostly female, hurtling away from us or exploding into our space; seductive yet somehow injured flesh extruded onto the picture plane with an uncanny combination of delicate brushwork and brutal slashing of pigment; a perspectival extravagance which at once bespeaks the realist objectivity of the photograph and the empathic angst of Expressionism. Saville's project includes the whole realist scale of possibility, from the gigantesque sublime to the most abject and grotesque.

It is helpful, in approaching her paintings, to think of Thomas Mann's *Doctor Faustus* and the idea, current in the last century, of

art as a kind of fatal spiritual illness, painterliness as a kind of disease of the pictorial, a symptom of some deep disturbance in the relation of paint to canvas. As a young student, Saville was impressed with the fact that women were equated with looked-atness, she confided at a recent lecture.[12] They were supposed to be petite and supportive. Saville's earlier nudes, based mainly on photographs of herself, are marked by their refusal to be what women nudes were supposed to be: instead of attracting, they overwhelm, in both scale and size, with their sheer apotropaic power. A text by the French feminist Luce Irigaray, written backward, is inscribed on the skin of the 5 × 7 foot *Propped* (1992; fig. 79). The painting was shown with a mirror the same size placed seven feet from the painting, which reversed the text and made it readable. The title suggests the female body as a prop, on display, overflowing its frame, not "fitting," either literally or figuratively.

Strategy consists of three panels. It is enormous as a painting, and so is the model within it. One thinks of the traditional three graces, but not for long. Here, as in so many of her early works, Saville is dealing with the feminist issue of fat. The photos from which she derived the poses were taken from a medical journal. Certainly, a strong sense of critique is involved in this imagery, although it is not specified as such—critique of the socially and

79 · Jenny Saville,
Propped, 1992

medically constructed body norms imposed and self-imposed on women.

The 9 × 7 foot painting *Plan* again uses language and text, this time drawn in part from an image in *Cosmopolitan* magazine of the markings for liposuction. These are called "target-in" areas, an organic map for getting rid of fat. In the process of research, Saville marked her own body and carved out target marks with a linoleum cutter. *Trace* also deals with inscriptions on the flesh, and the fact that the body is never really naked. Here, the inscription of the bra is at issue in an 11-foot-tall back view.

In *Hem,* a 10 × 7 foot image, the figure climbs upward from a huge pubis articulated with broken fur across mountains of belly and midriff, breasts, and finally to the relatively small but individuated head. It is a late twentieth-century Venus of Willendorf seen in ant's-eye perspective. Yet the impact of the gross flesh is deflected by evidence of the pure act of painting itself: the viscous white plane to the left, which extends across to lower belly and crawls up the left breast. For the quality of the white, Saville looked to Rembrandt's *Woman Bathing in a Stream* and to the work of Ryman and De Kooning for inspiration, mainly in the more distancing form of reproduction.

Fulcrum, measuring 16 feet in width, deploys across its surface

three naked figures, tied together with string like butcher's meat. Inspired by a book of horrific crime-scene photographs by a Los Angeles detective, the bodies, alive or dead, dreaming or waking, in the absence of any visual clues as to place or even space, occupy the entire canvas with their oddly weightless girth.[13]

Matrix (1999) involves a graphic crotch shot of a highly ambiguous nude body—in this case, not a photo-collaged construction but an actual transsexual, Del LaGrace Volcano, whose mustache, tattoo, and clipped hair consort oddly with a pair of pouting breasts and—foregrounded—a richly impastoed pudendum. The figure floats in that Postmodern realm of gender nirvana brilliantly theorized by Judith Butler as a zone of shifting sexual identities and the rejection of essential difference between male and female. In its aggressive antiessentialism, Saville's work is as much an intellectual project, a social construction of the body as it is a neo-Rubenesque orgy. In the truly ambiguous and hugely disturbing *Matrix,* even the brushwork, juicy as it is, comes across as somehow intellectualized—immensely self-conscious and self-revealing as it goes about its business of welding male to female, making a visual rhyme between problematic genitalia and the lusciously rose-impastoed bloody wound.

The conjunction of bloody wound and masculine head brings to mind Freud's classic theory of castration, at the same time that

80 · Jenny Saville,
Matrix, 1999

it recalls Luce Irigaray's radically antiphallocratic redefinition of
female sexuality in terms of multiple sites of pleasure, endless
jouissance. Yet *Matrix* should not be read as a pictorial sermon on
a theme by Irigaray, or by Butler for that matter, if to do so means
negating its visual impact.

Seeing *Matrix*, I found it hard not to take the work as a painting about the very possibility of painting at the end of the century. The exaggerated foreshortening, the slablike rosy impasto on the thigh that almost seems to leap off the canvas, but above all the securing of the surface by means of the gray horizontal place beneath the body and the elegant tattoo on the vertical arm that intersects with it—these are strategies to recall both the traditions of Modernism and the anxieties of Postmodern representation. At the same time, in the context of a long-term discussion of realism, they may be taken as a paradigm of where realism, as a perpetually self-renewing discourse, might be going in the future.

Saville's commitment to painting in the present tense lies partly in the fact that it is always mediated by the photograph. Saville herself has said that she dislikes painting from life and prefers photographic models. All of her monumental subjects are based on photographic precedent, but not in any simple way. She collects illustrations from pathology textbooks, full-color photographs of horrific burns, bruises, and injuries, as well as books of reproductions of the work of Velázquez, Sargent, and De Kooning. The beautiful, the grotesque, high art, pornography, pages from the website Transsexual Women's Resources, the imagery of pain and deformity and that of its substantive recupera-

tion in the brushwork of Titian or Rubens are commingled, scattered across her studio floor, piled helter-skelter on chairs and tables. All or any of these may serve as the specific site of her art-making, or as a source of inspiration for significant textural or coloristic invention.

The most complex of all Saville's recent works is the ambitious *Reflective Flesh* (2002–2003; fig. 81). Here, through the magic of mirrors and multiplying of photographic images, the artist has created a nude that is at once aggressively sexual and physical, yet at the same time unabashedly abstract. With its legs painfully splayed apart, the breasts and the gaping sex front and center, the head veiled in shadow, the great nude creates a powerful emotional and pictorial presence. Nowhere does the agon of paint as volumetric representation in space struggling against the temptation of paint as pure form on the surface—always an issue in Saville's work—play itself out more overtly. The multiple reflections both add to the sexual impact, yet at the same time fracture it, spread it out, splinter the initial sensual shock into multiple shards of visual experience.

One thinks of Cézanne's bathers or even Picasso's *Demoiselles* in the presence of this image, not pornography. Saville's brush dwells lovingly on the model's sex, created with subtly variegated

81 · Jenny Saville,
Reflective Flesh, 2002–2003

pigments: velvety red, deep wine, paler moss, rose color. One thinks of the inspiration provided by the colorful, detailed repertory of newly constructed female sex organs made available by the online Transsexual Women's Resources printouts in the artist's collection. This pubic area is framed by the pulled-out left leg, with its foreshortened, overlarge foot prominent in the foreground and the splayed thigh. The model's face and upper body are reflected in the mirror to the right, her head in profile in the mirror to the left. The multicolored thighs are stretched, forced apart to the point of pain. Saville herself posed for the preliminary photographs. "What model would do it?" she asked, half jokingly.

But the personal presence is meaningful, infusing this image with a power both emotional and political. As such, it constitutes a challenge, not just to the whole history of the nude in high art, not just to Picasso's cubist and post-cubist versions of the nude or Matisse's decorative distortions of the female body, but to the very way we think of the nude woman in a painting: almost inevitably as the object of delectation or desecration for a male subject, who is entitled to bend the pliant female model to his will. Saville turns the tables on this cherished scenario by assuming the role of both subject and object at once. It is *her* body, *her* will that is

at stake, her powerful constructive imagination that creates the physical intensity and the intellectual bravado of the piece. Looking at *Reflective Flesh,* one thinks of the long history of this subject, the female sex organ, presumably the first image to be inscribed on the walls of caves at the dawn of history, according to current art-historical mythology accounting for the origin of art, a theme reaching its apotheosis in Courbet's scandalous *Origin of the World,* a small canvas meant for private delectation, once modestly hidden behind a green baize cloth, now hanging brazenly for all to see on the walls of the Musée d'Orsay.

In *Reflective Flesh,* and in all her recent paintings, Saville moves into unexplored territory, armed with the unexpected. Out of the raw material of the burn books, the unbearable medical photos of damaged bodies horribly garlanded with tubes and wires, out of the candid snaps of murdered corpses and traumatized heads, Saville has constructed new oppositions between a refocused tradition of the body and untrammeled invention. Above all, she has recreated the realist body in the image of our own ominous and irrational times.

Finally, continuing in the more-or-less autobiographical vein of this chapter, and as a preview for my next one, I would like to end with a few thoughts about realism and old age. One might almost say that realism and old age were made for each other. The

82 · Gustave Courbet,
Origin of the World, 1866

trope of the wrinkle—along with the sag, a token of the ever in-
creasing pull of gravity on the human frame and flesh—seems
admirably suited to the realist eye for detail, realist rejection of
generalized beauty, realist attraction to ugliness and the woes the
flesh is heir to. Realism is made to trace our mortality, and does
so with considerable authority and relish.

But with a difference, of course. Despite Lucian Freud's token
obeisance to the humility of Van Gogh's boots, in his self-portrait
Painter Working, Reflection (1993; fig. 83) he seems literally to "re-
flect" the mythology constructed about him; heavy with Rem-

83 · Lucian Freud,
*Painter Working,
Reflection,* 1993

brandtian overtones, this is a portrait of the aging artist as the traditional old master. The imperious claims of the artistic ego have triumphed over the demands of the challenge faced by the realist painter—to transform the visible world into image on surface in an interesting and novel way. In his nude—no, naked—self-portrait, the aging painter reveals "himself" to his audience. His body is presented as softening, even decaying, but still powerful. Armed as he is with palette knife and penis, the pathos of his fading physical strength is allegorically deployed to contrast with his undiminished creative powers.

Alice Neel's self-portrait (1980) is far less confrontational, though it is startling (fig. 84). She sits, looking over her shoulder at what we presume is her reflection in a mirror. She too holds the tools of her trade. The brush tells us she is an artist, as does the rag and the resolutely deglamorizing eye-glasses. Old people need them to see, old artists especially, although they are hardly part of the traditional apparatus of the nude.

"More beautiful than a beautiful thing is the ruin of a beautiful thing," Rodin is said to have proclaimed apropos of *Ce qui fut la belle haulmiere*. Rubbish! Where the human form is concerned, at least. Neel's aging body droops, sags, and bulges; it is far from ideal, certainly not beautiful in the pathos-full way that Rem-

84 · Alice Neel,
Self-Portrait, 1980

brandt's old women are said to be beautiful. But there is nothing tragic about it; it is not meant to represent the ruin of a beautiful thing. What Neel is after in this portrait is what realists have always in their varying ways been after, and that is a certain notion of truth: unflinching, matter of fact, provocative. In a way, one might consider this nude self-portrait as a realist testament, a literal tribute to that naked truth, magic or critical or both, which has always been at the heart of the realist project.

More Beautiful
than a Beautiful Thing:
The Body, Old Age, Ruin,
and Death

\mathcal{A}T THE BASEL/MIAMI ART FAIR in December 2003, I came across one of the most horrific and yet seductive photos I have ever seen. I simply couldn't stop looking at it. Dead or alive, vertical or horizontal, a traumatic vision of sags, juts, and wrinkles, it was the body of a woman so old she had ceased to be not merely gendered—although traces of sexual difference remained—but even human. Yet the image was profoundly human, this ruined body bearing the signs of age, of experience, of decay—a human ruin. The metamorphosis was so complete one might think of a change in *substance*—from the youthful female body in Renoir's *Great Bathers* into something vegetable or mineral, a tree trunk or eroded cliff (fig. 85).

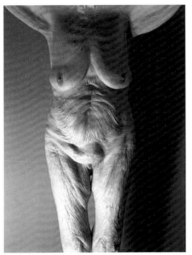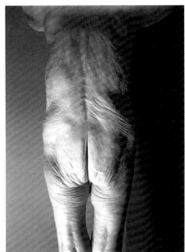

The tradition of representing the life of human beings as a
gradual ascent followed by inevitable decline is an old one, repre-
sented in its most primitive form by the *Degrés des Ages*—an *im-
age d'Epinal* popular in the eighteenth and nineteenth centuries
and no doubt before. The swift passage of youth and beauty,
followed by the miseries of old age, was a popular topos in early
modern song and poetry: "Gather ye rosebuds while ye may";
"Not long youth lasteth and old age blasteth"; or in France Ron-

sard's exemplary "Mignonne, allons voir si la rose," with its final lines warning of the swift passage of youth: "Gather, gather your youth: / Like that flower, old age will tarnish your beauty."

There are two ways we can understand Rodin's *Ce qui fut la belle heaulmière*. "She who was once the helmet-makers' beautiful wife" is the awkward translation, but the figure is also known as *The Old Courtesan, The Old Woman, Winter,* and *Dried up Springs* (fig. 86). The specific reference of the title is to François Villon's famous ballad, "Testament: Les regrets de la belle heaulmière," whether or not he created the statue of an old woman first and then found an apt reference in the work of the fifteenth-century poet of the people. Opposing views of his subject are attributed to Rodin. To one critic, Ludwig Hevesi, he reportedly declared, when asked about the genesis of such an unlikely subject, "Oh, I just happened to have such an old woman [82 is the age cited] to hand and the form intrigued me." Yet, he is also credited as the author of the phrase "More beautiful than a beautiful thing is the ruin of a beautiful thing," and at another time pointed to it in order to stress the transformative power of art, saying, "What is commonly called ugliness in nature can in art become full of beauty."

Yet it is the destruction of beauty by time that is the real point

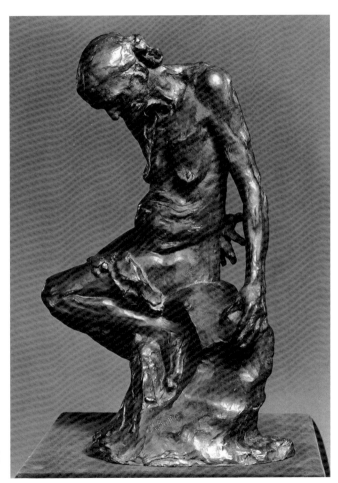

86 · Auguste Rodin,
Old Courtesan, 1887

MORE BEAUTIFUL THAN A BEAUTIFUL THING

of the topos, in both Rodin and his *quondam* source, Villon. As Camille Mauclair put it: "Here was the whole drama of the body's ruin, drawn from Villon's poem." And indeed, there are striking parallels. Rodin, whether he began with the verse or not, uses its features: breasts that sag, hands that curl, shoulders that hunch, thighs "shriveled like sausages." The fear and anger at the ruin of beauty by age is not an invention of modern plastic surgeons or the beauty industry—it has been there for a long time. Rodin is simply one of many who have represented the theme. Is he trying to present a different kind of beauty, a spiritual or transcendent beauty that takes over when the body beautiful itself fails? Is *Ce qui fut la belle heaulmière,* the representation of a ruin, in fact more beautiful than one of Rodin's more youthful nude bodies? I will leave the question open for the moment. Certainly, it conveys a somewhat different attitude to the aged woman's body than Francés's graphic photo, but how different?

Cézanne, in his last years, represented an old subject very differently. Of course, the old person in question happens to be a man rather than a woman, the figure is clothed rather than nude, and the question of what is lost in old age turns more on power or potency than on sexual attraction and beauty. As a representation, it is far less dramatic in its emphasis on the specific features

of the ruined body than either the photograph or the sculpture. And yet the depredations of age as well as its dignity are clearly signified by this image, in which sexuality plays a larger role than one might at first suspect.

The figure in the *Seated Peasant* is large, expansive at the bottom, narrow in the shoulders, and has a decidedly small head; indeed, paradoxically, in terms of portrait practice, the lower part of his body is in many ways more interesting, more expressive, even, than the head and upper part. (This diminution toward the top is, of course, what happens in a photograph taken too close: a dramatic enlargement of what is near the lens, a dramatic reduction of what is farther away—the top of the body, shoulders, head. It is inconceivable that an artist as interested in perception as Cézanne would not be aware of the possibilities offered by photography—not just as an *aide mémoire* or source, as the photographed male nude was for his *Bather* (fig. 44), but as a compositional stimulus as well. The strange lozenge patterning of the wallpaper sets the figure forth alarmingly, like a canopy of blood drops. (Cézanne is never thought of as a "decorative" artist, like the Nabis or Van Gogh, but only Van Gogh ever used wallpaper patterning to such effect, so often and with such variation as a compositional and expressive strategy.) This contrast between the

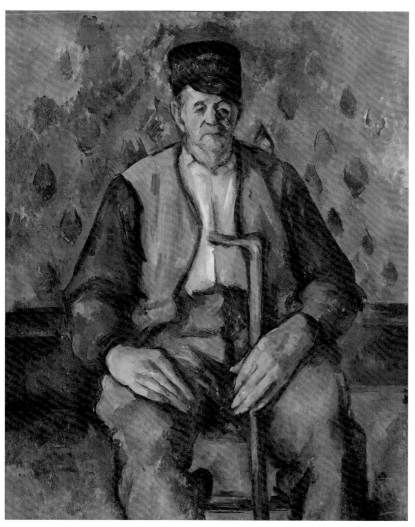

87 · Paul Cézanne,
Seated Peasant, c. 1900–1904

sheer energy of articulation of the peasant's expansive bottom half, the sags and wrinkles about the crotch area with their implications of impotence—literally, sagging balls—is completely missing in the detailed preparatory drawing. There, both the sitter's right hand and all the interior detail of the lower half of the body are oddly omitted: the paper in this area is blank. The man's failed potency is actually occluded and thereby becomes a focal point of the composition in its very white-paper absence.

These contrasting versions of the image remind us that the bathers are not the only sites of Cézanne's sexual travail, early and late. Sexuality is imbricated in the very structure of many of the portraits, male and female, as well. In the painted version of the *Seated Peasant,* the hands and lower part of the body are emphasized—even coloristically, with the V-shaped patch of the trousers picking up the red patterning of the wallpaper, whereas the hands and the crotch are almost invisible in the drawing, which also lacks the forceful diminution of scale characteristic of the finished work. Empathy with the phenomenology of old age is the subtext of the painting, and the old age in question is shared by both the painter and the sitter. How interesting it is, in view of the *Seated Peasant*'s stiff, almost primitively frontal, open-legged, vulnerable yet majestic pose—the pose of kings and rulers—to

Class is built into these late peasant or servant sitters, in their poses, their costumes, their physicality, their awkwardness. The idea that the notation of class or character is foreign to Cézanne's work, that his painting is too transcendent, universal, and aesthetic to convey such vulgar specifics, is totally mistaken: the representation of class is simply inseparable from Cézanne's phenomenology of appearances. It is at one with his construction of pose, bodily type, dress, and expression, not something added in by narrative or a revealing touch of daily life.

In a certain number of these latest portraits, there is a reduction of color to a contrast of light and shade, a focus on tense hands and concentrated faces. In the rare instances when Cézanne tries for traditional spirituality in the late works, he inevitably fails: the much admired *An Old Woman with a Rosary (Vieille au Chapelet)* has always made me uneasy with its faux Rembrandtian *clair-obscur* and uncharacteristic air of humility (fig. 88). Compare the almost contemporary *Woman with a Coffeepot (Dame à la Cafetière;* fig. 89), ramrod straight and no nonsense—and no rosary, either, just a good, plain coffeepot, cup, and spoon as assertively vertical as the sitter herself, the effect of rigidity subtly softened by the delicate floral patterning of the slice of wallpaper to the left.

88 · Paul Cézanne,
Old Woman with Rosary,
1895–1896

An important source of old age representations is artists' por-
traits of their parents. But this is as far from objective reportage as
possible. The enormous ambivalence of children with respect to
their parents—sons toward their fathers in particular—shapes
the image as much as the fact of old age per se. In a portrait of his

89 · Paul Cézanne,
*Woman with a
Coffeepot*, c. 1895

90 · Paul Cézanne,
The Painter's Father, Louis-
Auguste Cézanne, c. 1862

MORE BEAUTIFUL THAN A BEAUTIFUL THING

91 · Paul Cézanne,
The Artist's Father, c. 1866

father painted by Cézanne c. 1862, when his father was about 63, the massive body of the master of the house seems too weighty and towering for the frail legs of the chair that must support him, set at an abrupt angle against the brilliant red-tiled floor (fig. 90). The thickly painted figure is harshly segmented, as if the young artist can only with effort bear to put together all the pieces of his domineering father, who at this point opposed his career as an artist. The bulging thighs, the swelling upper arms, the rigidly clenched jaws, the muscular neck function as so many crude visual indicators of Cézanne *père*'s phallic strength, as he glares down at his newspaper with more than concentrated attention. One can almost see the child's vision of his elderly father as an ogre, whose possibly malevolent power is kept in check by the well-defined limits of the pictorial space that encloses his form.

In a portrait painted about four years later, it seems that the excessive charge has defused; his elderly father becomes the topic of a more unified, formally harmonious composition: he is not an ogre but simply an old man reading his newspaper within an organized domestic setting that includes a back plane established by Cézanne's own still life (fig. 91).

Degas paints his father as half of a masculine binary, contrasting his frail, passive old age with the virile, active maturity fig-

92 · Edgar Degas,
*Lorenzo Pagans, Spanish
Tenor, and Auguste Degas,
Father of the Artist,*
c. 1869–1872

ured by their friend, the singer and guitarist Lorenzo Pagans. The upright posture and active gesture of the musician is further strengthened by the way the delicate, subtle, listening head of the old man is set off by the square halo of white sheet music behind his white head, a space of introjection, listening, inwardness.

93 · Mary Cassatt,
Reading Le Figaro,
1877–1878

MORE BEAUTIFUL THAN A BEAUTIFUL THING

But of course there are very different ways of representing the elderly parent. Age is not a monolithic quality, and the old woman, despite the clichés of her visible presence, is investigated with great sympathy—and objectivity—by Mary Cassatt in a portrait of her mother of 1877–1878. Despite the fact that this portrait shares a certain formal emphasis with Whistler's famous painting of his mother of 1871 (fig. 94), and despite the fact that, from a coloristic point of view, Cassatt's painting, playing on a subtle scale of whites tinged with gray, could, like another famous painting by Whistler, also be called *A Symphony in White,* her mother is represented not staring blankly into space, in disembodied profile, an object within a world of objects, but rather in solid three-quarter view. And she is represented reading with great concentration, and not some fluffy novel but the rather politically oriented and literary *Le Figaro,* its title prominent if upside down in the foreground.

In her classic text *Motherhood according to Bellini,* the French theorist Julia Kristeva meditates on the Virgin's body, its ineffability, the way it ultimately dissolves into pure radiance. In various writings, she and other psychoanalytically inclined French feminists stress the maternal body as the site of the prerational, the incoherent, and the inchoate. Cassatt's portrait inscribes a very dif-

94 · James Abbott McNeill Whistler, *The Artist's Mother,* 1871

ferent position vis-à-vis the maternal figure—in its old age, to be sure, and without the child. For this is a portrait-homage not to the maternal body but to the maternal *mind.* Put another way, one might say that, finally, we have a loving but dispassionate rep-

resentation of the mother not as nurturer but rather as logos. It doesn't really matter whether the real Mrs. Cassatt was an intellectual or not—for all we know, she may have been absorbed in the racing news—it is the power of the representation that counts. Instead of the dazzling, disintegrative, ineffable colorism with which Kristeva inscribes the maternal body according to Bellini, Cassatt reduces the palette of the maternal image to sober black and white—or its intermediate, gray—the colors of the printed word itself.

Even in a portrait painted when her mother was sick and visibly older, Cassatt creates an image of power. She frames and sets off the head, gives her body a certain amplitude—and places her in the traditional *Thinker* pose (fig. 95). This is a portrait which, perhaps, connects the old mother portrait not with the sentimental tradition of frail spirituality but with the worldly wisdom that comes through experience, a power grounded in this world rather than the next.

And yet I would insist that the quest for a positive image of old age is as futile as that for a positive image of women—futile because it reduces and essentializes the myriad ways old age can be and has been represented. Positive for whom, at what age, and for what reason? Simone de Beauvoir, in what is still the most bril-

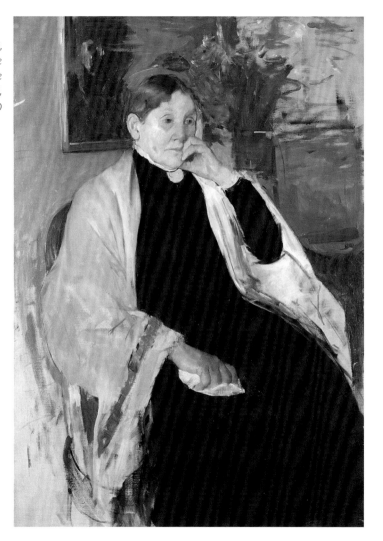

95 · Mary Cassatt, *Mrs. Robert S. Cassatt, the Artist's Mother (Katherine Kelso Johnston Cassatt),* c. 1889

liant and thorough-going account of age and aging that I know—
The Coming of Age, first published in 1970 under the blunt ti-
tle *La Vieillesse*—divides her study into two major sections: the
first, old age seen from without, dealing with old age and bi-
ology, the ethnological data, old age historically, and old age in
contemporary society. The second part, called "The Being-in-the-
World," takes on the subjective experience of old age, the discov-
ery and assumption of old age: the body's experience, the con-
tradictions each subject experiences between her consciousness of
herself and her unique identity, which may remain stable, and the
world's vision of her as someone old, useless, or at best "a won-
derful old woman"—a sexless, helpless, ridiculous old creature
defined categorically by her curved back, her white hair, and her
wrinkles.

Which, for example, would we denominate a "positive" view of
old womanhood: a remarkable photo from a remarkable book,
Wisconsin Death Trip, one of the myriad glass plates left over in
the office of a defunct rural newspaper in the late nineteenth cen-
tury (fig. 96), or a photojournalist's image of Liz Taylor at an
AIDS benefit in Cannes in 2002 (fig. 97)? It is possible that the
two women are approximately the same age—Liz Taylor was over
seventy, an old woman, when her photo was taken—but the

96 · *Wisconsin Death Trip, Old Woman,* c. 1893

anonymous old woman did not have the surgical or cosmetic advantages of Ms. Taylor, not to speak of her vast amounts of money and spectacular jewelry and wardrobe. From the moral/ ethical/aesthetic/historical point of view, we might well say that the nineteenth-century portrait is more "positive." The woman's backbone is ramrod straight, her expression unrelenting, her wrinkles on display, incising years of hard work and experience

97 · Photograph of Elizabeth
Taylor at 72, 2002

on her bony visage, her eyes hooded, her teeth honestly absent. It
is hard, from the outside, for intellectuals, aesthetes, and academ-
ics, at any rate, not to find this memorably relentless, honest im-
age the more "positive." But think of the issue from the inside:
would any woman you know really want to see herself in the
guise of that final terrifying, sexless mask? At least Elizabeth Tay-
lor, with a lot of help from her friends and employees, retains

some vestige of sexual allure, some scintilla of her famous beauty, some of the juice of desire no matter how vulgar and phony its expression, some ray of hope however misplaced.

I must admit that the older I get and the more difficult the encounter with the mirror becomes each morning—Who is that old stranger? What has become of Me, the real me?—the more I sympathize with the Liz Taylor images of this world, though I wouldn't choose to look like her any more than the woman from Wisconsin. But who wouldn't jump into the fountain of youth, if they could, a fountain that has existed one way or another as a Utopian dream from time immemorial? There is something particularly off-putting about the historic image of the good or worthy old woman, inevitably cast as unattractive or a mite smug, certainly lacking in come-hither, which is the very sign of her worthiness?

Given the drastic division between external and internal attitudes toward old age, some contemporary women artists and filmmakers have taken over another feminist topos, that of masquerade in relation to aging. If, as Joan Rivière long ago asserted, femininity is itself a masquerade, then what about considering old age a masquerade of sorts as well—but a masquerade with drastic social and psychic consequences? Such a project is embodied in the filmic work of the Czech artist Milena Dopitová, *Sixty-*

something. Stills from this project show not the socially sanctioned cosmetic rejuvenation of an old woman but rather the transformation of two individual younger women (the artist and her twin sister) into the undifferentiated entity "old woman." In the words of the catalogue essay, "On the one hand, what we encounter here is a taboo theme, at its core the deconstruction of the routine of 'rejuvenation' . . . On the other hand, the work is not just a critique on institutions. It is as much a truly intimate reflection on the artist's own life, a life closely linked, in a way that no closer relation could be imagined, with another person, that of her twin." What is amazing about the figures in the video is that it is only after the twins have adopted the masquerade of old age that their individual uniqueness fades, and their clothing, features, expressions, and posture assume the socially imposed generic character of "old woman."

Having surveyed the issues of old age and ruin, I would like to turn to the imagery of death, specifically to death as it is figured in the work of one artist, Edouard Manet. In a sense, Manet's work will represent that secularization and reduction this theme suffered in the art of the nineteenth century.

Manet's *Funeral,* a work of about 1870 (or perhaps even a bit earlier, if we believe, as some do, that the painting was inspired by the death of Baudelaire in 1867), creates an image of death that is

almost totally devoid of traditional transcendent implications.[2] The artist's sense of the occasion is defined simply by locality and time of year. The place is Paris, viewed from the specific vantage point of the Montagne Sainte-Geneviève in the neighborhood of the rue Monge, further localized by the cupola of the observatory and the church of the Val-de-Grâce to the left, the Pantheon, the belfry of Saint-Etienne-du-Mont, and the tower of Clovis to the right (fig. 98). The time is a gusty day of overcast clouds, probably before the fall of the Second Empire, to judge by the presence of the grenadier of the Imperial Guard in the modest funeral cortège. While the imagery is ultimately controlled by truth to ordinary, perceived fact, Manet was obviously more interested in the appearance of the cityscape panorama as a whole than in the funeral—the fact of death—per se.

Now precisely the same comment might be made of Poussin's *Landscape with the Burial of Phocion* (fig. 99). One might even suspect that this composition was in the back of Manet's mind when he started his unfinished *Funeral,* substituting observed, contemporary Paris for imaginatively reconstructed Athens and a shabby, shambling nineteenth-century procession for that of the stoical hero of antiquity. Despite the small scale of the figures in Poussin's painting, the importance of man and his human sig-

nificance looms large. Poussin's basic aim in the painting was to express a human idea through landscape. Whether it be, in this particular instance, the didactic-political and moral one of Plutarch and Valerius Maximus or simply the more general one of an orderly, finite, rationally comprehensible nature in which the specific story of Phocion exists as a single element is unimportant in this connection.

Poussin, without ever renouncing the essential qualities of pictorial vision, has masterfully integrated the notions of heroic death, stoical sacrifice, and an orderly, meaningfully organized universe into a unified visual image; the death of Phocion is the central issue of the canvas, both literally and figuratively, even if it does not dominate the composition. Latent significance controls the entire painting through the organization of space and time, leading us from the cortège and landscape through antique Athens, which had condemned Phocion to death, then into the distance where we are transported to the metaphorical apotheosis of the dead hero: the erect, isolated tower at the right, its triumphantly soaring verticality the very redemption of the passive, shapeless horizontality of the dead martyr himself; and then finally, upward to the sky and the clouds, white, horizontal, and relatively formless, like the body of Phocion, and like him, mutable, but unlike him,

98 · Edouard Manet,
Funeral, c. 1870

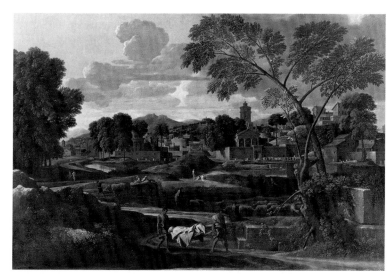

99 · Nicolas Poussin,
*Landscape with the
Burial of Phocion*, 1648

freed from all physical weight and density, free-floating, beyond the bounds of earthly necessity. This complex interrelation of natural, architectural, and human orders within a clearly articulated, finite, three-dimensional space is all determined by the over-reaching view of the significance of Phocion's death, and of death in general within an ordered and meaningful universe.

It is precisely this over-reaching significance that Manet has cast out of his *Funeral*. A sense of casual nonsignificance controls

Manet's pictorial structure, composed as it is of lightly brushed, discrete entities—formless figures, shapeless clouds, scrubby trees —scattered across the surface of the canvas. Coherence arises from the conjunction of immediate perception and swift notation: at no point does one element give pictorial or conceptual reinforcement to another. On the contrary, the dome of the Pantheon falls off axis with the hearse, and the most striking figure, the red-and-blue-clad grenadier at the very end of the procession, is on axis with nothing and has no particular reason for being so prominent, apart from the fact that he was there and was wearing a colorful uniform. The space in which the scene takes place is neither finite and measured nor infinite and boundless: it is a contingent space, both extensive and flat at the same time, the result of certain conjunctions on the picture surface. It is above all a shallow space: one cannot progress through it or measure it off, or see it as an ample, coherent stage for the presentation of significant action and meaning, as one could in Poussin's painting. To be so resolute in destroying traditional order—and so successful—implies a consistent if not totally conscious viewpoint on the part of the artist.

What is true about Manet's representation of death in a multifigure composition is true of his single figures, like the memora-

ble *Dead Toreador,* which can be characterized by an even more literal isolation of the fact of death from a context of transcendent significance or value (fig. 100). It is a work that was quite literally severed even from its own pictorial context, a larger composition laconically entitled *Episode in the Bullfight* by the artist himself. Yet the dead toreador exists most effectively as an image in its own right, seeming to require no more amplification or justification than does Manet's painting of a dead salmon of the same year (fig. 101). Indeed, the French term for still life, *nature morte,* would seem to do just as well for the man as for the fish. In either case, death is treated simply as a visual fact, the dead man being concretely defined by his costume and a discreet patch of blood beneath his shoulder, as is the salmon by his scales, his lemon, and his parsley.

Even in a more casual, off-handed, down-to-earth death scene of the later seventies, *The Suicide,* Manet spurns the usual dignity—or mock-dignity—offered the viewer confronted by a foreshortened view of the dead figure (fig. 102). In its casual pose and air of immediacy—it's as though we have just opened the door and come upon the poor fellow at the very instant of death, sprawled on his iron bedstead in an ordinary bedroom, the gun still clutched in his limp right hand, his legs in that ungainly,

100 · Edouard Manet,
The Dead Toreador,
1864

sprawling foreshortened position characteristic of the realist corpse—it shares something with the cool, if much bloodier, reportage of an image like those in the detective's scrapbook *Los Angeles Death Scenes*. Indeed, the subject may depend on a contemporary *fait divers* culled from a daily newspaper. Once more, Manet's painting of death posits the value of immediacy, truthfulness, and directness. If any emotion arises from the depiction, it comes from the juxtaposition of the casual pose, the free, spontaneous, and open handling of the matière—the drops of blood sparkle like jewels of pure pigment on the surface of the canvas—and the inherent darkness and pathos of the situation depicted so apparently casually and directly, even callously.

101 · Edouard Manet,
Fish (Still-Life), 1864

Indeed, it seems to me that Manet displaces some of the emotional empathy and pathos he so deliberately withdraws from his representations of human death onto the realm of dead things, the objects—flowers, fruit, vegetables, fish, or rabbit—of the *nature morte*. The shadow of death, even at times the specter of violence, hangs over many of Manet's innocent still lifes, recalling

102 · Edouard Manet,
The Suicide, 1877–1879

the more explicit death imagery of *The Rabbit* and its floral equivalent, *A Stem of Peonies and Pruning Shears* (figs. 104 and 105), both of 1864. Of course, there is a tradition of game painting, which Manet doubtless drew upon, offered by the work of Desportes, Oudry, and Chardin in the eighteenth century. And within my own memory butchers in Paris hung dead, gutted hares and pigs' heads decorated with paper flowers in their shop windows. Still, there is something sad and touching—funereal, if I may say so—in Manet's deployment of the rabbit's appealing little head, the crossed paws, and the fluffy belly in relatively close-up view, a darkness of view even more pronounced in *The Hare,* a decorative panel of 1881, where the body hangs rigidly by its feet from a nail on the door.

In the end, the gap between the cut branch of peonies—splayed blossoms down against the wall facing the sharp blades of the open shears—and the dead rabbit hanging from its cruel hook is not a great one. In both, a sense of mortality is evoked, despite the fact that one subject is merely floral. Manet never made such literal *nature mortes* as Géricault, with his still lifes of heads and limbs, nor did he resort to the more obvious trope of the Vanitas, as did the Dutch and Cézanne in some of his late still lifes.

103 · Edouard Manet,
The Rabbit, 1864

Nevertheless, *The Dead Toreador* is no more pathetic, no more
—in fact, less—replete with poignant significance than the white
blossom, with its marginalized but menacing flower cutter in *A
Stem of Peonies*. The evocative subtlety of the imagery here is ex-
traordinary: the blossoms are dead or dying, their petals alter-

104 · Edouard Manet,
*A Stem of Peonies
and Pruning Shears*,
1864

nately resplendent and drooping. Little unevennesses at the edges
of the petals mark their individuality, creamy curls of white paint
tinged with rose or pale yellow at times, framed against the leath-
ery green of the leaves. Shape is created and destroyed—melted—
by the same brushstrokes that conjure up with vital immediacy
the death throes of a flower.

So, paradoxically, we may find these murdered flowers, hares, or glassy-eyed fish more shocking, more redolent of untimely death than the human figures Manet painted, in part because we do not expect to find such references to brutality or death in the still-life genre. Despite Manet's celebrated deadpan coolness in the face of human mortality, a whiff of decay mingles with the roses in his late work, an impalpable shadow darkens the golden glow of the lemons and peaches with the promise of still greater and more final darkness to come.

In a way it seems entirely appropriate that Manet should suggest, though never insist upon, the most profound, indeed unutterable, notions of life and death in the seemingly superficial, everyday, domestic—dare I say "feminine"—realm of the still life.

Epilogue

\mathcal{I}N CLOSING, I would like to turn briefly from mortality to autobiography. In my case, the two are not entirely disconnected. When I first thought of ending with the subject of old age, ruin, and death, the memory that immediately came to mind was that of Panofsky lecturing on the late Titian. It must have been one of the Wrightsman Lectures given at the Metropolitan Museum shortly before the scholar's death in 1968 at the age of 76.[1] I was interested in late styles at the time, partly because of the brouhaha over the late work of Monet, suddenly redeemed and brought back from the outer darkness of Katia Granoff's Paris basement (the paintings were supposedly available by the yard), in the wake of the triumph of Abstract Expressionism, which made large, blurry, all-over brushwork newly fashionable. Being myself a champion of the early styles of the nineteenth century—

the early Monet, for example, with its risky air of visual discovery and crisp invention, as against "that oceanic feeling," that art of blurred vision and generalized impasto redeemed by the late Monet—I was fascinated to hear what Panofsky, always a brilliant lecturer, had to say about the late Titian.

Indeed, I had intended to deal with the question of late styles in Chapter 6. But when I thought about it, I realized that it was not the issue of the late Titian that drew me back to those last lectures of Panofsky's, but the "late" Panofsky himself. For in those moving and eloquent talks about late works and last things, Panofsky rehearsed before an audience his own old age, the advent of his own mortality. His lecture was an art-historical valediction. Panofsky looked so bent and frail and quavering, standing at the podium, so different from the way he had looked and sounded only fifteen years before, when—solid, sprightly, and jovial—he had participated in a Renaissance festival at Vassar. The high point of that event was Pan, in a white toga, being crowned with laurels, surrounded by a bevy of similarly draped Vassar girls, as I played my recorder with the Renaissance Consort in the background. The moving and majestic Titian paintings projected on the screen at the Metropolitan Museum became mere background for the equally moving late style of Erwin Panofsky.

Thinking about Panofsky took me back to my whole intellectual past, those lost mothers and fathers, like Agnes Claflin, head of the Art Department at Vassar, where I first learned about the discipline, then my art-historical ancestors at the Institute of Fine Arts, who taught me as a graduate student, shaping the way I think about art and history, giving me a firm sense of tradition to hold on to or rebel against, as the case might be. Walter Friedlaender was already part of history—in his eighties—when I studied with him, and his past in prewar Germany interested me so much that I wrote a novella about him called "The Age of Salzburger." The manuscript is still lying at the bottom of a filing cabinet. Karl Lehmann, in a memorable course in Late Antique art, demonstrated to me the interconnection of art, power, and politics within the Roman Empire, preparing me for my later work on French colonialism and nineteenth-century Orientalism. Meyer Schapiro, although he was at Columbia, was one of the formative influences on my thinking, both about Courbet, the subject of my doctoral dissertation, and more generally about the impact of political movements on the very style of art, rather than merely on iconography.

But most important of all in my latter years has been the imaginary presence of a scholar-ancestor whom I never met (he died

in 1929, two years before I was born) and whose work I was only vaguely familiar with until recently—an adopted father, if you will: Aby Warburg. About three or four years ago, for a variety of reasons, both scholarly and personal, I came under his spell—as have quite a few people recently, and not merely art historians but at least one film-maker, Eric Breitbart, and a performance artist, Joan Jonas, in "The Shape, the Scent, the Feel of Things" (2005).[2] I was particularly fascinated by the whole *Mnemosyne* picture atlas project—those atemporal, imaginatively connected giant screens of photographed topoi spanning centuries and cultures that were Aby Warburg's last and most original project.

I became particularly enthralled by the idea of the *Nachleben* of ancient forms, that vivid afterlife of Antiquity in the Renaissance, and after that I discovered, in contemporary women artists' works, pieces like Pippilotta Rist's *Ever Is Over All*, a video of 1997 representing an energetic young woman joyfully marching down a city street smashing car windows with a kind of iron flower. This topos is subtly vitalized by the "afterlife" of the antique maenad theme, a woman heady with wine creating mayhem with her thyrsis. Rist's contemporary female activist is even dressed in something that recalls antique drapery.

Or take Sam Taylor-Wood's poignant, large-scale self-portrait

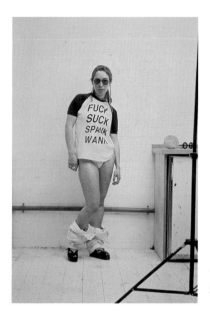

105 · Sam Taylor-Wood,
Fuck, Suck, Spank, Wank, 1993

Fuck, Suck, Spank, Wank of 1993, a photograph that brings up both antique and Renaissance memories in the contrapposto pose, the escaping strands of hair, the trousers about the sitter's feet—displaced classical drapery. Taylor-Wood's image is Botticelli's Venus, a subject deeply explored by Warburg, incidentally, made new and thereby given an afterlife of meaning in a contemporary woman artist's studio with a cabbage instead of a scallop shell as a still-life accompaniment. The *Fuck Suck* photograph is

as harmoniously composed as any Greek frieze, and much the richer for its references, however bizarre, to the past. I am not talking about anything as academic as influence here, nor do I think Aby was; and I am not referring to anything as trendy as appropriation. I am speaking, quite literally, of the *afterlife* of elements of the Western tradition achieving new meaning in the work of contemporary artists who use them as both continuity and critique in the representation of women.

It is not only Aby's ideas and research that have intrigued me, but his life, his spirit of adventure, his refusal to tie up his work in neat, easily apprehended packages—the way he leaves you still speculating, still waiting for more at the end of each scholarly but open-ended article. What a mythic life he led! A rich man who gave up his interest in the family banking business to start a library on his own, circular plan. A scholar of the Renaissance and Antiquity who fled across the sea to study the Pueblo Indians in New Mexico and Arizona in 1895–96, observing their rituals, taking numerous anthropological photographs of all aspects of Pueblo life, including the masked katchina dances, which created a deep resonance with his own studies of Renaissance pageantry, and especially those rituals that involved the handling of rattlesnakes, which he related to the snake handlers of the antique

Laocoön. I was fascinated by his long period of madness—bouts of schizophrenia and strong depression, which completely disrupted his work and led him to be hospitalized in Ludwig Binswanger's famed neurological clinic in Kreuzlingen, Switzerland, from 1921 almost to the end of his life.

But I was also drawn to Aby because he was a Jew, like me, a Jew but a cosmopolitan: as he himself put it, "a Jew by blood, a Hamburger by heart and a Florentine in his soul." Although he did not seem to be particularly concerned with anti-Semitism during the greater part of his life, he was, nevertheless, as a Jew in Germany, well aware of its presence. One may speculate, indeed, that part of the motivation impelling him, consciously or not, to grapple with the history of culture and its relation to the social order historically was to extinguish the bases for superstition and prejudice, and along with them, anti-Semitism, prejudice at its most painfully exacerbated.

But these good, rational, objective reasons are not the ones that, in my old age, put me in the thrall to Aby Warburg. It was the creative possibilities his life and work offered to the imagination that stirred me. Indeed, at one point a friend and I were determined to write a music-drama about him, a postmodern multimedia extravaganza to which Aby's life and ideas so beautifully

lent themselves. Imagine on stage: the voyage of discovery to Florence, revelation at the Sassetti Chapel, the exaltation of the maenad figure, draperies flying, interpreted by some nouvelle Isadora, Indian dances with masks and rattlesnakes at the Pueblo, a provocative mad scene, with all the stops pulled out, followed by psychic redemption through the insights of Binswanger, etc. Perhaps it is his face—those melting brown eyes, the mustache, the dainty compactness of the man—who knows?

More likely, it is all these reasons and unreasons together. Like all consuming passions, this one of my old age, for a teacher I never had and a father I never lost, is inexplicable on the rational level. Only in poetry can it be expressed, if not explained. For this reason, I am going to end these essays with a cycle of poems: a sonnet sequence dedicated to Aby Warburg, entitled "Dear Aby." They are not by any means polished poems, but they say something about my relation to history, to mortality, to art, to language, and to that "visceral eye" that runs as a leitmotif through all the essays.

I. Aby Baby
You little creepy Jew, why do I care
About your weird ideas, katchinas, snakes,

Decidedly, you fell for duds and fakes
And yet the pathos of your wet mustache
Drooping in Arizona, at the brink
Of vanishing rituals, all the rash
Assertions of connection make me think
About my past, of maenads, what I lost
By being who I am and what I've been.
We save ourselves from madness at great cost
And guilt is the overriding Jewish sin.
Whirling from space to silence you began
A work that can be finished by no man.

II. Aby Asks
Why is the past, he asked, always impure?
Only in ghosts, rags, patches, mad desire
Can the afterlife of vanished art endure.
Left on the ashes, history, child of fire
Less like the phoenix than a burnt-out bush
Rises from flame to Pyrrhic victory
That pedants try to simplify and crush
Into a rational, boring, well-wrought story.
Not so, not so, brave Aby testifies
Only in pain and contradiction, dance

Of fellating satyrs, nymphs, perverse pliés,
Of dryad-tupping goats, of wreathes askance
Can all that vanished magic live today.
Aby takes up a note-card, rubs his head
And dreams of snakes, katchinas and the dead.

III. Aby Weeps
Aby is weeping, tears run down his face,
He stamps, he tears his shirt off, then his pants,
Takes his schlong in hand and masturbates
Dreaming of maenads, breasts, the pagan dance
Of lust and rainfall, laughing as he comes
Hearing the howls of Dionysian rut
Beating about his head like Indian drums.
The doctor quickly enters, says "Tut Tut—
We cannot have this in our clinic's halls
Control must be our aim, you have regressed
Nietzsche's in hell, thou shalt not scratch thy balls
In public; Freud agrees. You must get dressed."
But Aby's back in the kiva, where his joy
Is fondling rattlesnakes, that naughty boy.

IV. Why no music, Aby?
If time was what you yearned for, passionate time
And the vehemence of dancing, veils in the wind

The serpent's slither and the body's mime,
Why didn't music send you, fill you in?
You never describe music on the grounds
Of princely revels, only costumes, gestures, sets
Theorbos and lutes, perhaps, but not the sounds.
They made, those plangent contrapuntal tête-à-têtes.
Ephemeral as dawn, more intimate than the flight
Of painting's rituals, Mnemosyne's voice
Is always absent from your cavalcade of light,
Silenced by imaged reason, ominous choice.
Nymphs, maenads, satyrs, *boti,* get in line
Dance all you buggers, dance to the music of time!

V. Aby's Pain
Auschwitz was in his eyes, he learned of hate
When he was in the army. Anachron
ism was his forte, pain his fate
He missed the grand finale, that great sun
Of evil that burned his world to ash
Transformed the dance of lust to dance of death,
His mustache quivered, he took a different path.
Madness was his salvation, taking a breath
Before the end, he burned upon the stake
Of bourgeois reason, the distinguished thing.

No matter how wild a gesture he might make
The trains were waiting, the last reckoning.
Mad he might be, Aby was never blind.
In madness he saw the murder of his kind.

VI. The World is broken, Aby
The world is broken, Aby, and the word
Is shaken loose from sacred meaning. All
Is exile, rupture, we have lost the way
Shevirah mocks us with its fatal sword,
Splitting hope from being, man from god,
Tsimtsum constricts us, takes the light away
We live in a library without a catalogue.
Only myth can save us, turn our night to day.
But Aby, brainstruck, doesn't listen, screams his pain,
His nymphs have turned to harpies, primal will
Can only make his ravings more insane
Kabbalah cannot reach him, the Jew is ill,
That Jew beneath the skin of pagan lore.
Aby is silenced, and can speak no more.

VII. Aby Daddy
Aby Daddy pray for me
Far across the water.

Aby, the darkness closes in
The days are getting shorter.
Iambs desert me, I ams intrude
Into the holy pattern.
My eyes grow dim, my bones protrude,
There is no goose to fatten.
Tell me Aby where and when
We grew up together;
Surely you and I were kin
Bred for stormy weather.
Back and back the past unfolds
A past of books and reading
Safe in my hands I'll always hold
That sign of Jewish breeding.
Don't leave me Aby, stay with me
Through the dark night coming;
Somewhere in the dusk I hear
Hopi tom-toms drumming.
Take my hand and lead me there
There beside still waters.
Let me be, within your arms
Fairest of Zion's daughters
Or if not fairest, smartest then

That's more what we were after,
Making the memory collage
Ring with skeptical laughter.
Aby, this passage is almost run—
We're sailing into harbor
Aby, my lover, my teacher, my son
My nemesis, my father.

\mathscr{N}otes

1. Renoir's *Great Bathers*

1. Caroline Knapp, *Appetites: Why Women Want* (New York: Counterpoint, 2003), ix.
2. George Steiner, *New York Times,* February 28, 1971. Michel Foucault, *Les Mots et les choses: Une archéologie des sciences humaines* (Paris: Gallimard, 1966).
3. Tamar Garb, *Bodies of Modernity: Figure and Flesh in Fin-de-Siècle France* (London: Thames and Hudson, 1998), 169–170.
4. These conclusions are based on a methodical search for representations of female bathers in the Salon *livrets* from 1814 to 1890. This was not an easy task, although it became somewhat easier after 1879, when partial illustrations in the form of engravings were provided. *Diana* was clear enough, as was *Bathsheba* or just plain *Une Baigneuse.* But what about *Le Bain,* which, especially if it were by a woman artist, might turn out to be a mother bathing her baby; or *Aux Bords du Lac,* which often meant the presence of nudes on the shore, whereas *Aux Bords du Lac Leman* inevitably referred to a

landscape? Guesswork was inevitable, but some interesting information nevertheless resulted from this survey.

5. In attempting to answer this question, or at least to formulate questions to be asked about it, my approach will be both diachronic and synchronic: concerned both with change and evolution and with the interaction of simultaneous practices and products.

6. For a discussion of the twentieth-century *rappel à l'ordre,* a time after World War I when political conservatism in France found its artistic equivalent in a variety of reactionary "harmonizing," sometimes historicizing styles, see *Les Réalismes, 1919–1939* (exhibition catalogue; Paris: Centre Georges Pompidou, 1980); Kenneth E. Silver, *Esprit de Corps: The Art of the Parisian Avant-Garde and the First World War, 1914–1925* (Princeton: Princeton University Press, 1989); and Romy Golan, "Modes of Escape: The Representation of Paris in the Twenties," in *The 1920s: Age of Metropolis,* ed. Jean Clair (exhibition catalogue; Montreal: Montreal Museum of Fine Arts, 1991), 336–377. All of these constructions of the conservative reaction after World War I influenced my thinking about the recall to order characteristic of many of the dominant art styles in France, particularly those of the erstwhile avant-garde, during the last twenty years of the nineteenth century.

7. For a recent attempt to contextualize Renoir's *Great Bathers* historically, within the context of the cultural politics of the Third French Republic, see John House, "Renoir's *Baigneuses* of 1887 at the Politics of Escapism," *Burlington Magazine,* 134, 1074 (September 1992): 636–642.

8. See, for example, Christopher Riopelle, Philadelphia Museum of Art *Bulletin,* 1990: 28, and fig. 30 for an illustration of the François Girardon relief, *Nymphs Bathing,* c. 1670, in connection with Renoir's project.

9. For a thoroughgoing account of the role of lesbian imagery in nineteenth-century representation, see Maura Reilly, "Le vice à la mode: Gustave Courbet and the Vogue for Lesbianism in Second Empire France," Ph.D. diss., New York University, Institute of Fine Arts, 2000.

10. This is, of course, an opposing effect to Roland Barthes' oft-cited *effet de*

réelle, or reality effect. It seems to me what many of these purveyors of the female bather were getting at were "effects of the aesthetic" within a basically naturalistic premise. This effect is particularly evident in the orientalizing bathers of Gérôme, in which motifs from Ingres "aestheticize" the otherwise scrupulously "objective" representations of naked black and white women in obsessively detailed interior spaces. For a further examination of this topos, the "sign of the artistic" in realist art, see Linda Nochlin, "The Imaginary Orient," in Nochlin, *The Politics of Vision: Essays on Nineteenth-Century Art and Society* (New York: Harper & Row, 1989), 47–49.

11. The recent controversies over high and low art and their relationship, to which an extremely controversial exhibition at the Museum of Modern Art in New York in 1990–1991 gave rise, have stimulated interest, I hope, in these neglected aspects of visual representation which social and cultural historians, in the United States, England, and France, have been investigating with great intelligence and originality for quite a few years now. See *Modern Art and Popular Culture: Readings in High and Low,* eds. Kirk Varnedoe and Adam Gopnik (New York: Museum of Modern Art, H. N. Abrams, 1990). There has also been a good deal of original work on the history and social positioning of the body in recent times, an issue, like that of popular art and culture, relevant to the subject of this essay. See, for example, the various investigations of the body in relation to cleanliness, sport, and hygiene by Georges Vigarello: *Le Propre et le sale: L'Hygiène du corps depuis le Moyen Age* (Paris: Seuil, 1985); *Le Corps redressé* (Paris: Delarge, 1978); and *Une Histoire culturelle du sport, techniques d'hier et d'aujourd'hui* (Paris: EPS/R. Laffont, 1988). These studies investigate subjects relevant to bathing and swimming in their textual, if not in their visual, aspects.

12. For a long discussion of the rise in importance of boating and sailing as leisure activities in the later nineteenth century, see Paul Tucker, *Monet at Argenteuil* (New Haven: Yale University Press, 1981). Robert L. Herbert, *Impressionism: Art, Leisure, and Parisian Society* (New Haven: Yale Univer-

sity Press, 1988), devotes a substantial section of his study to sailing at Argenteuil and rowing and boating at Chatou (229–245).

13. See the versions of this theme by Renoir of 1869 now in the Pushkin Museum in Moscow, the Nationalmuseum in Stockholm, and the Oskar Reinhart Collection in Winterthur. Robert L. Herbert publishes a richly detailed engraving of men and women bathing together at La Grenouillère of 1873; see Herbert, *Impressionism: Art, Leisure, and Parisian Society* (New Haven: Yale University Press, 1988), fig. 210, p. 211. And there is a spirited and sexy color print of 1880 illustrating mixed bathing and general good fun at this popular bathing establishment in François Beaudouin, *Paris sur Seine: Ville fluviale: son histoire des origins à nos jours* (Paris: Editions de la Martinière, 1994), 172.

14. Cited in Ambroise Vollard, *Renoir: An Intimate Record*, tr. H. L. Van Doren and R. T. Weaver (1925; New York: Alfred A. Knopf, 1934), 49. It is interesting to see how often artists, and the rest of us as well, tend to look back at our youthful years as "preindustrial," simpler, and more leisured, despite the fact that one person's youth is, of course, another's old age, and that the period from which Renoir was looking back so nostalgically was dubbed "the gay Nineties" by people who had been young during it, looking back from their vantage point of the twentieth century.

15. Daumier's series devoted to female bathers in the pools of Paris, entitled *Les Baigneuses,* appeared in *Le Charivari* in 1847. There was also a series featuring male *habitués* of the Paris swimming pools.

16. For an excellent account of Daumier's counter-discursive practice and the complexity of the notion of counter-discourse itself, see Richard Terdiman, *Discourse/Counter-Discourse: The Theory and Practice of Symbolic Resistance in Nineteenth-Century France* (Ithaca: Cornell University Press, 1985). See especially chapter 3, "Counter-Images: Daumier and *Le Charivari,*" 149–197.

17. Article-advertisement for the Bains Lambert, illustrated by Daubigny and others, c. 1850, in Album *Bains,* Salle des Estampes, Bibliothèque Nationale, Paris.

18. For a description of the coarse behavior of women at swimming pools, one of many, see Eugène Briffault, *Paris dans l'eau* (Paris: J. Hetzel, 1844), 99: "In the women's bath meet, for the most part, heroines of gallantry and of opulent pleasure; other women keep themselves apart, and good reputations separate themselves from the golden belts . . . they smoke there as much as men." Many of the illustrations accompanying these descriptive texts are far from flattering either to women's bodies or their character!

19. See, for example, Michel Foucault, *The Birth of the Clinic: An Archaeology of Medical Perception,* trans. A. M. Sheridan Smith (New York: Pantheon Books, 1973); *Discipline and Punish: The Birth of the Prison,* trans. Alan Sheridan (New York: Pantheon Books, 1977); or *The History of Sexuality,* vol. 1: *An Introduction,* trans. Robert Hurley (New York: Pantheon, 1978). See also Alain Corbin, *Les Filles de noces; misère sexuelle et prostitution: 19e et 20e siècles* (Paris: Aubier Montaigne, 1978); and his *Le Miasme et la jonquille: L'Odorat et l'imaginaire social XVIIIe–XIXe siècles* (Paris: Aubier Montaigne, 1982). Equally relevant is the work of Georges Vigarello, cited above, n. 11.

20. See, for example, Eugène Chapus, *Le Sport à Paris* (Paris: Hachette, 1854), 187: "At the swimming school, the domination of rank disappears in the uniformity of the bathrobe and the bathing suit required by everyone. There is no longer any distinction, except in the art of diving, of doing the jack-knife or swan-dives, of getting up from the water without tiring. The great dignitaries of the swimming school are those who dare to do high dives from the top of the diving board, or who hurl themselves boldly from the top of the tower into the pool."

21. See, for example, the descriptions cited by Michel Jansel, *Paris incroyable* (Paris: Hachette, 1986), 98–99, of the "perfect equality" reigning in all the female bathing establishments of the mid-nineteenth century; nevertheless, the "vraies jeunes filles" distinguished themselves by preferring sugar-water to the stronger refreshment selected by more morally equivocal women swimmers.

22. The Seine became choked with *établissements flottants* at the end of the nineteenth century. See *Deux siècles d'architecture sportive à Paris: Piscines, gymnases* . . . (exhibition catalogue; Paris: Mairie du XXe arrondissement, 1984), 34.

23. Ibid., 29–31, and cat. no. 37, p. 34, for the history of the Château-Landon pool and the origin of pools away from the Seine in 1884, as well as the staggering attendance figures at Château-Landon. Also see Paul Christmann, *La Natation et les bains* (Paris: Librairie Alcide Picard et Kaan, 1886), 16–27. Christmann, president of the Société des Gymnases Nautiques, created at Château-Landon the first covered pool provided with warm water. A staunch advocate of all-year-round pools in Paris, from a point of view both hygienic and patriotic, he seems to have gotten the concession to supply warm water to the Paris *piscines* (44–45).

24. See, for example, Barbara White's contention that the two sides are disparate in style, which accounts for the failure of the painting to attain unity: "The forms on the left side and foreground are linear, realistic and clarified; on the right side and in the distance they are Impressionist. But the figures do not relate to one another or to their setting in a natural or comfortable fashion . . . With such complex intentions, it is no wonder that, in the end, Renoir created a stilted, labored exercise that lacked stylistic unity." Barbara Ehrlich White, *Renoir: His Life, Art, and Letters* (New York: H. N. Abrams, 1984), 174.

25. For extended analysis of Renoir's reactionary attitudes toward women, see Tamar Garb, "Renoir and the Natural Woman," *Oxford Art Journal,* 8, no. 2 (1985): 3–15; also see Desa Philippi, "Desiring Renoir: Fantasy and Spectacle at the Hayward," *Oxford Art Journal,* 8, no. 2 (1985): 16–20, as well as articles by Fred Orton and John House also published in the same journal. Of equal importance in evaluating Renoir's gender position is Kathleen Adler's review article, "Reappraising Renoir," *Art History,* 8 (September 1985): 374–380.

26. For a detailed, and radical, analysis of the place of economics in the transformation of French painting during the period from 1870 to the end of

the nineteenth century, see Nicholas Green, "Dealing in Temperaments: Economic Transformation of the Artistic Field in France during the Second Half of the Nineteenth Century," *Art History,* 10, no. 1 (March 1987): 59–78.

27. For an analysis of the association of femininity and Impressionist style, see Anne Higonnet, "Writing the Gender of the Image: Art Criticism in Late Nineteenth-Century France," *Genders,* 6 (Fall 1989): 60–73, and Tamar Garb, "'Soeurs de pinceau': The Formation of a Separate Women's Art World in Paris, 1881–1897," Ph.D. diss., Courtauld Institute of Art, University of London, 1991, 337–339.

28. The classic article constructing this topic is Maurice Merleau-Ponty's "Cézanne's Doubt," first published in 1945 and then republished in the great phenomenologist's *Sens et non-sens* (Paris: Nagel, 1966), 15–44.

2. Manet's *Le Bain*

1. Theodor Adorno, *Aesthetic Theory,* trans. C. Lenhardt (1970; London: Routledge & Kegan Paul, 1986), 105.

2. In the catalogue of the Salon des Refusés, 1863, it was listed as no. 363 *(Le Bain).*

3. The two were in Couture's studio together. This is obviously a reference to Giorgione's *Fête Champêtre* in the Louvre. Antonin Proust, *Edouard Manet: Souvenirs* (1897; Paris, 1913), 171–172.

4. Beatrice Farwell, "Manet's Bathers," *Arts Magazine,* 54, no. 9 (May 1980): 124–133.

5. I was reminded of this work in the pages of Germaine Greer's wonderful *The Beautiful Boy* (New York: Rizzoli, 2003).

6. For a discussion of the *Déjeuner* as *blague* (joke), see Linda Nochlin, "The Invention of the Avant-Garde: France, 1830–1880," in *The Avant-Garde* (*Art News Annual,* 34 [1968]), and *Avant-Garde Art* (New York: Collier-Art News paperback, 1971).

7. See Françoise Cachin, Charles S. Moffett, and Juliet Wilson-Bareau, *Manet:*

1832–1883 (exhibition catalogue; Paris: Galeries Nationales du Grand Palais, and New York: The Metropolitan Museum of Art, 1983), no. 87, for information about this work.

8. Charles Harrison, "The Effects of Landscape," in W. J. T. Mitchell, ed., *Landscape and Power* (Chicago: University of Chicago Press, 1994), 203–239.

9. The relation to Raphael has been brilliantly analyzed at great length by Hubert Damisch in *The Judgment of Paris,* trans. John Goodman (Chicago: University of Chicago Press, 1996), 61–76. See Marcia R. Pointon's recent anti-allegorical interpretation of the *Déjeuner* in *Naked Authority: The Body in Western Painting, 1830–1908* (Cambridge: Cambridge University Press, 1990).

10. See Farwell, "Manet's Bathers."

11. Achille-Etna Michallon, *Achille-Etna Michallon* (Paris: Réunion des Musées Nationaux, 1994), 14.

12. Ibid., 14.

13. Manet may be seen as continuing Baudelaire's work by calling into question the time-honored project of the *paysage composé* through artifice and parody of both ancient and modern painting as a medium of "natural" representation and of the natural itself. Nature is parodied here with figures stuck on the surface, asserting their status as constructions with supreme nonchalance.

14. See especially Gavarni's series of the *Débardeuses,* featuring young women fetchingly got up in close-fitting "longshoremen's" outfits for costume balls.

15. Terry Castle, "Fielding's Female Husband," in *The Female Thermometer* (New York: Oxford University Press, 1995), 80.

16. The prize for the heroic landscape sketch of the Ecole des Beaux-Arts had been established in 1816.

17. P. H. Valenciennes, *Elémens de perspective pratique à l'usage des artistes, suivis de réflexions et conseils à un élève sur la peinture et particulièrement sur*

le genre du paysage (Paris: An VIII, 1800), xxv, 404–409, 489–490, 493–495. Cited in Peter Galassi, *Corot in Italy: Open-Air Painting and the Classical Landscape Tradition* (New Haven: Yale University Press, 1991).

18. Valenciennes, *Elémens*, xxv, 384, 631.

19. Galassi, *Corot in Italy*, 37, 38.

20. On Cézanne as a painter of modern life, see the excellent discussion by Richard Kendall, "The Figures in the Landscape," in *Cézanne and Poussin: A Symposium*, ed. Richard Kendall (Sheffield, UK: Sheffield Academic Press, 1993), 98–105. For a discussion of the implications of this work, see Damisch, *Judgment of Paris*, 330–331.

21. Kendall, "The Figures in the Landscape."

22. Theodor Reff, "Cézanne and Poussin," *Journal of the Warburg and Courtauld Institutes*, 23 (1960): 150–174.

23. Camoin, 1905, cited by Richard Shiff in *Cézanne and the End of Impressionism: A Study of Theory, Technique, and Critical Evaluation of Modern Art* (Chicago: University of Chicago Press), 1984, 288–289.

24. Emile Bernard, "Une conversation avec Cézanne," *Mercure de France* (June 1921): 372–397. Cited by Richard Kendall, "The Figures in the Landscape," p. 95 and n.3. Also see other relevant Cézanne "citations": Gasquet on Cézanne and Giorgione's *Concert:* "Cézanne remarks on Giorgione's *Concert Champêtre:* 'The whole landscape in its brown glow is like a supernatural eclogue, a moment of balance in the universe perceived in its eternity . . .'" Cited in Joachim Gasquet, *Cézanne: A Memoir with Conversations* (New York: Thames and Hudson, 1991), 186.

25. The quintessential *paysage historique*, as figured in the work of Poussin or Claude, was deliberately deprived of particularized national or regional specificity. The universality and idealization of the historic landscape was premised on the priority of the Roman *campagna*, or an imaginary Grecian harbor. Such landscape sites, supported by appropriate classical architectural elements, are, in comparison, say, to Constable's home country, his river Stour landscapes, Utopian in the most literal sense of the word.

26. The painting carried the title "Le Chêne de Flagey, appelé chêne de Vercingétorix. Camp de César, près d'Alésia, Franche-Comté" when it was shown in Courbet's private exhibition in Paris at the Alma in 1867, increasing its historic and regional specificity through the extended title.

27. Simon Schama, *Landscape and Memory* (New York: Alfred A. Knopf, 1995), 124, 126. Later, on p. 126, in discussing Kiefer's monumental *Varus* of 1976, Schama declares: "Modernism upended the picture plane . . . rejoicing in the integrity of flatness. But Kiefer was concerned with a different kind of integrity: that of the undisguised storyteller, the orchestrator of a visual *Gesamtkunstwerk* . . . So he pushed the plane back down, using aggressively deep perspective to create the big operatic spaces in which his histories could be enacted."

28. For more ideas on this subject, see Alan Wintermute, ed., *Claude to Corot: The Development of Landscape Painting in France* (New York: Colnaghi, 1990); and W. J. T. Mitchell, ed., *Landscape and Power* (Chicago: University of Chicago Press, 1994).

3. The Man in the Bathtub

1. Régis Michel, *Posséder et détruire* (exhibition catalogue; Paris: Louvre, 2000), 199.

2. "Picasso's women are nothing but monsters—hysterics, murderers, castraters—in the silent cry of their obscene forms, where the victim becomes the torturer," says Régis Michel, never afraid of rhetorical overstatement (p. 201; my translation).

3. David Douglas Duncan, *David Douglas Duncan Photographs Picasso* (New York: Mitchell-Innis & Nash, 2000), nos. 17, 18, and 19.

4. See John Russell, *New York Times,* February 27, 2004, E29.

5. Donald Posner, *Antoine Watteau* (London: Weidenfeld & Nicholson, 1984), 106.

6. See Linda Nochlin, "Watteau: Some Questions of Interpretation," *Art in America,* 73 (January 1985): 68–87, for this material.

7. See Eunice Lipton, *Looking into Degas: Uneasy Images of Women and Modern Life* (San Francisco: University of California Press, 1986).

8. See Linda Nochlin, "A House Is Not a Home: Degas and the Representation of the Family," for this reading of the brothel monotypes. In *Dealing with Degas: Representations of Women and the Politics of Vision,* ed. Richard Kendall and Griselda Pollock (New York: Universe, 1992).

9. Carol Armstrong, in her fine study of Degas, *Odd Man Out: Readings of the Work and Reputation of Edgar Degas* (Los Angeles: Getty Research Institute, 2003), 182–183, points to the Bakhtinian grotesque as a mode of interpretation for this bather.

10. See Tamar Garb's excellent analysis of Caillebotte's *Bather* in *Bodies of Modernity: Figure and Flesh in Fin-de-Siècle France* (London: Thames and Hudson, 1998).

11. See Garb's important analysis of gender signs in this work in her chapter on the painting in *Bodies of Modernity.*

12. I am not calling into question more recent interpretations of the figure by queer theorists who insist on a gay reading of the figure and, in more extreme cases, a gay Caillebotte as well. No matter what the sexual desire evoked by this bather, the figure is, in my opinion, constructed as unequivocally "masculine."

13. See Armstrong, *Odd Man Out,* chap. 3.

14. Gauguin picks up this theme in his intriguing nude of the Magdalene collapsed in a paroxysm of grief at the foot of the cross, in a graphic work from *L'Imagier.*

15. The series actually may be said to begin with two almost identical lithographs of *Le Bain* produced for the publisher Edmond Frappé in about 1925.

16. John Elderfield, "Seeing Bonnard," in *Bonnard* (exhibition catalogue; London: Tate Gallery, 1998), 33–48.

17. Or as the Pre-Raphaelite John Everett Millais does in his minutely painted, overdressed, flower-strewn *Ophelia* of 1852, for which the artist actually had his unfortunate model lie for hours, fully clothed, in the bathtub.

18. Sasha Newman, *Bonnard: The Late Paintings* (Washington, DC: Thames and Hudson/Phillips Collection/Dallas Museum, 1984).

19. In *Pierre Bonnard, Stealing the Image: Works on Paper* (exhibition catalogue; New York: New York Studio School, 1997).

20. For this citation, see www.guggenheim.org/exhibitions/singular_ forms/ highlights_15a.html.

4. Monet's *Hôtel des Roches Noires*

1. Katherine MacQuoid, *Through Normandy,* 1874, p. 317, cited in Robert Herbert, *Monet on the Normandy Coast: Tourism and Painting, 1867–1886* (New Haven: Yale University Press, 1994), 28–29.

2. See Gabriel Désert, *La Vie quotidienne sur les plages normande du Second Empire aux Années folles* (Paris: Hachette, 1983), 89.

3. I am grateful to my former student, Dr. Lucia Tripodes, for her insights about this novel.

4. Dumas cited in Albert Blanquet, *Les Bains de mer des côtes normandes: Guide pittoresque* (Paris: L. Hachette, 1859), 76.

5. Gustave Flaubert, *Par les champs et par les grèves: Voyage en Bretagne* (Paris: Charpentier, 1866), cited in Henry Gilles, *Promenades en Basse-Normandie, avec une guide nommé Flaubert* (Paris: Charles Corlet, 1979), 44.

6. Blanquet, *Les Bains de mer des côtes normandes,* 74–76.

7. Alphonse Karr, *Sur la plage* (Paris: Michel Levy, 1862), 246–247, 249.

8. Albert Blanquet, "Petite guide pratique du baigneur" (Appendix to *Les Bains de mer*), 219, 223, 243.

9. Jules Jean Baptiste Le Coeur, *Des Bains de mer: Guide médical et hygienique du baigneur,* 2 vols. (Paris: Labé, 1846).

10. Alphonse Karr, "Deuxième promenade," in *Promenades au bord de la mer* (Paris: Michel Levy, 1874), 53, 62.

11. "We must return to the Lebenswelt, the world in which we meet in the lived-in experience of the world." Maurice Merleau-Ponty, *The Phenomen-*

ology of Perception (1945; London: Routledge, 1970). Also see "Primacy of Perception," in *Primacy of Perception, and Other Essays,* ed. James M. Edie (Evanston: Northwestern University Press, 1964), in which Merleau-Ponty explains his theory of perception: "[Our experience of perception comes from our being present] at the moment when things, truths, and values are constituted for us; that perception is a nascent Logos; that it teaches us, outside of all dogmatism, the true conditions of objectivity itself."

12. The lines come from a poem I wrote on March 8, 2000, called "Family History":

> My mother claimed
> James Joyce winked at her
> In a Paris café in 1930;
> Of course, she couldn't really tell
> Because of the eye-patch.
> Perhaps he merely stared, and then,
> Thinking of something else entirely,
> Blinked.
> I never stood up straight from childhood.
> Don't be deceived
> I wasn't shy.
> Inside, my arrogance was hard as a shield,
> Internal armor that has stood me
> In good stead ever since;
> Better than the vertebrae
> That first refused my strenuous will
> And then lapsed into indifference.
> My father taught me three things:
> How to tie a square knot,
> How to do the fox-trot,
> And always to keep my side toward my opponent
> When boxing.

All three lessons
Have proved invaluable during my journey through life.
Alas, I have not passed on
This wisdom to my children,
My grandparents dreamed of glory
But kept their feet on the ground.
There is a picture of one set
Feeding a cloud of pigeons in
San Marco Square
Solid among a cloud of blurry wings. At Neponsit Beach
I would cry when my grandfather
Vertical, steady, relentless
Swam too far out to sea.
"How far" you ask "is too far?"
Any distance away from me
Is too far:
That is the definition
Of too far.

13. See Freud's famous "Fort/Da" discussion for an analysis of childish worries about the disappearance of the parent figure and ways of coping with it. Sigmund Freud, *Beyond the Pleasure Principle* (New York: Norton, 1989).

14. The whole association of water with the feminine, and the sea with uterine safety, "rocked in the cradle of the deep," etc., is a standard trope of psychoanalytic discourse. But if sea is associated with maternal protection, it is, at best, a changeable femininity, at worst a menacing stepmother, stormy, threatening, death-dealing—or even masculine, fearsome, punishing. Think of Courbet's muscular waves and the very association, in French at least, of the pounding surf with a sword blade implied by the word *lame*. The sea, the ocean, lends itself to a multiplicity of readings, feelings, and interpretations.

15. For a more complete account of the *Raft* and its genesis, see Linda Nochlin,

"Géricault, or the Absence of Women," *October,* 56 (Spring 1994): 45–60, and the account of it in the exhibition catalogue *Géricault* (Paris: Grand Palais, 1991–1992).

16. See Patrick Noon, *Crossing the Channel: British and French Painting in the Age of Romanticism* (exhibition catalogue; London: Tate Publishing, 2003).

17. For a detailed discussion of the fate of Rochefort in relation to Manet's paintings, see Juliet Wilson-Bareau and David Degener, *Manet and the Sea* (exhibition catalogue; Philadelphia: Philadelphia Museum of Art, 2003), 86ff.

18. Lorenz Eitner, "The Open Window and the Storm-Tossed Boat: An Essay in the Iconography of Romanticism," *Art Bulletin,* 37, no. 4 (December 1955): 281–290.

19. See Linda Nochlin, *The Politics of Vision: Essays in Nineteenth-Century Art and Society* (New York: Harper & Row, 1989), 1–18.

20. Sigmund Freud, *Civilization and Its Discontents,* trans. and ed. James Strachey (New York: Norton, 1961), 10–14.

21. Bruce Hainley, "Legend of the Fall (Photographer Bas Jan Ader)," *Artforum,* 37 (March 1999), 95.

22. Ibid., 92–93.

23. Jody Zellen, "Review of Bas Jan Ader at UC Riverside, Sweeney Art Gallery," http://artscenecal.com/ArticlesFile/Archive/Articles1999/Articles1099/BJAderA.html.

5. Real Beauty

1. Thomas Crow, review of Philippe-Alain Michaud, *Aby Warburg and the Image in Motion,* in *Bookforum,* 1 (Spring 2004): 28.

2. Quoted in ibid.

3. Linda Nochlin, "The Realist Criminal," Part I, *Art in America,* 61, no. 5 (September–October 1973): 54–61; Part II (November–December 1973): 96–103.

4. See Linda Nochlin, *Realism* (London: Penguin Books, 1971), especially the introduction, for an extended discussion of this subject.

5. Roman Jakobson, "The Metaphoric and Metonymic Poles," in *Fundamentals of Language* (The Hague: Mouton, 1956).

6. See Linda Nochlin, "Gustave Courbet's *Meeting:* A Portrait of the Artist as a Wandering Jew," *Art Bulletin,* 49 (September 1967): 209–222.

7. See Linda Nochlin, "The *Cribleuses de Blé:* Courbet, Millet, Breton, Kollwitz and the Image of the Working Woman," in Klaus Gallwitz and Klaus Herding, eds., *Malerei und Theorie: Das Courbet-Colloquium 1979* (Frankfurt am Main: Städel, 1980), 64–83, for more about working-woman imagery.

8. I am speaking here of Pearlstein's work of the 1960s and 1970s rather than his recent work, which is considerably more complex and elegant.

9. See David Hockney, *Secret Knowledge: Recovering the Lost Techniques of the Old Masters* (London: Thames and Hudson, 2001), and the symposium relating to the subject of the use of optical devices, held at New York University in 2001. The camera lucida and the camera obscura were both implicated.

10. See Linda Nochlin, "Philip Pearlstein's *Portrait of Linda Nochlin and Richard Pommer,*" *Artforum,* 32 (September 1993), 142ff.

11. For an extensive discussion of twentieth-century women and realism, see Linda Nochlin, "Some Women Realists," *Arts Magazine,* Part I, February 1974, 46–51; Part II, May 1974, 29–33.

12. Jenny Saville, lecture at the New York Academy, April 16, 2004.

13. The book in question, now issued in paperback because of its cult popularity, is Jack Huddleston, *Death Scenes: A Homicide Detective's Scrapbook,* introduction by Katherine Dunn (Portland, OR: Feral House, 1996).

6. More Beautiful than a Beautiful Thing

1. The Bernard photographs, reproduced by T. J. Clark in his "Freud's Cézanne," *Representations,* no. 52 (Fall 1995): figs. 5 and 6, pp. 103 and 104,

were originally published in Erle Loran, *Cézanne's Composition: Analysis of His Form with Diagrams and Photographs of His Motifs* (Berkeley: University of California Press, 1963), 9, and John Rewald, *Cézanne: A Biography* (New York: H. N. Abrams, 1986), 254.

2. This analysis originally appeared, in expanded form, in Linda Nochlin, *Realism* (London: Penguin, 1971), 92–95.

Epilogue

1. Posthumously published as *Problems in Titian, Mostly Iconographic* (New York: New York University Press, 1969).

2. I have now read a great deal of Warburg's published work in the Getty edition (*Aby Warburg: The Renewal of Pagan Antiquity,* trans. D. Britt [Los Angeles: Getty Institute, 1999]); read Gombrich's biography (*Aby Warburg: An Intellectual Biography* [London: Warburg Institute, 1970]); carefully perused the magisterial volume *L'Image survivante: Histoire de l'art et temps des fantômes selon Aby Warburg* (Paris: Editions de Minuit, 2002), as well as the inventive study of Warburg and the moving image by Philippe-Alain Michaud (*Aby Warburg et l'image en mouvement* [Paris, 1998]); and took on a giant biography of the entire Warburg clan by Ron Chernow (*The Warburgs: The Twentieth-Century Odyssey of a Remarkable Jewish Family* [New York: Vintage Books, 1993]).

\mathcal{A}cknowledgments

In the course of preparing the Norton Lectures on which this book is based, I received the help of many friends, students, and colleagues. I am grateful to all the members of the Harvard faculty involved in the presentation of the lectures, including my brilliant introducers and dinner hosts: Homi Bhabha, Yve-Alain Bois, Brad Epps, Marge Garber, Irene Winter, Henri Zerner, and most especially Ewa Lajer-Burchart, my former student, now a professor of history of art and architecture at Harvard and a constant source of information and inspiration. Rosalyn Deutsche should also be named among those who helped to implement this series of lectures.

I am especially grateful to Elizabeth Young-Bruehl for the long letter she wrote me after a lecture on Renoir's *Great Bathers* many years ago. I also want to give special thanks to my friend and former student Joe Hill, who offered criticism and support throughout the long process of writing these lectures and who read the final manuscript with great care. Lori Waxman and Nicole Myers helped with proofreading, while Luis Castañeda, Camille Mathieu, and, at Harvard University Press, Alex Morgan assisted in obtaining illustrations and permission for their reproduction.

Without the aid and support of Alison Gass, my former graduate research assistant, I quite literally would not have been able to produce the Norton Lectures. Elizabeth Marcus, my long-time assistant, was always there when I needed her. For intellectual support, stimulation, and criticism, I am, as always, grateful to my friends and fellow art historians Tamar Garb, Marni Kessler, Rosalind Krauss, Abigail Solomon-Godeau, and Régis Michel, who provided the introductory theme for "The Man in the Bathtub" essay and has always encouraged me down the path of intellectual risk-taking. Elizabeth Baker, editor at *Art in America* and my longtime friend, ushered some of this material, in a different form and context, through the press. In France, two artist friends, Roseline Granet and Zuka Mitelberg, accompanied me on an informative outing to Trouville. The late Nikos Stangos, former editor at Thames and Hudson and my dear old friend, encouraged me in the early stages of this project. Nearly last but not least, I am grateful to all the participants in a lively graduate colloquium on "Bathers and Bathing from Courbet to Picassso" at the Institute of Fine Arts, New York University, as well as those in a seminar titled "Beauty, Body, and Society," taught in conjunction with Harvey Molotch of the Department of Sociology, both of which took place in the fall of 2003.

Finally, I wish to thank my patient and devoted editors at Harvard University Press, Margaretta Fulton and Susan Wallace Boehmer, whose help and encouragement urged me onward when I flagged, with energy, tact, and good cheer.

*I*llustration Credits

1 Auguste Renoir, *The Great Bathers,* 1884–1887. Philadelphia Museum of Art: The Mr. and Mrs. Carroll S. Tyson, Jr. Collection, 1963.

2 Auguste Renoir, *Blonde Bather,* 1881. Pinacoteca Gianni e Marella Agnelli, Turin. Gilles Mermet/Art Resource, NY.

3 Charles Gleyre, *Bathers,* c. 1860. © Musée Cantonal des Beaux-Arts de Lausanne. Photo: J.-C. Ducret, Musée Cantonal des Beaux-Arts.

4 Adolphe-William Bouguereau, *Bathers,* 1884. A. A. Munger Collection, The Art Institute of Chicago. Photograph © The Art Institute of Chicago.

5 Honoré Daumier, *Naiads of the Seine,* 1847.

6 C. Hugot, Bains de Paris, 1844.

7 Negrier, Le Bain des Lionnes.

8 Nadar (Gaspard Félix Tournachon), *Les Chaleurs,* c. 1860s.

9 Emile Levi, Poster of Bains Bourse Pool, 1882.

10 Gustave Courbet, *Bathing Women,* 1853. Musée D'Orsay, Paris. Erich Lessing/Art Resource, NY.

11 Auguste Renoir, *Nude in Sunlight,* 1876. Musée D'Orsay, Paris. Photo: Hervé Lewandowski. Réunion des Musées Nationaux/Art Resource, NY.

12 Paul Gauguin, *What, Are You Jealous?* 1892. Pushkin Museum of Fine Arts, Moscow. Scala/Art Resource NY.

13 Auguste Renoir, *Le Moulin de la Galette,* 1876. Musée D'Orsay, Paris. Scala/Art Resource NY.

14 Paul Cézanne, *Large Bathers,* 1906. Philadelphia Museum of Art: Purchased with the W. P. Wistach Fund, 1937.

15 Auguste Renoir, *The Bathers,* 1918. Musée D'Orsay, Paris. Erich Lessing/Art Resource, NY.

16 Gustave Courbet, *Sleepers,* 1866. Musée du Petit Palais, Paris. Photo: Hervé Lewandowski. Réunion des Musées Nationaux/Art Resource, NY.

17 Edouard Manet, *Déjeuner sur l'herbe,* 1863. Musée D'Orsay, Paris. Erich Lessing/Art Resource, NY.

18 Giorgione, *Concert in the Open Air (Fête Champêtre),* 1508–1509. Louvre, Paris. Erich Lessing/Art Resource, NY.

19 Alexandre Cabanel, *Birth of Venus,* 1863. Musée D'Orsay, Paris. Erich Lessing/Art Resource, NY.

20 Marcantonio Raimondi, *Judgment of Paris,* 1510–1520. Louvre, Paris. Réunion des Musées Nationaux/Art Resource, NY.

21 Titian, *The Three Ages of Man,* 1513–1514. Duke of Sutherland Collection, on loan to the National Gallery of Scotland.

22 Edouard Manet, *Surprised Nymph,* 1859–1860. Museo Nacional de Bellas Artes, Buenos Aires.

23 Edouard Manet, study for *Surprised Nymph,* c. 1859. Photo © The National Museum of Art, Architecture and Design, Oslo.

24 Edouard Manet, *Fishing at St. Ouen (La Pêche),* 1861–1863. The Metropolitan Museum of Art, Purchase, Mr. and Mrs. Richard J. Bernhard Gift, 1957 (57.10). Photograph © 1993 The Metropolitan Museum of Art.

25 Annibale Carracci, *Fishing,* c. 1595. Louvre, Paris. Erich Lessing/Art Resource, NY.

26 Edouard Manet, *On the Beach, Boulogne-sur-Mer,* 1869. Virginia Museum of Fine Arts, Richmond. Collection of Mr. and Mrs. Paul Mellon. Photo: Katherine Wetzel © Virginia Museum of Fine Arts.

27 Edouard Manet, *On the Beach at Boulogne,* 1868. Bequest of Robert H. Tannahill. Photograph © 2000 The Detroit Institute of Arts.

28 Edouard Manet, *Isabelle Diving,* 1880. Louvre, Paris. Réunion des Musées Nationaux/Art Resource, NY.

29 Pierre-Henri de Valenciennes, *The Ancient City of Agricentum,* 1787. Louvre, Paris. Erich Lessing/Art Resource, NY.

30 Edouard Manet, *Mlle Victorine in the Costume of an Espada,* 1862. The Metropolitan Museum of Art, H. O. Havemeyer Collection, Bequest of Mrs. H. O. Havemeyer, 1929 (29.100.53). Photograph © 1993 The Metropolitan Museum of Art.

31 Paul Cézanne, *Déjeuner sur l'herbe,* 1870–1871. Private Collection.

32 Nicolas Poussin, *Orpheus and Eurydice,* 1659. Louvre, Paris. Erich Lessing/ Art Resource, NY.

33 Anselm Kiefer, *Tree with Palette,* 1978. Courtesy Sonnabend Collection.

34 Pablo Picasso, *Le Meutre,* 1934. © 2005 Estate of Pablo Picasso/Artists Rights Society (ARS), NY. Photo: B. Hatala. Musée Picasso, Paris. Réunion des Musées Nationaux/Art Resource, NY.

35 Jacques-Louis David, *Death of Marat,* 1793. Louvre, Paris. Erich Lessing/ Art Resource, NY.

36 Inuit Mask of Swan and Whale. Louvre, Paris. Erich Lessing/Art Resource, NY.

37 Ernst Ludwig Kirchner, *Artillerymen,* 1915. Solomon R. Guggenheim Museum, New York. By exchange. 88.3591.

38 Jean Frédéric Bazille, *Bathers,* 1869. Courtesy of the Fogg Art Museum, Harvard University Art Museums, Gift of Mr. and Mrs. F. Meynier de Salinelles, 1937.78.

39 Eugène Jansson, *Piscine,* 1911. Private Collection.

40 Richard Hamilton, *He Foresaw His Pale Body,* 1990. © 2005 Artists Rights

Society (ARS), New York/DACS, London. Picture Courtesy Alan Cristea Gallery, London.

41 Frida Kahlo, *What the Water Gave Me,* 1938. © Banco de Mexico Trust. Private Collection. Schalkwijk/Art Resource, NY.

42 Jean-Antoine Watteau, *The Intimate Toilet (La Toilette intime),* c. 1715. Private Collection.

43 Edgar Degas, *Woman Bathing in a Shallow Tub,* 1885–1886. Alfred Atmore Pope Collection, Hill-Stead Museum, Farmington, CT.

44 Paul Cézanne, *The Bather,* 1885–1887. The Museum of Modern Art, NY. Digital Image © The Museum of Modern Art/Licensed by SCALA/Art Resource, NY.

45 Gustave Caillebotte, *Man at His Bath, Drying Himself,* 1884. Private Collection.

46 Edgar Degas, *After the Bath, Woman with a Towel,* c. 1886. Courtesy of the Fogg Art Museum, Harvard University Art Museums, Gift of Mrs. J. Montgomery Sears, 1927.23.

47 Pierre Bonnard, *Nude in the Bath Tub,* 1925. Private Collection. © 2005 Artists Rights Society (ARS), New York/ADAGP, Paris.

48 Pierre Bonnard, *Leaving the Bath Tub,* c. 1926–1930. © 2005 Artists Rights Society (ARS), New York/ADAGP, Paris. Private Collection, Switzerland. Bridgeman-Giraudon/Art Resource, NY.

49 Pierre Bonnard, *Nude in the Bath,* 1936. © 2005 Artists Rights Society (ARS), New York/ADAGP, Paris. Musée d'Art Moderne de la Ville de Paris. Réunion des Musées Nationaux/Art Resource, NY.

50 Pierre Bonnard, *Nu dans le bain au petit chien,* 1941–1946. Carnegie Museum of Art, Pittsburgh. Acquired through the generosity of the Sarah Mellon Scaife Family.

51 Pierre Bonnard, *The Boxer (Self-Portrait),* 1931. © 2005 Artists Rights Society (ARS), New York/ADAGP, Paris. Musée D'Orsay, Paris. Réunion des Musées Nationaux/Art Resource, NY.

52 Rachel Whiteread, *Ether,* 1991. Astrup Fearnley Collection, Oslo, Norway.

Photo: Tore H. Røneland, Oslo. Courtesy of the artist and Gagosian Gallery.

53 Robert Gober, *Subconscious Sink,* 1985. Courtesy of the artist.

54 Robert Gober, *Untitled,* 1993–1994. Astrup Fearnley Collection, Oslo, Norway. Photo: Tore H. Røneland, Oslo. Courtesy of the artist.

55 Robert Gober, *Untitled,* 2001. Photo credit: Liz Deschenes. Courtesy of the artist.

56 Claude Monet, *Hôtel des Roches Noires, Trouville,* 1870. Musée D'Orsay, Paris. Scala/Art Resource NY.

57 Charles Mozin, *Trouville, Les Bains,* 1825.

58 Trouville-sur-Mer, c. 1860s.

59 Claude Monet, *The Beach at Trouville,* 1870. National Gallery, London. Bridgeman Art Library.

60 *Baigneur faisant prendre la lame* ([Master] Bather Making Woman "Take the Wave").

61 Claude Lorrain, *Seaport with the Embarkation of the Queen of Sheba,* 1648. National Gallery, London. Bridgeman Art Library.

62 Claude Monet, *Beach at Trouville,* 1870. Wadsworth Atheneum Museum of Art, Hartford, CT. The Ella Gallup Sumner and Mary Catlin Sumner Collection Fund.

63 Theodore Géricault, *Raft of the Medusa,* first oil sketch, 1819. Louvre, Paris. Réunion des Musées Nationaux/Art Resource, NY.

64 Edouard Manet, *The Escape of Rochefort,* signed version, 1880. Musée D'Orsay, Paris. Photo: Hervé Lewandowski. Réunion des Musées Nationaux/Art Resource, NY.

65 Bas Jan Ader, *In Search of the Miraculous,* 1975. Courtesy Patrick Painter Editions/Bas Jan Ader Estate.

66 Alphonse Bon Le Blondel, *Man at the Bedside of his Dead Child,* 1850. The Metropolitan Museum of Art, Gilman Collection, Purchase, The Horace W. Goldsmith Foundation Gift, 2005 (2005.100.31). Copy Photograph © 1998 The Metropolitan Museum of Art.

67 Gustave Courbet, *Stone Breakers,* 1849. Gemaeldegalerie, Staatliche Kunstsammlungen, Dresden, Germany. Foto Marburg/Art Resource, NY.

68 John Currin, *The Gardeners,* 2001. © 2001 John Currin. Courtesy Gagosian Gallery.

69 Jean-François Millet, *The Gleaners,* 1857. Musée D'Orsay, Paris. Erich Lessing/Art Resource, NY.

70 Philip Pearlstein, *Two Models on Kilim Rug with Mirror,* 1983. Collection of the Kemper Museum of Contemporary Art, Kansas City, MO. Bebe and Crosby Kemper Collection, Gift of the Enid and Crosby Kemper Foundation, 1995.59.

71 Thomas Eakins, *William Rush and His Model,* 1907–1908. Honolulu Academy of Arts, Gift of Friends of the Academy, 1947 (548.1).

72 Philip Pearlstein, *Portrait of Linda Nochlin and Richard Pommer,* 1968. Courtesy of the artist and Betty Cunningham Gallery, New York.

73 Alice Neel, *The Family (John Gruen, Jane Wilson and Julia),* 1970. © Estate of Alice Neel. Courtesy Robert Miller Gallery, New York.

74 Alice Neel, *David Bourdon and Gregory Battcock,* 1971. © Estate of Alice Neel. Courtesy Robert Miller Gallery, New York. Jack S. Blanton Museum of Art, The University of Texas at Austin, Archer M. Huntington Museum Fund, 1983.

75 Alice Neel, *Andy Warhol,* 1970. © Estate of Alice Neel. Courtesy Robert Miller Gallery, New York. Whitney Museum of American Art, New York.

76 Alice Neel, *Linda Nochlin and Daisy,* 1973. © Estate of Alice Neel. Courtesy Robert Miller Gallery, New York. Museum of Fine Arts Boston. Photograph © 2006 Museum of Fine Arts, Boston.

77 Sylvia Sleigh, *The Turkish Bath,* 1973. The David and Alfred Smart Museum of Art, The University of Chicago; Purchase, Paul and Miriam Kirkley Fund for Acquisitions. Photograph © courtesy of The David and Alfred Smart Museum of Art, The University of Chicago.

78 Jean-Auguste-Dominique Ingres, *The Turkish Bath,* 1862. Louvre, Paris. Photo: Gérard Blot. Réunion des Musées Nationaux/Art Resource, NY.

79 Jenny Saville, *Propped,* 1992. Courtesy Gagosian Gallery.

80 Jenny Saville, *Matrix,* 1999. Courtesy Gagosian Gallery.

81 Jenny Saville, *Reflective Flesh,* 2002–2003. Courtesy Gagosian Gallery.

82 Gustave Courbet, *Origin of the World,* 1866. Musée D'Orsay, Paris. Réunion des Musées Nationaux/Art Resource, NY.

83 Lucian Freud, *Painter Working, Reflection,* 1993. Courtesy of the artist and Acquavella Galleries.

84 Alice Neel, *Self-Portrait,* 1980. © Estate of Alice Neel. Courtesy Robert Miller Gallery, New York. National Portrait Gallery, Smithsonian Institution/Art Resource, NY.

85 Alex Francés, *Eva Futura,* 2001. Galeria Luis Adelantado.

86 Auguste Rodin, *Old Courtesan,* 1887. The Metropolitan Museum of Art (11.173.3). Photograph © The Metropolitan Museum of Art.

87 Paul Cézanne, *Seated Peasant,* c. 1900–1904. Private Collection. Erich Lessing/Art Resource, NY.

88 Paul Cézanne, *Old Woman with Rosary,* 1895–1896. National Gallery, London. Bridgeman Art Library.

89 Paul Cézanne, *Woman with a Coffeepot,* c. 1895. Musée D'Orsay, Paris. Scala/Art Resource NY.

90 Paul Cézanne, *The Painter's Father, Louis-Auguste Cézanne,* c. 1862. © The National Gallery, London.

91 Paul Cézanne, *The Artist's Father,* c. 1866. Collection of Mr. and Mrs. Paul Mellon. Image © 2005 Board of Trustees, National Gallery of Art, Washington.

92 Edgar Degas, *Lorenzo Pagans, Spanish Tenor, and Auguste Degas, Father of the Artist,* c. 1869–1872. Musée D'Orsay, Paris. Erich Lessing/Art Resource, NY.

93 Mary Cassatt, *Reading Le Figaro,* 1877–1878. Private Collection, Washington, D.C.

94 James Abbott McNeill Whistler, *The Artist's Mother,* 1871. Musée D'Orsay, Paris. Réunion des Musées Nationaux/Art Resource, NY.

95 Mary Cassatt, *Mrs. Robert S. Cassatt, the Artist's Mother (Katherine Kelso Johnston Cassatt),* c. 1889. Fine Arts Museums of San Francisco, Museum purchase, William H. Noble Bequest Fund, 1979.35.

96 *Wisconsin Death Trip, Old Woman,* c. 1893. Michael Lesy, *Wisconsin Death Trip.* Albuquerque: University of New Mexico Press, 2000.

97 Photograph of Elizabeth Taylor at 72, 2002. Getty Images.

98 Edouard Manet, *Funeral,* c. 1870. The Metropolitan Museum of Art, Catharine Lorillard Wolfe Collection, Wolfe Fund, 1909 (10.36). Photograph © 1993 The Metropolitan Museum of Art.

99 Nicolas Poussin, *Landscape with the Burial of Phocion,* 1648. Collection Earl of Plymouth, Oakley Park, Great Britain. Scala/Art Resource NY.

100 Edouard Manet, *The Dead Toreador,* 1864. Widener Collection. Image © 2005 Board of Trustees, National Gallery of Art, Washington.

101 Edouard Manet, *Fish (Still-Life),* 1864. Mr. and Mrs. Lewis Larned Coburn Memorial Collection, The Art Institute of Chicago. Photography © The Art Institute of Chicago.

102 Edouard Manet, *The Suicide,* 1877–1879. Fondation E. G. Buehrle, Zurich. Erich Lessing/Art Resource, NY.

103 Edouard Manet, *The Rabbit,* 1864. Avignon. Musée Angladon. Cliché Loury.

104 Edouard Manet, *A Stem of Peonies and Pruning Shears,* 1864. Musée D'Orsay, Paris. Erich Lessing/Art Resource, NY.

105 Sam Taylor-Wood, *Fuck, Suck, Spank, Wank,* 1993. Courtesy Matthew Marks Gallery, New York.

Index

Titian, 142, 241, 295, 296; *Three Ages of Man,* 63, 65
Tournachon, Gaspard Félix. *See* Nadar (Gaspard Félix Tournachon)
Trouville, 160, 161–165, 167

Valenciennes, Pierre Henri de, 76; *The Ancient City of Agricentum,* 77; *Elémens de perspective pratique,* 82–86
Van Gogh, Vincent, 213, 245–247, 258; *Portrait of Dr. Gachet,* 225
Velázquez, Diego, 240; *Las Meninas,* 4
Venus of Willendorf, 237
Vernet, Joseph, 167

Vigarello, Georges, 30
Villon, François, "Testament: Les regrets de la belle heaulmière," 255, 257
Vollard, Ambroise, 22

Walter, Marie-Thérèse, 107
Warburg, Aby, 200, 298, 299, 300–302
Watteau, Antoine, *The Intimate Toilet (La Toilette intime),* 116–118
Watts, George Frederic, *Found Drowned,* 180
Weegee (Arthur Felig), 203–204
Weyden, Rogier van der, *Last Judgment,* 132
Whistler, James Abbott McNeill:

The Artist's Mother, 271, 272; *A Symphony in White,* 271
White, Barbara Ehrlich, 316n24
Whiteread, Rachel, 146–148; *Ether,* 146, 147
Wilde, Oscar, 13
Wisconsin Death Trip: Old Woman, 275–278
Woolf, Virginia, 180

Young-Bruehl, Elizabeth, 10–13, 19

Zellen, Jody, 194
Zola, Emile, 76